# THE WATERCOLOR LANDSCAPE TECHNIQUES

## OF 23 international artists

international
artist

*international*
**artist**

International Artist Publishing, Inc
2775 Old Highway 40
P.O. Box 1450
Verdi, Nevada 89439
Website: www.artinthemaking.com

Edited by Terri Dodd and Jennifer King
Designed by Vincent Miller
Typeset by Cara Herald
Editorial Assistance by Dianne Miller

ISBN 1-92983-426-8

Printed in Hong Kong
First printed in hardcover 2003
07 06 05 04 03   6 5 4 3 2 1

Distributed to the trade and art markets
in North America by:
North Light Books,
an imprint of F&W Publications, Inc
4700 East Galbraith Road
Cincinnati, OH 45236
(800) 289-0963

# MAY ALL YOUR NUDGES BE GREAT ONES!

The 23 chapters in this book represent a summary of the crucial elements of landscape painting by 23 of the best watercolor landscape painters in the world today. The following table of contents lists the wonders on offer. Each artist has focused on a unique aspect of landscape painting so that even though you may not currently work in that way, the lesson contained therein gives not only something different for you to consider, but is essential for your ongoing development.

As you turn these pages a myriad of landscape possibilities become available to you. Each contributing artist generously allows you special insight into their different ways of expressing their vision of the landscape so that you may be able to find your particular vision too. And it could be just a simple nudge in the right direction from any of these artists that sets you on the path to becoming a truly accomplished, professional quality artist. Perhaps there's no better example of such a transformation than the Turning Point recorded by Phil Hobbs that so aptly sums up the spirit and intention of this book. In Chapter 8 Phil writes:

*"Nearly 30 years ago now, fresh out of college, at the summer exhibition of a society of which I dreamt of becoming a member one day, I was standing gazing at a group of paintings by an artist that I particularly admired. Seeing him standing nearby I asked in awe, 'How do you do it?' He looked at me, smiled and quietly, almost conspiratorially said, 'It's all about understanding shape, Phil'. At the time his reply sounded almost too simple, too profound. Recently however, at the annual exhibition of that same society of which I am now vice-president, I saw the same eminent painter looking at my work. As I approached, he turned and said with a knowing chuckle, 'Go on Phil, how do you do it'? I could have cried, and perhaps should have said, that in part, it was because over the years during countless struggles I was able to hear a quiet steady voice saying, 'It's all about understanding shape, Phil'. I didn't say it, as it was not needed; I just smiled."*

There could be just such a paradigm shift waiting for you in one of the following chapters.

We would like to thank the generosity of the wonderfully talented artists without whom this book could never have happened: Lionel Aggett, Greg Allen, Dagfinn Bakke, Alvaro Castagnet, Dominic Distefano, Miguel Dominguez, Nita Engle, Phil Hobbs, Kiff Holland, Robert Lovett, Boguslaw Mosielski, John Newberry, Tom Nicholas, Juliette Palmer, Herman Pekel, Vivian Ripley, Bob Rudd, Jean Uhl Spicer, Robert Tilling, Marilyn Timms, Bernhard Vogel, Joseph Zbukvic and Zhong-Yang Huang.

To everyone who opens this book we say, may all your nudges be great ones!

Vincent Miller was responsible for the original concept and design of this book, which was compiled by a team of *International Artist* staff, including Editor/Executive Publisher, Terri Dodd, US Editor, Jennifer King, International Editor, Jeane Duffey and UK Editor, Susan Flaig.

All 23 chapters have a unique 6-page format so you can see how each international artist focuses on their personal approach to painting a watercolor landscape

## THE ELEMENTS IN EACH 6-PAGE CHAPTER

### THE 2 PAGE OPENING SPREAD IN EACH CHAPTER

Explains the artist's personal way of working and the main ideas you can use in your own art.

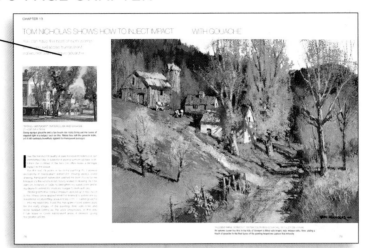

### THE 2 PAGE DEMONSTRATION SPREAD IN EACH CHAPTER

A step-by-step sequence shows all the stages of development of a major painting. Full descriptive captions, plus a list of colors and materials used, turn each demonstration into an exercise you can follow.

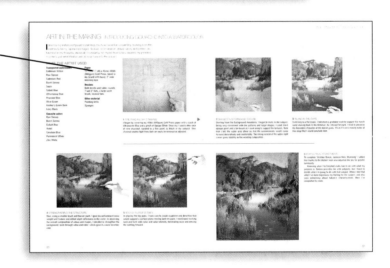

### THE 2 PAGE GALLERY SPREAD IN EACH CHAPTER

Magnificent gallery paintings reinforce the point of each chapter. Then find out a little about the artists themselves.

### THE TURNING POINTS

Read the significant Turning Point moment that changed each artist's art, and even their lives.

# CONTENTS

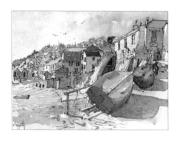
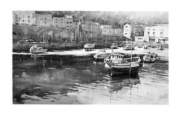
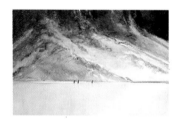

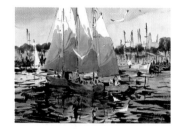

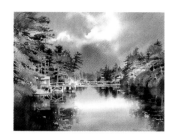
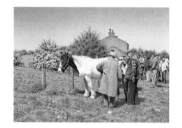
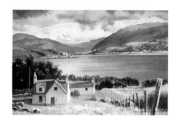
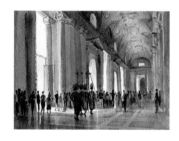

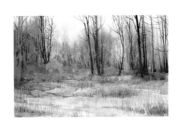
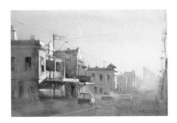
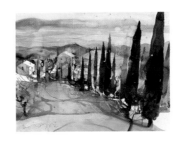
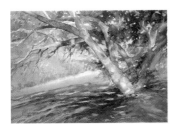
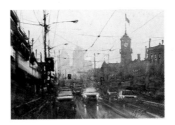
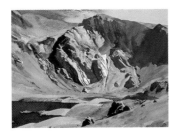
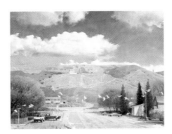
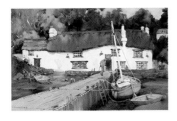

# HOW LIONEL AGGETT PAINTS OVER A CONTÉ

If you are in love with line, then there is no need to sacrifice it. See how this British artist manages to achieve a soft atmosphere but keep the edges too!

**M**uch of my work is executed in the open air and it is this responsive act of painting outdoors that helps to fuel my inspirational drive. I tend to use mostly watercolors or pastels for these situations. I find both are perfect for rapidly working through to conclusion in one extended session, where the moment to be captured is carried before the constantly changing light. It is this confrontation with nature's variables that makes painting on location so exciting.

In addition to completing full paintings on site, this outside work is supplemented with numerous drawings and diary sketches wherever I travel. These are used later in the studio to produce further work for exhibitions comprising both plein air and studio paintings. I treated the following demonstration as I would the latter, working from a double page spread of the diary kept during one of our visits to Italy.

Assisting in the rapid delivery on site is a restricted palette selected from my traditional Winsor and Newton 12 pan metal box held in one hand, a #10 series 7 Winsor and Newton sable brush in the other, and a board supporting the paper on the easel.

We live in Mid Devon, fairly close to the West Penwith, Cornwall, renowned in the UK and beyond, for the quality of its light. Most of the paintings shown are of this area, which is surrounded on three sides by the unpolluted sea. The light has intense vibrancy and here purple-grays predominate. On the other hand, violet-blues emerge from the palette when painting in Southern Europe, especially Provence and Andalucia (to my eyes that is, for we all see light differently). Inland rural Spain, another of my favorite haunts, features in another painting shown here.

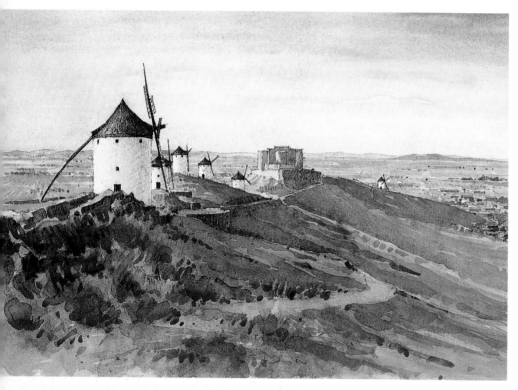

"WINDMILLS OF LA MANCHA, CONSUEGRA, SPAIN", 15 x 22" (39 x 57cm), SAUNDERS WATERFORD 300lb (640gsm) NOT

I have painted this group of windmills and castle, romantically set atop the steep sided isolated hill above the small town of Consuegra under various conditions. I have worked from the protection of my VW Camper during ferocious wind and near horizontal rain. I have worked at my easel under clear skies and baking sun. I have also worked, as here, in the warm evening sunlight — perhaps the most moving and atmospheric time to witness these sentinels presiding with truly majestic and loving countenance over the Quixotesque landscape. From late afternoon until sunset and into the afterglow the windmills' white cylinders reflect the increasingly warm sunlight, contrasting with the violet blue haze of the vast landscape far below.

Warm washes were applied wet-in-wet with my #10 round sable using Yellow Ochre, Winsor Yellow, and Crimson Lake over the conté under drawing, and Ultramarine Blue blended into the upper position of the sky, again wet-in-wet. Tonal contrast was then developed with wet-in-wet and dry washes using Ultramarine Blue, Light Red, Crimson Lake and Raw Sienna.

# STICK UNDER DRAWING

"MORNING LIGHT, MOUSEHOLE, CORNWALL", 12 x 16" (30 x 40cm),
SAUNDERS WATERFORD 300lb (640gsm) NOT

Mousehole originally possessed a proud fishing fleet, and boats continue to thrive and
work from neighboring Newlyn. The unspoiled nature of this most perfect of Cornish
coastal villages has been preserved. Buildings have been restored, many as holiday
rentals and rather sadly as second homes with prices beyond most of the young locals,
who are forced to move away. The UK tourism boom is not helping quite so much here,
although the season is gradually extending to shorten the winter.

The granite and rendered buildings, clean and glistening in the morning light, rise
from the solid granite plinth of the pincer-shaped harbor. Boats rested up for the winter
produce an interesting composition, just waiting to be painted!

## WHAT THE ARTIST USED

**Support**
Saunders Waterford,
300lb 640gsm Not paper

**Brushes**
Series 7, Size 10 round sable

**Other materials**
Conté A Paris 2654 square
section crayon

Paper towel

Fixative

### Colors

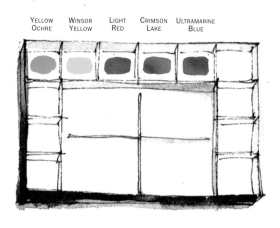

YELLOW OCHRE　WINSOR YELLOW　LIGHT RED　CRIMSON LAKE　ULTRAMARINE BLUE

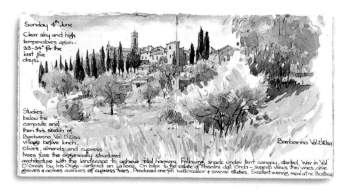

**1 DIARY SKETCH, SUNDAY 4TH JUNE**
"BARBARINO VAL D'ELSA, TUSCANY, ITALY", 8 x 8" (20 x 20cm) x 2

I remember this day so well. I left my wife Anne reading in the shade of our tent canopy while I cycled the very short distance to record this view of the village.

The sketch was executed in temperatures of 33° plus, where the sun dried each loosely applied heavily laden brushload almost as soon as it hit the paper. My #10 sable brush was used throughout. The result is, I think, quite lively, and my aim was to transport this immediacy to the studio, interruptions for photography permitting!

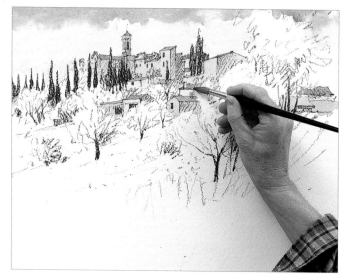

**4 DEVELOPING THE BUILDINGS**
The buildings, the skeletal structure from which the rest of the painting was hung, were tackled next. I applied a medium wash of Yellow Ochre plus a little Crimson Lake across the facades, dropping in stronger touches of the same mix but with an increase of Crimson to the church and middle foreground structure. Then, mixing Yellow Ochre, Light Red with a little Crimson I painted the roofs, adding wet-in-wet, but with a less full brush, a stronger mix of the same color for the more intense areas.

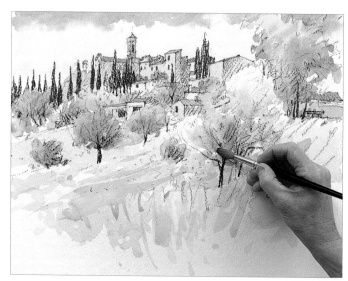

**5 SUGGESTING FOLIAGE AND GRASSES**
Moving on to the general foliage and ground area, I applied an under wash of Winsor Yellow plus a touch of Ultramarine Blue to the grassed olive and almond grove. This was quickly followed with a few more strokes of the same mix but with more Ultramarine, along the line of the slope to register the contours, and suggest foreground grasses and wild plants. Note the highlighted areas using whiteness of the paper, achieved solely with brush strokes.

Fluid applications were then made, Yellow Ochre and Ultramarine Blue for the olive, and Winsor Yellow and Ultramarine Blue for the almond trees. Then I dropped in stronger mixes with an increase of Ultramarine, but less on the brush, to the darker shaded area.

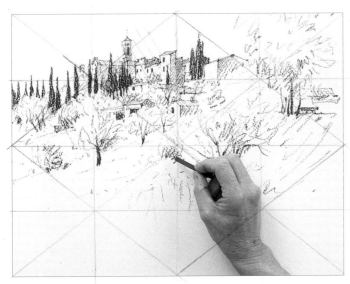

**2** TRANSFERRING THE SKETCH

Drawing from the sketch without squaring up, I followed the general composition which is transposed from the double 8 x 8" (20 x 20cm) format of the sketchbook to the painting size of 15 x 19" (38 x 49cm). The dark cypress trees, a strong inclined element of the composition, were applied with firm crisp strokes of the conté stick, as were the trunks of the olive and almond trees. Foliage was loosely indicated and the shaded sides of the building were cross hatched. A light spray of fixative was then applied to seal the conté ready to receive the watercolor.

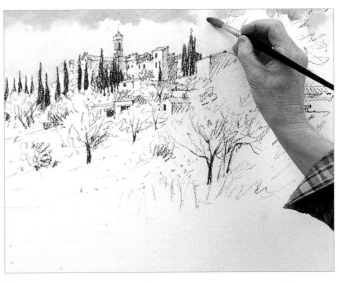

**3** MAKING THE FIRST WASHES

I started with the sky, the source of light, which always has so much influence on the mood of the subject. Working swiftly, I applied a light wash of yellow ochre to the lower two thirds of the sky, adding Crimson Lake wet-in-wet nearer the horizon, and leaving areas of the paper dry for the white cloud. I then brushed Ultramarine Blue, again with a fully loaded brush across the upper area, gradually thinning with water, but less on the brush as I worked wet-in-wet across the already drying lower portion.

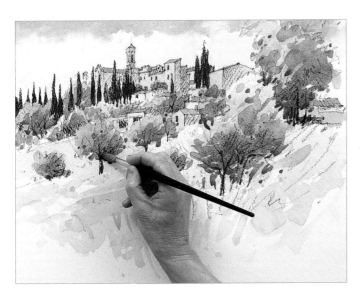

**6** ACCENTUATING THE CYPRESS TREES

Although slender, these trees would become the strongest and most striking elements in the painting, and accentuate the slope from the village. A generous application of Yellow Ochre and Ultramarine Blue, was followed by an even stronger mix (more Ultramarine Blue) but less full, to the shaded areas. The same principle applied to the other trees using the same colors as before. The treatment was broad but with one or two deft touches to suggest detail. Note the positioning of poppies behind my hand, registered in Winsor Yellow. This under color would make the flowers sing later!

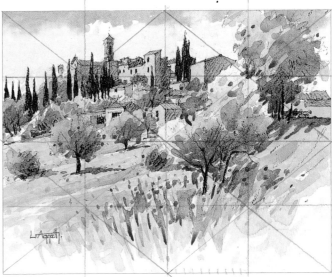

**7** FINISHED PAINTING: BARBARINO VAL D'ELSA, 15 x 19" (38 x 49cm)

The buildings were brought to life with the application of shaded areas using Light Red and Ultramarine Blue. The intensity of the grassed areas was increased using the same colors as before, adjusting the level to meet the tonal range established. Shadows beneath the trees were painted partly dry and wet-in-wet to the foreground and dry under the remainder. Finally the poppies were added using Cadmium Red and Crimson over the Winsor Yellow base.

I think a studio work never quite possesses the same magic as the original plein air sketch or painting, but perhaps that is all related to the initial act: the subconscious and lasting memory of being there, in a very beautiful place.

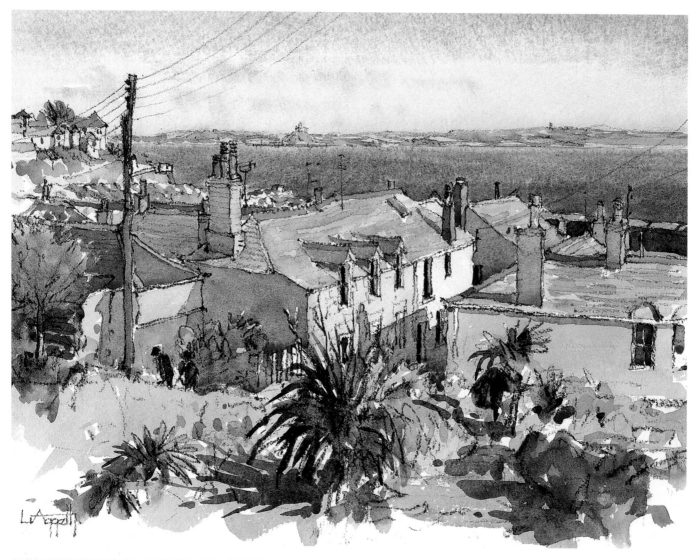

The sun-kissed lichen covered slate roofs contrast perfectly with the blue
sea whilst the red clay ridge and hip tiles complement the green Cornish
palms. Sparkling light pervades this scene looking out across the bay
towards St. Michaels Mount, with the fine chapel behind me, plain outside
and restrained elegance inside.

This painting was completed in one flowing session using my trusty
Series 7 No. 10 sable brush over conté stick under drawing.

(RIGHT) "THE PIPER, BOLEIGH, WEST PENWITH, CORNWALL",
14½ X 20" (38 x 50cm), SAUNDERS WATERFORD 300lb (640gsm) NOT
The group of farm buildings at Boleigh were often portrayed by the Newlyn
School of painters, more so it would seem, than the two massive granite
menhirs, known as the Pipers, the largest to survive in Cornwall today. At
15ft (4.5 metres) high, with a further 5ft (1.5m) underground, the Piper, the
northernmost and higher of the two by approximately 23½" (600mm) makes
a striking study set against the farm buildings.

This was painted on a cold windy day, mostly wet-in-wet apart from the
final broad washes depicting the foreground. The applications soon dried,
resulting in a rigorous but restrained rendering over a loose conté drawing.
with the exception of the Piper which was carefully considered.

# TURNING POINT

Following 25 years pulling both the strings attached to my
bow, that is, architectural practice and painting, the defining
turning point coincided with the decision to give up
architecture in order to pursue a full time painting career,
something I had always wanted to do.

I had been exhibiting regularly with the Pastel Society
since 1982, when in 1990 I was approached by three London
Galleries during the course of the annual show, regarding the
possibility of exhibiting with them. This resulted in a mixed
show at Llewellyn Alexander (opposite the Old Vic Theatre),
followed in 1992 by my first solo exhibition there, which was
a sell out. Since then I have not looked back, with regular
solo shows with Jilian and Ernest (to whom I am extremely
grateful for their encouragement and support), and also
Manya Igel, W. H. Patterson, both London, John Davies
Gallery, Stow, Clifton Gallery, Bristol, Walker Galleries,
Harrogate and Honiton, and Sarah Samuels, Chester.

Submitting work to and exhibiting with the principal
Societies, although requiring much hard work, is a
rewarding way of enabling your work to be placed in the
limelight. Leading galleries are always looking out for
consistency as well as quality, and will follow the work of an
artist over a number of years before declaring an interest.

"ST. MICHAELS MOUNT FROM MARAZION, CORNWALL", 12 x 16" (30 x 40cm), SAUNDERS WATERFORD 300lb (640gsm) NOT

This view of the Mount seen across the rooftops of Marazion from one of the higher terraces is full of sparkling bouncing February afternoon light. Making full use of the Saunders Waterford paper to express the wide tonal range experienced when looking towards the sun, I applied the watercolor with a #10 round sable. Rapid strokes were deployed without the use of masking fluid, which although a convenient tool, cannot to my mind match the freshness and spontaneity of natural brushwork. For the same reason I have experimented with, but then discarded the use of opaque white and mixed media.

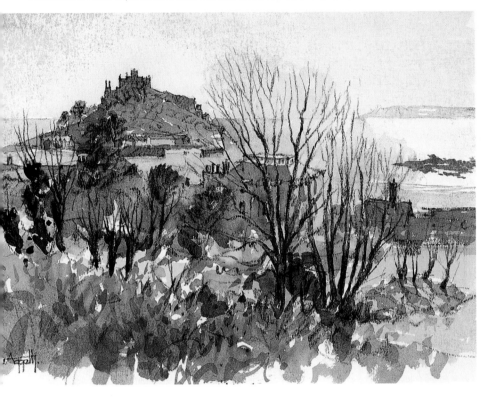

## ABOUT THE ARTIST

Lionel Aggett was born at Whiddon Down, on the edge of Dartmoor, Devon. He was educated at Exeter School and Kingston School of Art and Architecture. Lionel was elected a member of the Royal Institute of British Architects in 1967. He has won six architectural awards. He held his first solo show at Truro Galleries in 1968 and gave up architecture in 1991 to paint full time.

He exhibits in London with W.H. Patterson; Manya Igel and Llewellyn Alexander. His work can also be seen at John Davies at Stow; The Walker Galleries, Harrogate and Honiton; Clifton Gallery, Bristol; Sarah Samuds, Chester and the Coves' Quay Gallery, Salcombe.

Lionel Aggett's work now hangs in public, corporate and private collections in the UK, Europe and the USA. He has also exhibited at the Royal Institute of Painters in Watercolours, The Pastel Society, The Royal West of England Academy and the South West Academy.

Works have been reproduced as Limited Editions by Solomon and Whitehead, and also by the Robertson Collection as high quality cards. He is the author of five books for which he produced all the illustrations/paintings and full text. He has also contributed to seven other titles, as well as articles for several art magazines, including *International Artist* magazine.

Lionel is a member of both the Arts Club London, and of the resurgent St. Ives Society of Artists. He regularly gives lectures and demonstrations to art groups and societies.

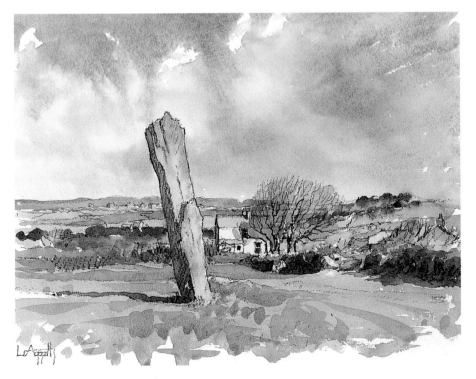

# GREG ALLEN GIVES YOU PERMISSION TO PAINT

Nature is beautiful, but painting exactly what you see does not necessarily result in a good painting.

"BRIXHAM HARBOR, DEVON", 23 X 34" (58 x 86cm)

Since Australia has very few seaside fishing ports of the cluttered and compressed kind so common around the shores of England, it is an absolute pleasure to occasionally visit these spots and paint such wonderful subjects. Harbors are invariably full and bustling and the boats seem quirkier and more varied.

This painting is all about a fishing village in the very early morning when no one is around and there is a sense of peace and tranquillity. There is also a suggestion of the impending heat. Notice how I handled the focal point, the main boat, and how all the other elements supported this. For example, notice where pure color was placed and where subdued color was placed. Notice the detail and the merely suggested. For the brightest highlights I left many areas of white paper, especially on horizontal planes.

HOW I CHANGED WHAT I SAW

In this image of Brixham, the arrangement was enhanced by manipulating and excluding some boats and working with the nature of the wall and its effect on the water.

When you are a realist painter it is easy to think that by copying you are creating. But reporting nature the way she is, is really nothing more than, well, reportage!

Classical picture making, on the other hand, is about creating an aesthetic ideal that is pleasing to the eye. So while we can all walk around this world and select subjects, then hang them up for contemplation, until we understand design and pattern and mass and shape relationships, we will continue to paint aesthetically flawed paintings. This is because we don't understand our function, which is to create. We are creators. It is okay to design and modify

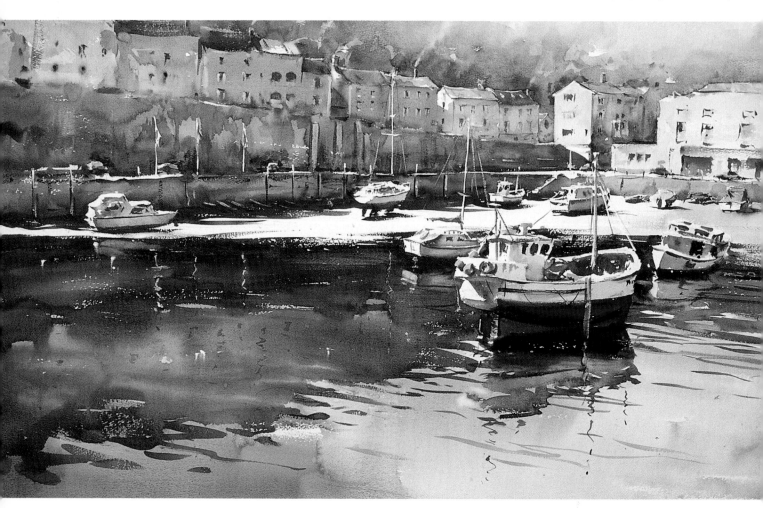

# YOUR OWN INVENTIONS

and synthesize the basic merits of our subjects. We can still tell the truth about nature, but we don't have to incorporate her irritating, distracting aspects as well. To understand this is to experience something profound.

## FINDING PERSONAL STYLE

We all paint relative to our personalities and I guess I'm no exception. I love different experiences and I love different artistic experiences that can be gained from painting a wide range of visual stimuli. So perhaps I'm your typical painter for today — influenced by styles and ideas of the past but happy to paint a diversity of subjects.

But my technical style has always remained resolutely impressionistic, for that era had a profound influence over me. My core concern is the beauty of the simple brushmark and how it can be two things at once — an elegant mark complete in itself, but when applied with forethought it can also represent a clear impression of some aspect of the subject being painted.

My style has evolved through a constant addressing of these two areas.

In order to paint a wide range of ideas or subjects, I've not only had to become reasonable at drawing but also a practitioner of the theories that are relevant to all subjects — the understanding that what I'm really painting are forms in light. So I've tried to understand forms, and, being an Australian, I've certainly had plenty of opportunities to understand light!

Aside from this, I try to incorporate the general hallmarks of good watercolor painting. That is, careful planning coupled with a "seizing of the moment" philosophy to make deliberate, confident marks on that paper directly and crisply. If anything, I treat them more like inks than watercolors. Thinking that way leads to minimal disruption to the first washes and brushstrokes. Call me an "alla prima" man through and through!

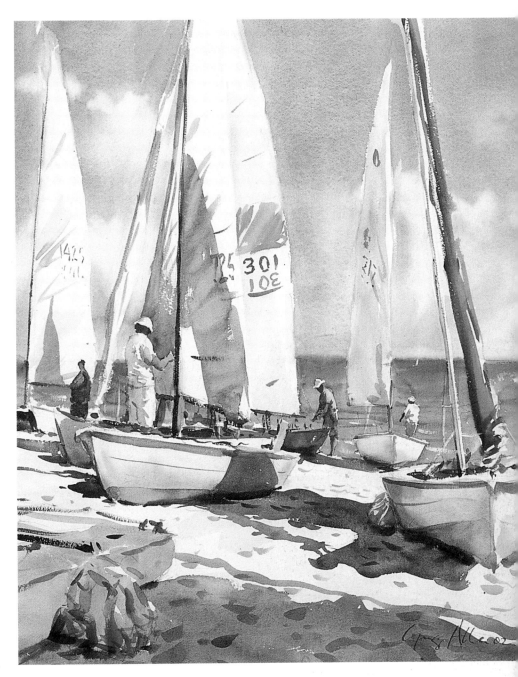

"RACE PREPARATIONS", 21½ x 17" (55 x 44cm)
This vertical format perfectly suits these sailboats. Zooming in and cropping off the top of the masts gives an intimate, dynamic view. The sailors readying their boats for the race tell a story and give scale and interest to the painting. Notice that these figures are anatomically correct, not just suggestions.

## HOW I CHANGED WHAT I SAW

The overlapping shapes, the diagonals, the striped object in the foreground and the interconnecting shadow give this painting plenty for the eye to appreciate. Notice the variation in size of shape and how I left the white of the paper for the sails. You cannot do this without having a plan first.

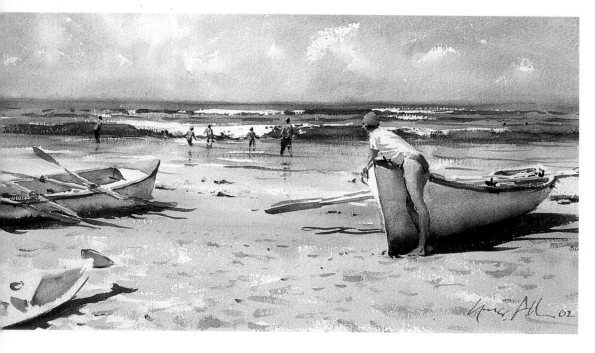

"THE LIFESAVER", 10 x 18"
(25 x 45cm)
Given Australia's bright summer sunlight it's always fun interpreting hot bleached days with a generous mutual contrast given to the forms that are horizontal and vertical. Sometimes the flat horizontal surfaces of a subject, in this case the beach, need only the lightest of washes to convey the effect of parched, hot sun.

### HOW I CHANGED WHAT I SAW

Here's an example of how you can place figures to support the composition, add interest and support the suggestion of scale and distance. See if you can spot the areas where I left plain white paper.

# ART IN THE MAKING CHANGING THE SCENE WITH IMAGINED FIGURES

I was inspired by the magnificence of the San Gimignano Arch in Italy. The scene for the painting was simple, yet monumental and inviting, with many helpful converging lines, thanks to the uphill slope.

My preliminary sketch helped to clarify all that was good about the subject, and helped me get to know it better.

I introduced some well placed figures to lead the eye in an interesting serpentine way through the painting. You have to be careful when you place figures because badly placed ones will detract from the composition. In this case, the large man on the right served as a counterbalance for the arch, which was pushed deliberately left of center.

## WHAT THE ARTIST USES WHEN WORKING ON SITE

I have what I call a skeleton crew of materials. Painting outdoors means doing some serious walking, so it's what you lug, and how you lug it that matters.

I pack my favorite items into a fishing tackle box or two. I suggest only six favorite brushes and only 10 or so versatile colors that you use frequently. The ones shown on the accompanying palette allow me to mix a good range of colors. I only carry a 2 pint water container because water is heavy.

My on-site easel is a steel one with telescopic legs that I cut down to suit my height. I also carry a compact stool. I pack all my equipment into a hiker's day-pack. My board and paper are contained in a very small portfolio boasting a shoulder strap.

**Paper**
Take 6 sheets of 140lb (300gsm) or 90lb (185gsm) 15 x 22" (38 x 56cm) paper.

**Brushes**
Two large mop brushes
# 2, 6, 8, 12 and 16 rounds

**Other materials**
Pencils, eraser, small cutting knife, masking tape, sketchpad, atomizer

**Colors**

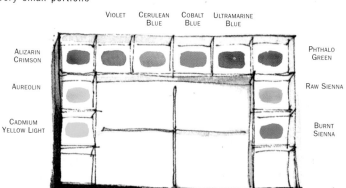

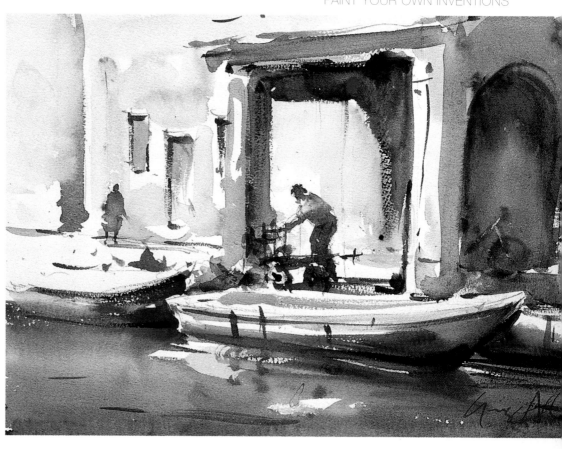

"STUDY AT BURANO, ITALY", 8½ x 12" (22 x 30cm)

This study is less than quarter-sheet but indicative of my general philosophy, where consideration is given to the various key moments in a painting that offer the potential for beautiful or at least efficient brushmarks. In short, I try to say to myself: "Hey, you're painting with inks, not watercolors. You've got one chance — one mark — don't waste it!"

This study was painted for my group when I was leading a painting vacation in Italy and it clearly shows the purity of the on-site experience. Notice the brilliant color, the loose but confident strokes, the handling of washes, the texture and the juxtaposition of warm and cool temperatures.

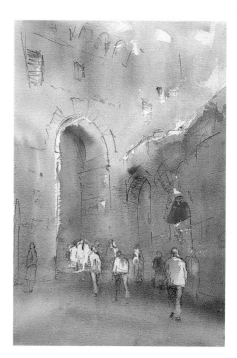

**1 MY SMALL ON-SITE SKETCH**
Practicing what I always preach, I made a preliminary sketch of the scene to plan the composition and where the main shadows would be.

**2 THE INITIAL DRAWING**
You can see a simplified, but accurate drawing, gave me all the information I needed.

**3 THE LIGHT COLORS AND VALUES**
All washes relating to color and tone were applied first. I used large brushes and let the edges of the washes touch and bleed together. I used lots of Raw Sienna, Burnt Sienna and Cerulean Blue.

I've always believed water to be a wonderful watercolor subject and am forever attracted to it. It's usually at its most beautiful when painted simply using watercolor's "chemistry" to recreate the subtle reflective effects of what really is an undulating liquid mirror. I hope that comes across in this picture.

I was searching for a quiet, picturesque quality, hence the overcast sky, gray-green tonings and non-monumental subject.

Water is a beautiful element to paint when perceived simply. This passage needed to be elegant, yet technically audacious.

### HOW I CHANGED WHAT I SAW
Overlapping shapes were linked with a serpentine composition. Warm and cool colors were knitted through the design. (Incidentally, this painting won a major Australian art award.)

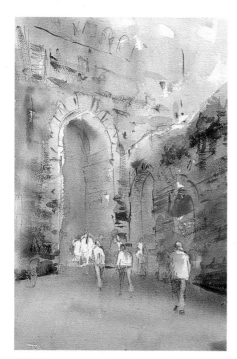

**4 TEXTURE**
While I waited for the clouds overhead to disperse, I added some texture.

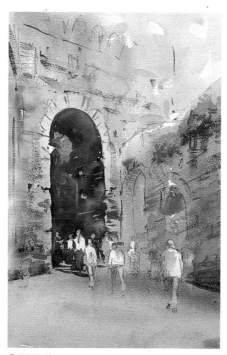

**5 FORMS**
A mix of Burnt Sienna and Ultramarine Blue was used to describe the forms, cavities and volumes in the areas of color previously applied. The figures were knitted into the design, while reflected light was observed and enhanced.

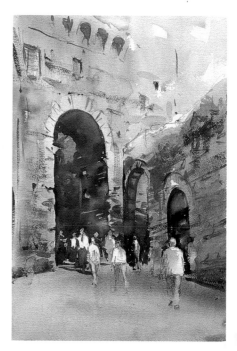

**6 OTHER ELEMENTS**
The other arches were completed while I cut around the figures. The whites were the white of the paper, which is why a plan is essential.

# TURNING POINT

In my case, turning points relate to real moments of understanding about art — about occasional paradigm shifts in my thinking.

## ABOUT THE ARTIST

Greg Allen was born in Australia in 1958 and studied at the Caulfield Institute of Technology in Melbourne. He established himself as a professional artist when he was 23 and had his first solo exhibition that same year. In 1982 he was awarded the prestigious Camberwell Rotary Travel Scholarship of five months study and travel in Europe. In 1990 he studied pastel painting under Daniel Greene in New York. In 1991 he won the Alice Bale Watercolour Prize. He has won the important Camberwell Rotary Watercolour Prize twice, in 1990 and 2000, and has 24 other major First Prizes and Best of Show Awards for watercolor to his credit. Greg is a sought-after tutor and has been a guest lecturer at Melbourne University.

With 12 solo exhibitions and 6 group exhibitions under his belt, Greg has a considerable reputation as one of Australia's most accomplished watercolorists. His work has been acquired for several major corporate and private collections. He belongs to the Victorian Artist's Society and the Watercolour Society of Victoria.

His work can be seen in the Howard Portnoy Galleries, Carmel, California, USA and the John Davies Gallery, Stow on the Wold, Gloucester, UK, as well as galleries in Australia.

His work has been published on several occasions, and articles on his working methods have appeared many times in *Australian Artist* and *International Artist* magazines. He has led International Painting Workshop Vacations to Europe for *International Artist* magazine.

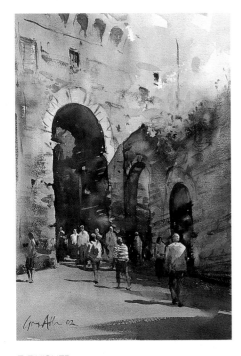

**7** FINISHED
The tubularity of the figures was developed. (See figures as forms in light.) Finally, all the shadows were put in before the subject changed too much. Shadow was cast across the major figure's back to fuse him into the scene a little more. Note the balancing effect of the large, fictional shadow in the right foreground and how my original invention of the figures leads the eye.

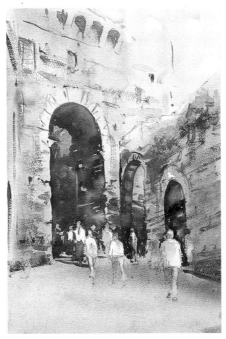

TONAL VALUE VERSION
Compare this mono version of the finished painting to my preliminary sketch. It helps to have a plan.

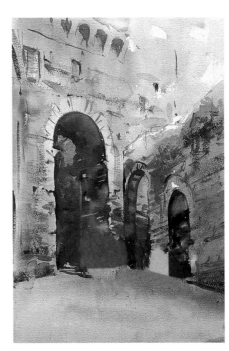

LOOK WHAT HAPPENS WHEN WE REMOVE THE FIGURES
This version doesn't work nearly as well, does it! In fact, the painting is bereft of balance.

# DAGFINN BAKKE HARNESSES COLOR AND SPACE

Norway's Northern Lights provide a
fascinating experience and they are
equally fascinating to paint

**W**hen electrical particles from storms on the sun are caught by the magnetism of the earth, and collide with the atmosphere a hundred kilometers above our heads, the fascinating Northern Lights Show unfolds on the sky.

The Northern Lights can be seen in an oval-shaped zone of the sky, encircling the geomagnetic North Pole — above Greenland, northern Canada, Alaska, along the coast of Siberia, and above northern Scandinavia.

The least cold place on earth where you can see the Northern Lights, is where I live — in northern Norway. Here people from all over the world come to experience this unique phenomenon.

The Northern Lights can provide magnificent visual experiences. The strong light is in constant movement, waving across the dark sky. Colors are constantly shifting. Cold green and red are the dominant ones.

Through the ages the Northern Lights have influenced our beliefs and mythology, but have only influenced our arts to a small degree. Here in the north of Norway we experience this remarkable phenomenon on the dark sky every autumn and winter. As an artist I am fascinated by the Northern Lights as a picturesque element, and I have often used the phenomenon in my watercolors. Not everyone has the opportunity to experience them. Therefore I would like to share my experiences as a watercolorist, with my colleagues in other parts of the world.

# WET-IN-WET

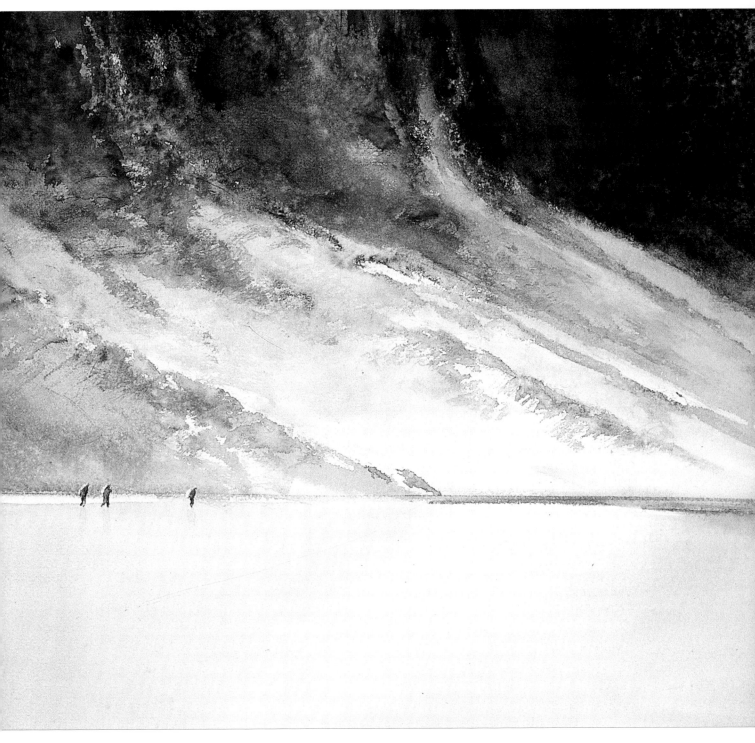

"WANDERERS ON ICE", 23 x 27" (58 x 68cm)
A fjord or a lake covered with ice below the mountains in the north of Norway, can provide a view both beautiful and frightening. People are so small in such a landscape.

# ART IN THE MAKING  A WET-IN-WET ILLUSION OF SPACE AND LIGHT

**A** good creative process often depends on rich freedom when choosing the tools, format and progress. When each stage of the process is to be documented by photography before moving on, the work suffers. The nature of watercolor demands a progress with a certain speed in it. Sometimes you have to work faster than water and color are drying. I hope that the demonstration on these pages gives an impression of my way of working. A watercolor painter will recognize the working methods and its continuous challenges.

For this demonstration I chose to show some Northern Lights, with a north Norwegian mountaintop as the geographical fixed point.

## WHAT THE ARTIST USED

### Support
140 lb (300 gsm) Hahnemuhle paper

### Brushes
A selection of flat brushes, sizes 1cm up to 2.5 cm

### Other materials
Spray bottle
A large bowl of clean, fresh water
Two smaller bowls of fresh water
Some ceramic bowls for the colors
A sponge
White drying paper
Cloths

### Colors

GAMBOGE  ALIZARIN  PRUSSIAN  INDIGO  HOOKER'S
CRIMSON  BLUE  GREEN

**1** THE FIRST WET-IN-WET STEPS
With a soft pencil I drew the main lines of the motif. Throughout the process I could choose to moisten all of the paper with water, or just parts. In the beginning, I chose to moisten just the area reserved for the sky. I used the sponge and fresh water. Then I placed a spot of Indigo, mainly as a focusing aid for the camera.

While the paper was still moist, I used Hooker's Green where the Northern Lights were meant to be. I allowed the colored water to run vertically to create an illusion of movement in the lit part of the sky.

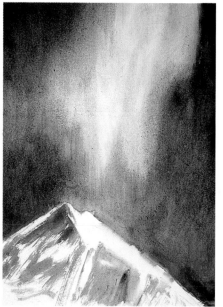

**4** STARTING TO PAINT THE MOUNTAIN
The mountain top makes up the foreground in the picture. It was meant to provide space, and I kept the perspective in mind.

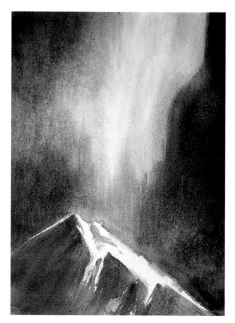

**5** SUGGESTING DISTANCE
I used Alizarin Crimson on the mountain in order to pull it closer and that way made the necessary space. Then I worked on the sky. Some parts I darkened using Indigo applied with a half-dry brush.

 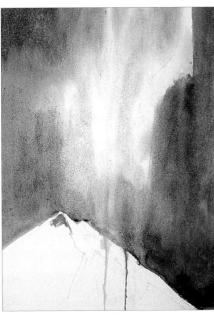

**2** INTRODUCING A COMPLEMENTARY COLOR
The green needed a complementary color. I used some drops of weak Alizarin Crimson at the top of the northern lights, and I let this run vertically too. The result was a good transition to the next color. Later I removed some of the color running down.

**3** ENRICHING THE COLORS
I worked the sky using Prussian Blue and Indigo. More Hooker's Green was used for adjusting. When the colors were half dried, I used the spray bottle to merge and soften the pigment.

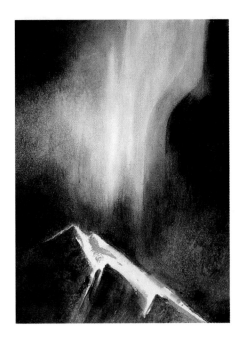 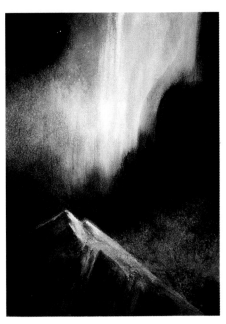

**6** INTRODUCING TEXTURE
In the final work on the sky and the northern lights I used half-dry brushes again. Some Gamboge and Alizarin Crimson were added to the mountainside. I let the paper dry, and then used sandpaper and a knife to work on the details.

**7** FINISHING OFF
The watercolor was finished. I only had to moisten the back of the paper in order to stretch it. Then the painting was ready for framing.

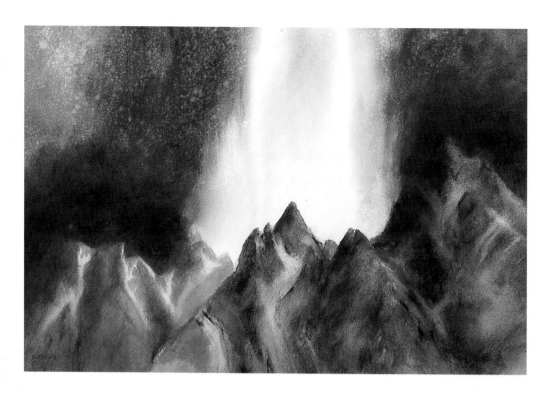

"MOUNTAINS OF THE NORTHERN LIGHTS", 36½ x 46" (93 x 117cm)

## TURNING POINT

During the 1970s I began painting black and white which demanded large space. As the formats grew I was forced to simplify. The paintings became more monumental, and this led to a positive development in my painting.

I continued to paint in black and white throughout the 1980s. I used ink, and developed a technique of my own. The reviews were good and so was the response from colleagues. My black and white paintings gave me great pleasure.

In the early 1990s I returned to watercolors. The experience gained from big formats and simplifying was very useful. Today, although I have left the black and white painting behind, undoubtly the decade of ink was an important period in my career as an artist.

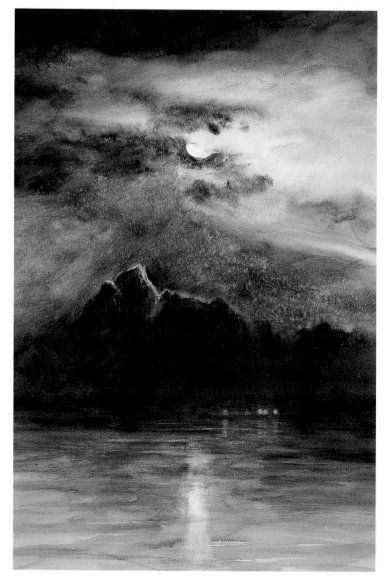

"LOFOTEN MOON", 33 x 25½" (83 x 65cm)
Here is a mood inspired by Lofoten one night in the autumn. The moon is hanging above the mountain, which stands in silhouette against the night sky. The moonlight is mirrored on the calm sea. This watercolor has a romantic character.

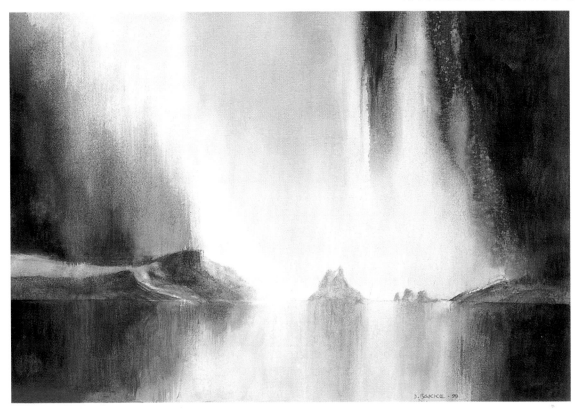

"THE LAND OF THE NORTHERN LIGHTS", 27 x 31" (69 x 78cm)

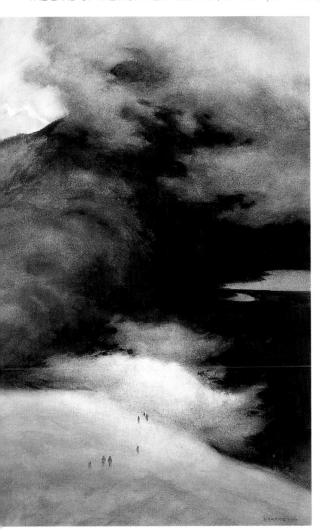

"VIEW", 37 x 28" (94 x 71cm)

In this watercolor I wanted to show the greatness of the landscape, and at the same time create space in the picture. The tiny people walking on the mountain in the foreground puts the scale of the landscape in perspective.

## ABOUT THE ARTIST

Dagfinn Bakke was born in 1933 in Loedingen, Norway. Since 1956 he has lived in Svolvaer, in the Lofoten islands. Dagfinn worked as a cartoonist in the daily newspaper *Lofotposten* from 1956 until 1992. He won first prize at the Salon of Cartoons, Montreal Canada 1983, for a cartoon showing Margaret Thatcher flying home after the Falkland Islands War — on a broomstick. When working at the newspaper, Bakke also made illustrations for use in books, television and theatres.

As an artist, Dagfinn Bakke has held several exhibitions in his home country. Works of his are purchased by the Norwegian National Gallery and many other large museums and institutions. His work has also been shown in Seattle, New York City and Washington DC. His most important solo exhibitions in his own country are held at Galleri Arctandria in Oslo.

Dagfinn Bakke has a gallery in his home town Svolvaer. Visit his website www.dagfinnbakke.no

# HOW ALVARO CASTAGNET PLACES ONE-GO STROK

One of the keys to confident brushwork is doing the groundwork first.

One of the secrets of producing a spontaneous looking watercolor is the effort you put into it in the beginning. In particular, I suggest you make a tonal value sketch first because that will be your guide to expressing mood and atmosphere. The aim is to produce a careful juxtaposition of light, mid-tone and dark SHAPES. Whatever you do, don't become bogged down in detail at the tonal drawing stage because you will kill the passion immediately.

Make sure that the focal point of your painting contains the strongest contrast. Place the darkest darks beside the lightest lights and you will find this area of the painting will capture the eye.

Once you have a tonal plan, you will have the confidence to put down a bold brushstroke that is rich in color and of the correct value. And you won't look back!

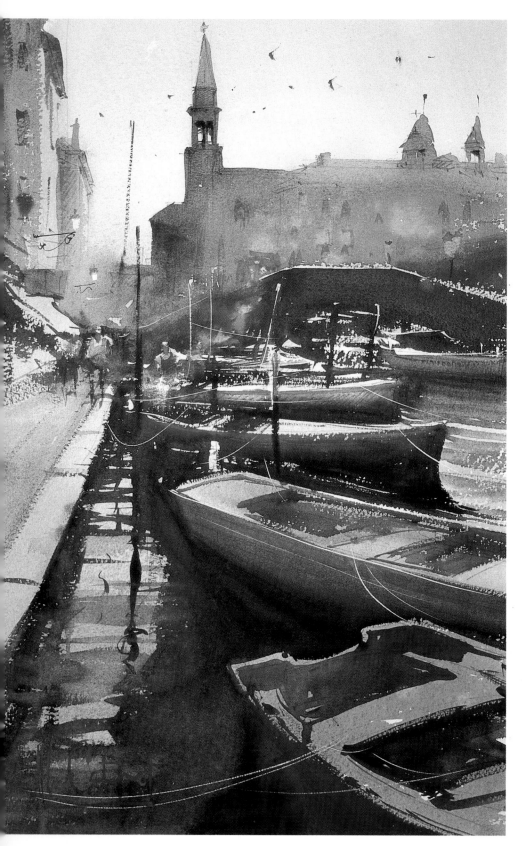

"GOING FISHING, CHIOGGIA — ITALY"
This is one of the best fishing villages of Italy, only an hour away from Venice, across the Venice lagoon.

Colorful boats, and a keen fisherman ready to turn the engines on to head out for a fresh catch — that is what this painting is all about!

I did this on site. I am fond of this painting because it captures the mood and feel of the place. It also shows, clear, handsome passages of dry brushstrokes and wet-on-wet technique — which is what I think a classical watercolor is all about.

Notice how the dry brushstrokes under the awning on the left contrast with the lovely wet-on-wet passage above the men walking on the footpath.

This painting was one of those that are fun from beginning to end. But there was also another element — I did this one for me, just for the sake of painting. The results show how important such feelings are.

# AND DOESN'T LOOK BACK!

"THE FISH MARKET,
VENICE, ITALY"

The amount of people shopping for fresh fish, and seemingly for every other fine gastronomic delicacy, was extraordinary.

The activity, the smells, the people, the hustle and bustle of this place was overwhelming and it certainly set up one of the best scenarios in the world — Venice. I loved this place and wanted to paint it and transmit that feeling.

In a busy scene it is important to isolate the focal point. Where there are so many people, great buildings and awnings you can easily create a conflict of interest. Decide what the focal point is to be at the start and then you won't get carried away by everything else.

In this painting the viewer's eyes wander through the painting but eventually they rest on the focal point — where the woman in red and the other two are contemplating something that caught their attention.

The bit of smoke in the middle ground helps to push the background area into a more hazy, blurry statement. It also creates a greater level of mood and atmosphere.

Everything fell into place as I worked on this painting. I did it in a short time and it was fun all the way!

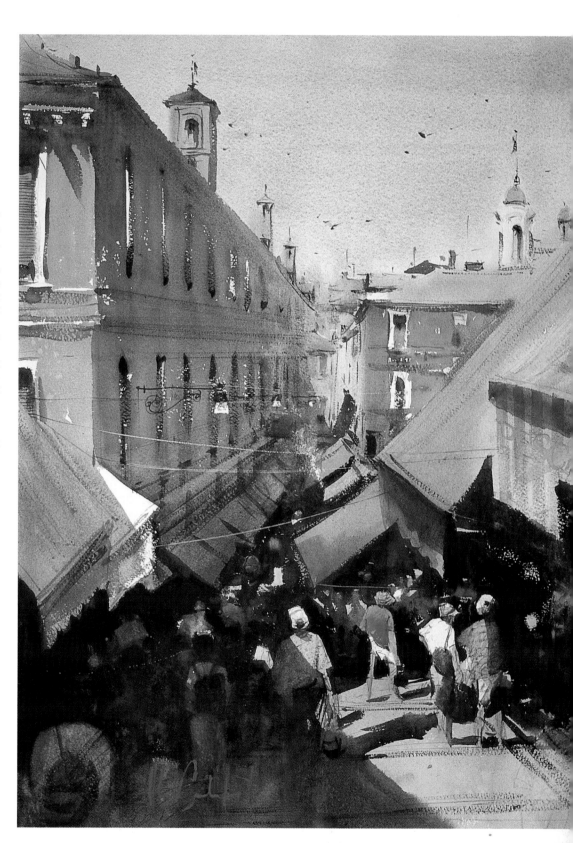

# ART IN THE MAKING
## USING ONE-GO STROKES

**T**his painting was inspired by an on-site sketch I made along Brighton Beach walkway in Victoria, Australia, with my artist friends, Joseph Zbukvic and Herman Pekel (both featured in this book) on an outdoors painting day.

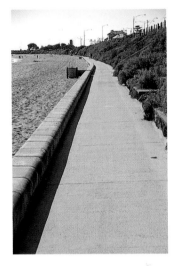

**1** THE FORMAT
This has an unusual vertical format, with an almost abstract tonal division and arrangement of shapes.

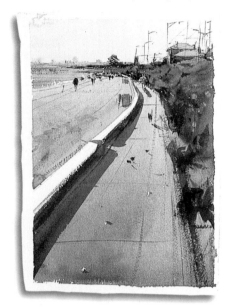

**2** MY SMALL ON-SITE SKETCH
When you compare the original on-site painting with my drawing back in the studio I didn't change anything at all.

**3** MY INITIAL DRAWING
My drawing was quite simple. I made just a few accent lines on the wall of the pub at the end of the walkway to enhance the three-dimensional look.

## WHAT THE ARTIST USED

**Paper**
140lb (300gsm), medium texture

**Brushes**
Mop brushes, pure sable or kolinsky hair.

My favorites are #8, 9, 10, 11, I use the largest because they hold lots of liquid, and I can go a long way without reloading. Mops are very versatile, since they always hold a beautiful point.

I use a rigger for fine lines.

**Other items**
Atomizer, towels, sponges, tissues, and a watercolor paper to test your strokes before you place them on the painting.

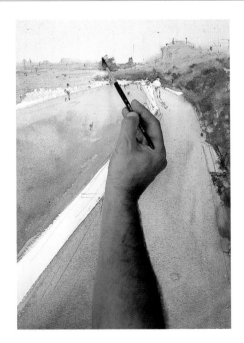

**5** SUGGESTING THE ILLUSION OF DISTANCE
Once this wash was completed, obviously the paper was almost dry, so I carefully rewetted the horizon — only a little bit — to develop a hazy, lost and found edge to suggest distance. As you can see in this photo, I changed my brush for a smaller one with more spring, to paint the foliage of that little tree. I exploited the dry technique to make it rich.

Then I used a bit of Cerulean Blue, Alizarin Crimson and Burnt Sienna on the distant buildings and Ultramarine Blue, Yellow Ochre and Viridian on the tree.

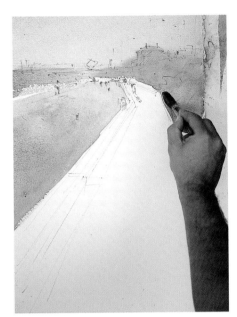

**4** STARTING WITH THE SKY

I applied a simple wash using Cerulean Blue on top and smoothly adding Yellow Ochre on the horizon.

I also quickly painted the pub building using Yellow Ochre, Alizarin Crimson and Ultramarine Blue. Then I painted the plants using Yellow Ochre, Cerulean Blue, Alizarin Crimson. I worked quickly, blending washes, which was very important for this step.

I completed the washes for the water and sand, working quickly and constantly in one go and not going back! The colors on the water were Cerulean Blue and a hint of Yellow Ochre and Viridian. For the sand I used Yellow Ochre, Alizarin Crimson, but with a hint of Ultramarine Blue to gray the foreground a bit.

Next I worked on the footpath using Ultramarine Blue and Burnt Sienna. I tilted the board several times to spread the pigment and gain a sedimentary, grainy look, exploiting that special characteristic of Ultramarine Blue, making it run through the paper! Then, before the vegetation area started to dry, I dropped the same vegetation mixture, with a bit of Alizarin Crimson here and there to create volume and depth among the plants.

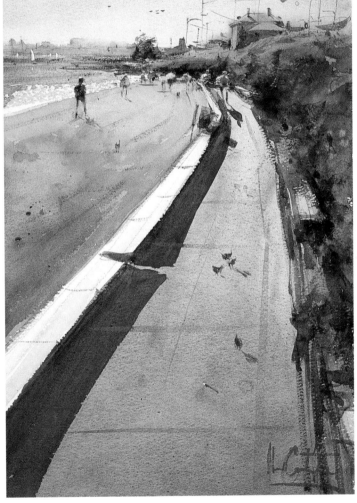

**6** MY ONE-STROKE SHADOW

It was time to tackle the long stroke for the shadows cast by the sea wall onto the footpath. Colors were Ultramarine(one part) mixed with Alizarin Crimson and a very small amount of Burnt Sienna.

I used a mop brush, holding the brush at the top because that gives greater spring and the right angle for placing that brushstroke without lifting the brush up. Then I used the point of the brush to finish the stroke. Mop brushes are very versatile because you can use the side or the point.

Notice how I connected the long shadow with the jogger's shadow. It was important to preserve the hue and the tone of the shadows for unity.

**7** FINISHING OFF

This was the easy stage where I pulled everything together. I used the dry technique here and there to maximize depth, texture and light. I finished the figures using a touch of red on the main one and added little dots to suggest pigeons. I used a bit of Chinese White watercolour for the yachts in the far distance.

I dropped a bit of color on the walls of the pub, the ones under the shade. After evaluating the painting, the last thing I did was apply a light wash of Yellow Ochre on top of the sea wall to reduce its tonal intensity.

## "CAFÉ IN BUENOS AIRES"

This is a typical café in Buenos Aires, old and weathered and with the smell of Tango! I couldn't resist painting it! The figures against the window, particularly the waiter, the old fashioned floor, the lonely table, the colors, the mood — what inspiration!

All the walls in the background were done in one go. I loaded my brush with lots of pigment and attempted to conquer the right value without meddling with superfluous strokes. I used the point of the brush to capture the light and frame of the window with finesse.

The main white-topped table in the foreground enhances the glow of the painting, and the man standing alone at the bar bench, drinking attracts the eye time and again.

I had great joy doing this painting, working with authority, knowing where to place the darkest darks and avoiding coming back to them. Watching the painting develop was great fun.

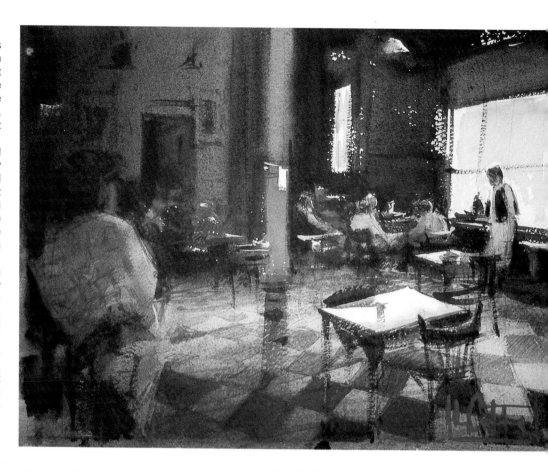

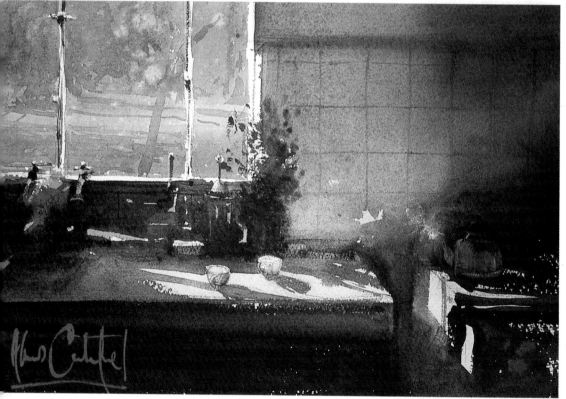

## "THE KITCHEN BENCH"

This is a view that is really familiar to me, since it is the kitchen of my family holiday house in Uruguay.

While getting ready for one of my favorites moments in the morning . . . a good cup of coffee and the newspaper to read . . . I was taken by the beautiful light coming in and bouncing on every little element that was on the bench. I decided to sketch it straight away while the light was still there — the newspaper would have to wait!

As you can see, I surrounded the beam of light coming through the window with beautiful darks. I was very sensitive to color and tonal values to create glow and contrast, maintaining interest all the way through.

I think I captured the magic of the moment. I am very fond of this painting — it is a big part of me.

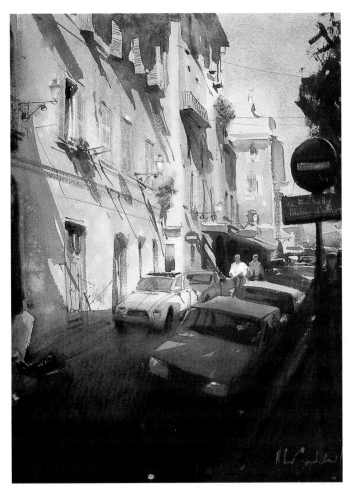

"THE STREETS OF NICE, FRANCE"

I love the yellow butter color of the buildings in the South of France, and this scene was too good to resist!

I like this painting because it shows how the shadows fall with such grace, the smooth diagonal lines and patterns, the green shutters and the entire ambience of the scene.

Notice the strong foreground, and how the shadows around the yellow façade, isolate and enhance the feel of sunlight in the focal area.

Obviously, the red car in the shade, plays an important role. What it does is create counterpoint and balance in the painting, without disturbing the focal point.

The entire painting was done mainly with two washes — the yellow building, the sky and the red car were done as one wash; then the shadows, and the juicy darks, around the car, trees and figures were washed in. The shadow holds the light together and brings the painting to completion.

## ABOUT THE ARTIST

Alvaro Castagnet was born in Montevideo, Uruguay, South America and moved to Australia in 1983. He has traveled extensively throughout the USA, Mexico, South America, Europe and Australia where he has a home in Melbourne.

He attended the National School of Art in Montevideo and was taught watercolour painting by Professor Esteban Garino. Alvaro also studied at the Fine Arts University, where Miguel Angel Pareja was his oil painting tutor.

Two years after arriving in Australia, Alvaro was appointed Art Director of Melbourne's Latin American Festival.

He has been holding solo exhibitions in Australia since 1985 and has won several prestigious national prizes. His work hangs in private and corporate collections around the world.

Alvaro has a considerable reputation as a workshop teacher in Australia and also tutors for *International Artist* magazine's *International Painting Workshop Vacations* to destinations in Europe.

He has written many articles for *International Artist* and *Australian Artist* magazines, and his first book, "Watercolor Painting with Passion!" published by *International Artist Publishing*, is a world-wide bestseller.

## TURNING POINT

The turning point in my career was when I finally understood that a work of art, more than being beautiful, should be meaningful. When I realized that passion, mood, magic and character are the pillars that sustain a work of art. I believe a painting lacking any of these abstract concepts, is "second hand art". There is no room in my heart to paint in a mechanical fashion. Every painting is a new experience, where we take the less travelled roads in pursuit of the elusive side of art, through the channels of our passion, insight, and feelings.

When we are able to capture that side of life, the unspoken, the untouched or the unseen, then our function on earth, as artists, is fulfilled.

# WHY DOMENIC DISTEFANO PAINTS THE DARK SHAF

This artist proves that if you use a full tonal value range and balance the dark shapes you will create dramatic watercolor landscapes.

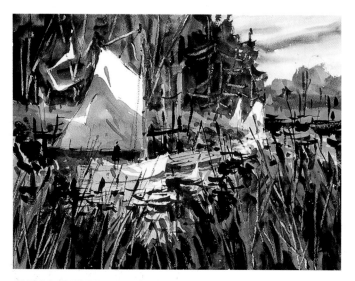

"CAT BOAT, ESSEX BOATYARD, MAINE", 22 x 30" (56 x 76cm)
I was attracted by the marsh grass in the foreground and the dark-valued trees in the background surrounding the white sail of the cat boat. It was a challenge to make the whites and greens work and to put the white sail in just the right spot. I used clouds for some much-needed action in the sky.

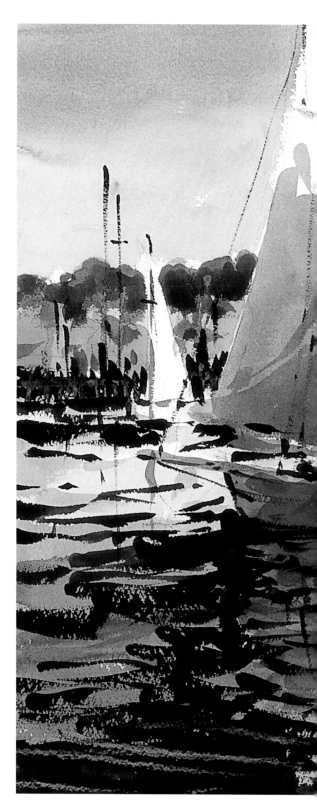

With transparent watercolor, I can create landscapes that are bold, free, spontaneous and direct. But the practice that probably gives my paintings the most visual impact is the use of a wide range of values. You'll find everything from dark darks to white paper in most of my paintings.

I put fairly dark darks in first, which helps the composition come alive by giving it a dramatic foundation of strong shapes right from the start. As I continue to develop my shapes, I have trained myself to use my painting surface as my palette by allowing the colors to mix on the paper. This keeps my colors juicy and transparent. I use the paper itself for the white shapes, painting around the whites and creating hard or soft edges as needed. Although the demonstration painting is an exception, I usually put the skies in last because I do not want them to dictate the rest of my painting.

Finally, I add dark accent strokes to tie a painting together. Combined with the initial darker shapes, these calligraphic notes contrast beautifully against any lighter areas, bringing out the drama of my subjects.

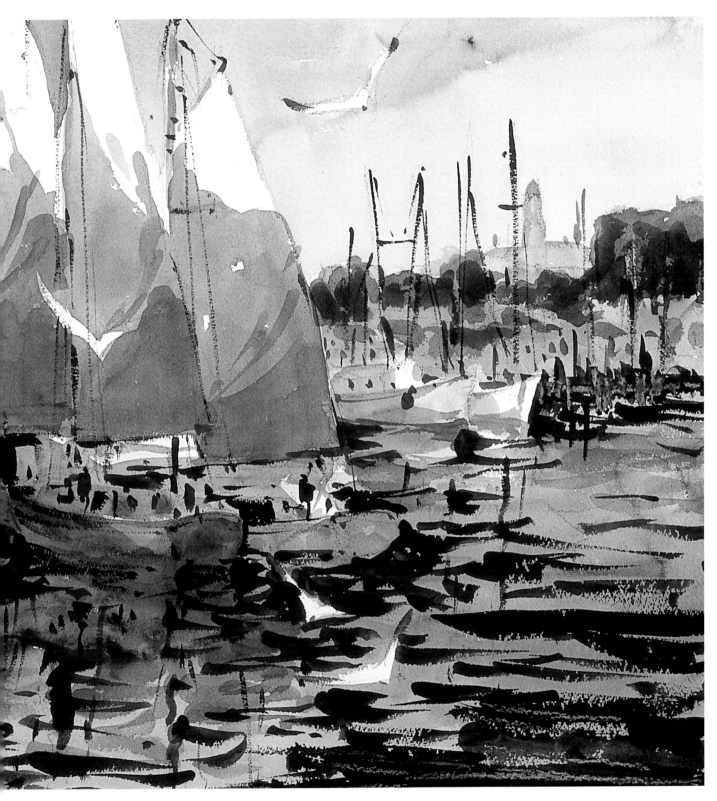

"THREE OF A KIND, GLOUCESTER HARBOR, MAINE", 22 x 30" (56 x 76cm)

I saw these three sailboats as I looked around the harbor. I said to myself, "Why don't I put them together and see what I can come up with? Can I get away with this composition?" I used the play of the light and dark shadow values on the sails to create a dramatic painting. I kept the sky on the quiet side. The buildings in the background have a little play of sunlight, which helped this composition.

**W**hen I go out to paint, I do so with the intention of coming back with a finished painting. Although I make changes and eliminate some detail in my subjects, I am always mindful of hanging on to my first impression. Dark values in the early stages and dark, calligraphic accents at the end help me convey that initial visual impact. I try to keep my paintings simple but dramatic.

## WHAT THE ARTIST USED

### Paper
300lb (640gsm) Rough, full sheet of 22 x 30" (56 x 76cm)

### Brushes
I use rounds and filberts of assorted sizes that I've collected over the years; they are sables and sabelines. I am a brush freak and love large brushes.

### Knife
My knife is used like a brush for scraping out lines, such as twigs, weeds and rigging, or for achieving other effects. The knife should be used with caution. It takes practice to prevent yourself from using it when the paper is too wet — the knife can damage the paper and create an overly dark line.

### Other
Portable folding easel; portable folding table to hold materials; paper towels; plastic bucket for water.

### Colors

| Cold palette | Warm Palette |
| --- | --- |
| Cerulean Blue | Yellow Ochre |
| Indanthrene Blue | Raw Sienna |
| Hooker's Green | Alizarin Crimson |
| Indigo | Burnt Sienna |
| | Burnt Umber |

**1** DRAWING IN MY MIND

This picture shows you my on-location subject, but in my work, the subject is just the starting point, for reference only. I always embellish with mood, drama, shapes, value and color.

I began by walking around my location and putting the composition together in my mind before I put anything on paper. As always, I was not afraid to move things around to improve my design.

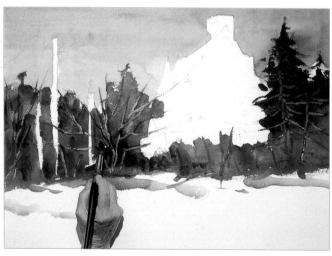

**4** HARMONIZING WITH COLOR AND VALUE

As I continued sketching, I was thinking about design, composition and balance of color and values. Although I usually put my sky in last so that it doesn't dictate the color values of my composition, in this painting, I put my sky in next. I used middle tones of both warm and cool grays mixed form my three primary colors. This way, the sky would complement the rest of the painting.

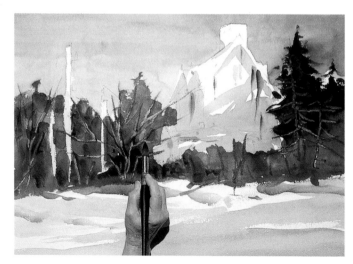

**5** LOOKING FOR SHADOWS

At this stage, I was looking for the shapes of the shadows, which in turn helped me make other shapes. I did not use resist or masking fluid, so the white you see is the white of the paper. By painting around the white shapes with my brush, I created both soft and hard edges that would contribute to the end result.

# CONTRAST

**2** MARKING REFERENCE POINTS

On dry watercolor paper taped to my board, I used very few pencil lines to sketch the composition. They were only points of reference. I didn't want the pencil lines to trap me, but rather I wanted to keep an open mind so that I could draw freely with my brush.

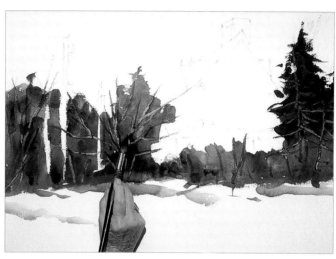

**3** STARTING JUICY AND DARK

I always put out fresh pigment in all my colors. I may not use every color but they are there if I need them. I want my paintings to be fresh and juicy, and this will not happen with dry pigment.

I started with dark values first. It is difficult to make the first statement a dark value against white paper, but this helps me feel that my whole painting is coming alive. I kept the dark values on the warm side because of the light. Notice how I made lines in the semi-wet painting with a painting knife.

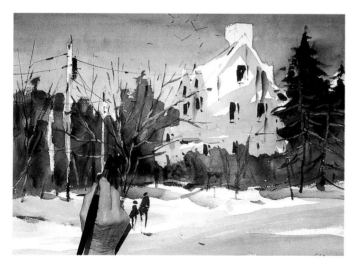

**6** ACCENTUATING WITH CALLIGRAPHY

With all of my shapes in place, I could work toward a finished painting. I made sure that my shapes fit together like a jigsaw puzzle. Then I used calligraphic strokes, mostly in deep values, to tie the painting together and make my composition work.

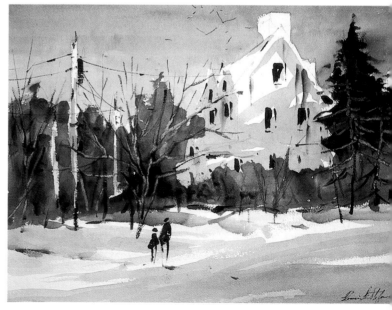

**7** PROVIDING A FRAMEWORK

The dark accents and large dark-value shapes in "February Snow", 22 x 30" (56 x 76cm) combined to create a dramatic impact in the painting.

"AUGUST, LOW TIDE, IPSWICH, MAINE", 22 x 30" (56 x 76cm)

The rocks had a play of color, which I embellished. I helped my composition by enlarging the rocks so that they filled my paper from side to side. This created more shapes for reflections in the water. I then put a little warm note in the sky that reflected in the water and added a touch of light. The color of the rocks against the dark green trees in the background resulted in a dynamic composition.

## TURNING POINT

My art education was somewhat convoluted but well worth the effort. I attended technical school for commercial art before serving in WWII, then afterward, I did eight years of night classes at the Cannon Art School and the Pennsylvania Academy of the Fine Arts, both in Philadelphia. At the time, I was not interested in selling or exhibiting my work, I just wanted to learn from excellent teachers and meet others who shared my interest in art.

Eventually, I landed a job as a space planner and designer with an interior design firm, working on such projects as industrial furniture and bowling lanes! I also taught art classes. When the firm closed, I was faced with a decision: find other design employment or pursue art full time. I have never been sorry that I chose a career in fine art, and I've never looked back.

"HODGKINS COVE, CAPE ANN, MAINE", 22 x 30" (56 x 76cm)

A white sail came from behind the island and was framed by the shrubbery in the foreground. It created a ready-made composition. The contrast of the white sail and dark green shrubs excited me. I put a little action in the sky to contrast against the quiet mood of the rest of the painting.

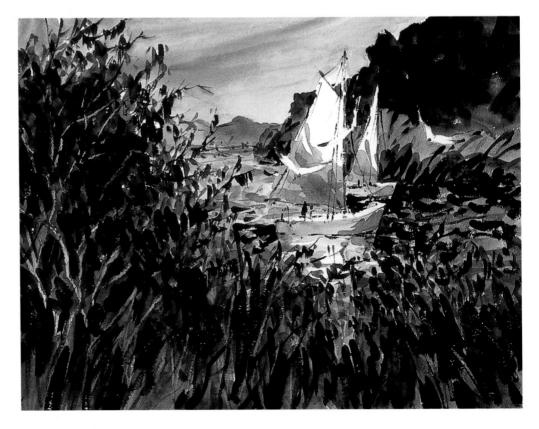

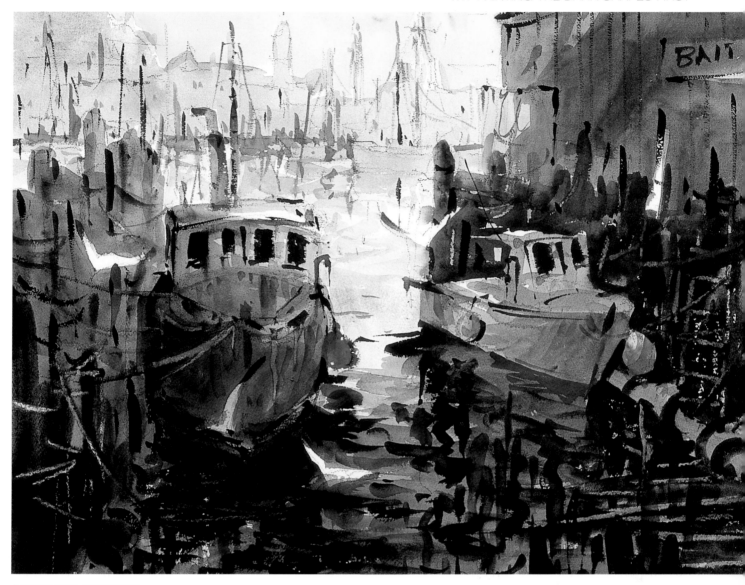

"LIFTING FOG, ST PETER'S SQUARE, GLOUCESTER, MAINE", 22 x 30" (56 x 76cm)

The fog had just lifted when I did this painting. I helped the composition along by moving things around, still keeping the essence of my first impression. There was a warm glow that I wanted to capture, so I pushed the dark notes to enhance the shadows and emphasize the glow. I worked quickly so I would not lose that luminous quality.

## ABOUT THE ARTIST

Domenic DiStefano studied at the Cannon Art School and the Pennsylvania Academy of the Fine Arts.

Dedicated to teaching others, Domenic has served as a juror and demonstrator for workshops and art organizations across the US and Canada. He is the author of *Painting Dynamic Watercolors* and his work has been included in *Watercolor Your Way*, and featured in several art magazines.

Winner of numerous awards from regional and national art groups, Domenic is an elected member of many prominent art groups including the American Watercolor Society, the Philadelphia Sketch Club, the Salmagundi Club and the Watercolor USA Honor Society. He has twice served on the Board of Directors of the AWS, and is a member of their elite Dolphin Fellowship.

His paintings can be seen at his studio gallery in Havertown, Pennsylvania, and at the Shore Gallery, Ogonquit, Maine.

# MIGUEL DOMINGUEZ EXPLAINS DRY-BRUSHING

## Get bold, controlled, textured results with these dry-brushing techniques.

For those of us working with the wet and watery medium of watercolor, the idea of dry-brushing can be a bit confusing. Because dry-brushing practically eliminates the fluid appearance usually associated with a traditional wet-in-wet watercolor technique, you may wonder why any artist would want to use this approach.

For me, dry-brushing has the benefit of yielding a bold painting with crisp edges. This methodical, somewhat tedious process also allows me almost complete control of the painting while it is in progress.

Just to clarify, when dry-brushing, the brush is not dry but neither is it saturated. In fact, I use a variety of pigment-to-water ratios as I develop a painting, often working in small areas and adjusting the water content of my paint as needed. The paper is generally completely dry. It's a different approach, but one that results in unique effects well suited to my subjects and style.

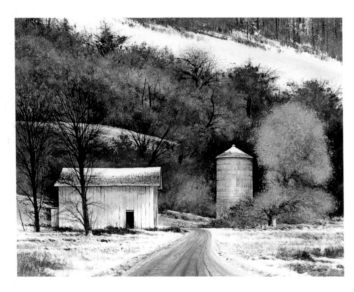

"RURAL WINTER",
30 x 40" (76 x 102cm)

The only areas where dry-brushing was not used were the light washes of blue in the snow areas. Otherwise, trees, barn, silo and shrubs were all dry-brushed. For the entire wooded hillside, I used a #3 fan brush, pressing, pushing and pulling on the still-moist pigment to create the light and dark areas. I dry-brushed the trees, limbs, dry grass and detail of the barn and silo more deliberately with a variety of small brushes. My palette consisted of Permanent Sap Green, Terre Verte, Burnt Sienna, Yellow Ochre and Sepia.

"COLD WATER",
30 x 40" (76 x 102cm)

This isolated site rests far back in Carmel Valley, where herds of cattle roam free. To capture this rustic scene, I used dry-brushing on the entire surface of this painting, even the sky and distant hill. I created the cloudy appearance by rubbing out some of the blue areas with a bamboo brush to expose the white of the paper. For the tree foliage, I applied six layers of pigment from light to more dense mixtures of Yellow Ochre, Burnt Sienna, Light Red and Cadmium Yellow. One very worn, flat watercolor brush was used for the entire area. However, I used a small, flat watercolor brush with full-strength Sepia to create the tree trunks and limbs with multiple brushstrokes.

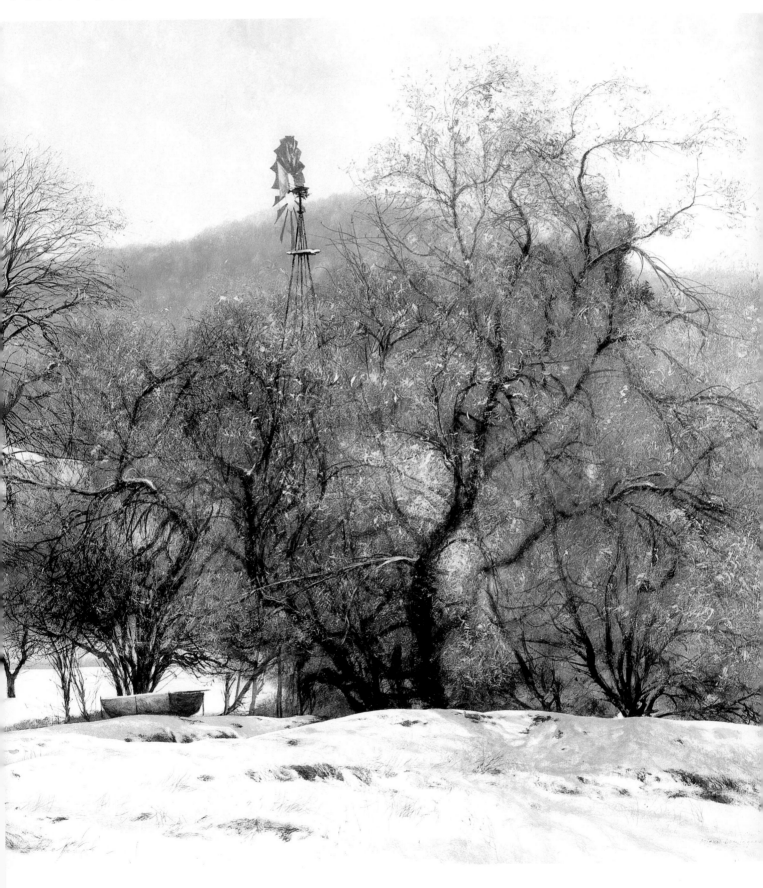

# ART IN THE MAKING HOW TO PAINT A LANDSCAPE USING DRY

**S**ince I prefer to work on dry paper, I find the paint is quickly absorbed, sometimes requiring repeated applications over an area and making it difficult to blend. I minimize this problem by using a Hot Press surface, which is less absorbent than a Cold Press surface. This is especially useful in the first stage of painting, when I typically put in a nice, wet-into-wet sky. The rest is developed through dry-brushing.

## WHAT THE ARTIST USED

**Surface**
100 percent cotton,
140lb (300gsm) Hot Press
paper size 18 x 24" (46 x 61cm)

**Brushes**
Japanese bamboo brushes;
#2, 3 and 5 fan brushes;
#2 through 8 round oil brushes;
variety of small watercolor
brushes; note that many are old
and worn with just a few hairs
remaining

**Other materials**
Small white dishes for
mixing colors

Paper towels

Metal pen nib for scratching out
small details

**Colors**
Yellow Ochre

Cadmium Yellow

Light Red

Alizarin Crimson Permanent

Ultramarine Violet

French Ultramarine

Permanent Blue

Sap Green

Olive Green

Terre Verte

Burnt Sienna

Davey's Gray

Sepia

**1** GETTING OFF TO A CORRECT START
I began with a 4B pencil drawing that would completely vanish once I applied the color. I carefully worked out the composition and avoided potential problems. It took a few hours, but the time spent on establishing a well-proportioned drawing up front saves much more time and frustration once the painting is in progress.

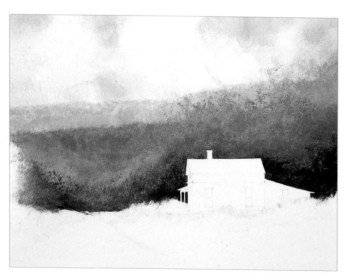

**4** SWITCHING TO DRY-BRUSH
After allowing the paper to dry completely, I began working in dry-brush to block in the background wooded areas. For this, I used a #3 fan blender, pressing down hard enough to spread the brush bristles to create the look of dense foliage. My colors were lightly thinned-down blends of Cadmium Yellow, Yellow Ochre and Alizarin Crimson, plus Permanent Sap Green in the darker areas. As I got down to the white areas of the snow, I used a smaller rough oil brush for better control.

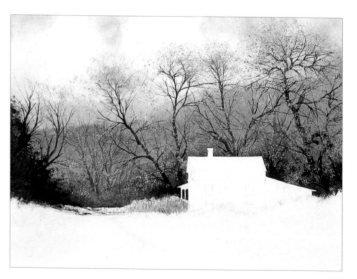

**5** PROVIDING MORE STRUCTURE
The composition really began to take shape when I added more structure in the tree trunks and denser brush and limbs of varying sizes extending up to the tree crowns. To enhance the mood of the painting, I put in highlights of Cadmium Yellow against the sienna undertones. For both the trunks and highlights, I used nearly full-strength pigments applied with very worn, flat watercolor brushes. My special brushes that have only a few hairs remaining were ideal for putting in the smaller limbs and branches.

BRUSHING

**2** LAYING DOWN A WET SKY

Like the initial drawing, my second phase is critical. I used a wet-into-wet technique for the sky, which meant I did not have total control over how the color was dispersed. Working on a flat surface, I moistened the paper haphazardly and used a Japanese bamboo brush to lay down a single wash of a thin combination of Permanent Blue, Ultramarine Violet and Davey's Gray. As I had anticipated, the color spread into wet areas and resulted in an interesting sky.

**3** PUTTING IN DISTANT SCENERY

While the paper was still moist, I added the distant mountains, using slightly more intense values of the same cool sky colors to accurately place them in the distance. I used a #2 acrylic liner brush in downward strokes. I kept in mind that, although much of the distant scenery would be covered up with the warm tree foliage to come, the thin application of cool pigment should still be easily seen.

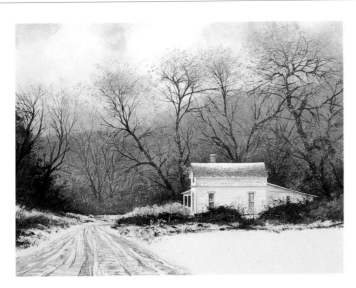

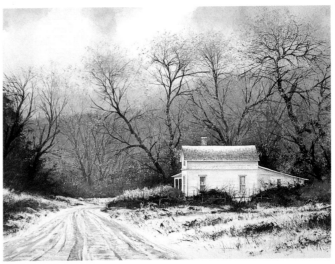

**6** ATTENDING TO DETAIL

For the most part, the previous steps were made with loose, quick brush strokes. However, at this stage deliberate and meticulous brushwork was needed. My goal was to attend to the fine detail while still maintaining a semblance of fluidity. Using old, worn brushes, mostly small in size, I carefully applied the correct color variations to the house, bushes and vegetation. To give the roadway the appearance of being freshly traveled, I used a bamboo brush to apply thin washes of Davey's Gray and watered down Sepia.

**7** CONCLUDING WITH BALANCE

To conclude "Winter Victorian" I added light washes of blue with a bamboo brush. Following this, I used the edge of a fan brush and a full-strength mix of Permanent Sap Green and Burnt Sienna to create the effect of wispy, dormant grass. These horizontal applications gave the painting a base of support that countered the vertical perspective lines of the road. Finally, I carefully reviewed my work to ensure that all elements within the composition were finished to my satisfaction, and that no detail from my original concept had been overlooked.

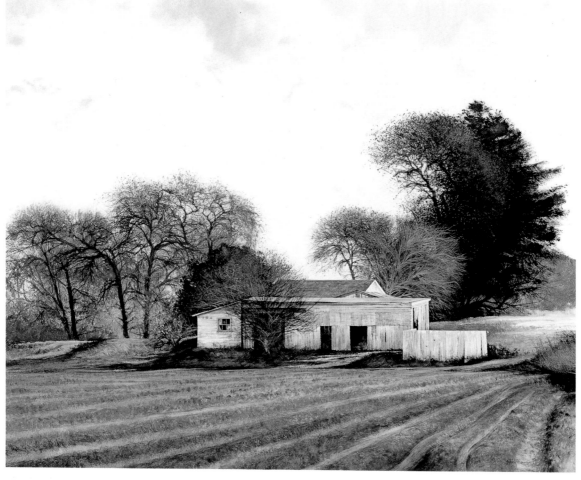

"AUTUMN GLOW", 30 x 40" (76 x 102cm)

The dilapidated condition of this country shed and the harvested furrows with their fading perspective made this an interesting subject. But I was more impressed with the bright, translucent fall colors of the deciduous trees behind the building. To achieve the effect of an autumn glow, I applied a few transparent washes of Cadmium Yellow, Yellow Ochre and Burnt Sienna. As the painting progressed, I used more pigment and less water to add the tree trunks, foliage, buildings and field. Highlights of Cadmium Yellow with touches of white acrylic made the fall leaves more brilliant.

"POINT LOBOS SUNRISE", 40 x 30" (102 x 76cm)

Point Lobos, a state park just south of Carmel, California, has often been described as the most beautiful meeting of land and sea. It has long been a popular site for artists and I, too, have been drawn to its rugged beauty. This painting depicts one of my favorite locations within the park. The grandeur of its granite cliffs and pine summit is an irresistible subject.

I achieved the granite effect by applying light washes of Davey's Gray and Yellow Ochre, progressively moving to darker washes for the shadows that give form to the rocks. For the final effects of the deep, dark crevices, I used a fairly dry mixture of Sepia and Davey's Gray applied with an old brush worn down to stubble.

## THE CHALLENGE

Through no small effort, I have managed to remain a professional artist for most of my adult life. I attribute it to two things — one is my overwhelming passion to be an artist, the other is that failure has simply never been an option. To this very day, I am preoccupied by the challenges life as an artist imposes on me. I welcome these challenges, as they are the best motivational factors I have.

"CARMELITE MONASTERY BELFRY",
40 x 30" (102 x 76cm)
Surrounded by oak, pine and palm trees, the Carmelite Monastery, a prominent landmark on the Monterey Peninsula, is nestled in the foothills of the Santa Lucia Mountains. From a distance, its white walls contrast sharply against the dark green foliage, but it is the tall belfry that makes this structure so attractive to artists. I chose this viewpoint because of the descending ravine that leads the eye to the tower jutting out from the trees.

The white façade of the tower is the white of the paper. As with all of my paintings, I simply painted around the white areas, then came back in to dry-brush the details.

## ABOUT THE ARTIST

Miguel Dominguez was born in El Paso, Texas, in 1941. He spent his formative years in the agricultural valley of Salinas, California, where he gained an appreciation for open spaces, wooded areas and rolling hills. These early observations now reflect themselves in many of his paintings.

Miguel is primarily self-taught, although he took every art course available at Hartnell Junior College. Studies at a four-year college were interrupted by the draft for service in the US military. Upon his discharge, Miguel spent five years as a cartographer.

Eventually, however, he gravitated back to his primary interest, and in 1971 began painting full time.

Galleries currently representing his work include the Howard Portnoy Gallerie and the Carmel Art Association (by invitation), both in Carmel, California, as well as Henley's Gallery in Gualala, California. His work has also appeared in galleries in New York City; Cape Cod, Massachusetts; Sedona, Arizona; and Santa Fe, New Mexico.

Miguel lives with his family on the Monterey Peninsula in California.

# NITA ENGLE USES INITIAL CONTROL AND THEN LETS

Landscapes can show off the true beauty of the watercolor medium when you use free-flowing techniques

It has always been my goal in all of my work to devise means and methods to keep the paintings true to the medium — to use all of the marvelous qualities of watercolor and allow the essence of water and color on paper to shine through. This has involved finding ways to let the watercolor run free but still be harnessed — a blend of spontaneity and control that combines the looseness of pure abstraction with the focused realism of landscape painting. I call it a form of "illusionism" because various texture techniques are combined with fine detail to make an illusion of the whole.

In achieving this goal I had to learn how to steer the running paint and how to keep all the colors going at once, rather like a juggler — an exciting way to paint! The star here is the watercolor; I am just the agent-manager paving the way. For me, results are achieved with the use of the spray bottle, masking and other texture tools.

The end result should be a watercolor painting that couldn't be painted in any other medium — one that uses to the full extent the wonderful, unique properties of watercolor!

"ANCIENT WATERS", 18 x 25½" (46 x 67cm)
I have always considered the wetlands to be true wilderness country. In earlier times, it was not feasible or even possible to log or mine or develop here so the wetlands were spared encroachment. They remain forever in their wild state with their own life cycles and their own ancient ways. Staring at the ancient, silent rock and the still waters, it is possible to enter a trance-like state of being — at one with the ages.

# THE PAINT LOOSE!

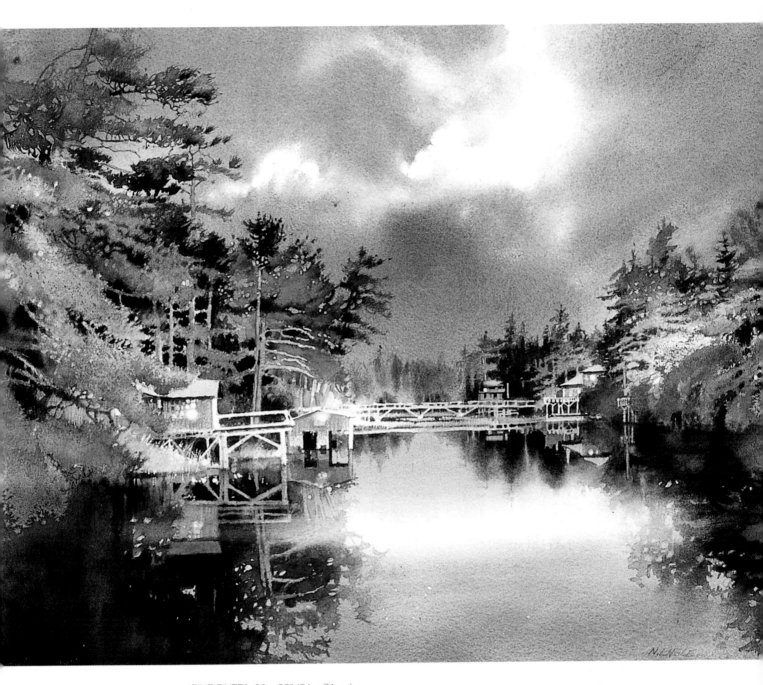

"PINE RIVER", 20 x 28" (51 x 71cm)
There is something about a river or a road that travels into the very heart of a painting because it supports the artist's aim to lead the viewer's eye. Here, I wanted the viewer to go with me into the painting, to go down that road until we and the road disappear in the distance, to canoe that river until in our imagination we reach the sea.

This painting was built around a riveting scene I observed while prowling around with a camera on the edges of a marsh near my home. I was looking for patterns of melting ice. It was already an interesting scene, but suddenly the sun made a dramatic appearance, flooding the marsh with light. This painting is the result of an emotional reaction to what I saw, and is one of the two elements I believe necessary for a successful painting. The first is passion, the other is design.

To emphasize the light, I knew the painting had to have strong value contrasts. To avoid detracting from the impact, it should have strong, large shapes rather than a lot of small, busy areas. In other words, all of the elements — grasses, water, reflections, trees, ice and so on — had to connect in some way. The colors chosen, mostly primaries, were also kept simple for more impact. You will find fairly heavy washes tempered by a heavy use of the spray bottle and not much brushwork as the colors were mostly floated in.

The scene demanded boldness — so it was designed, so it was painted.

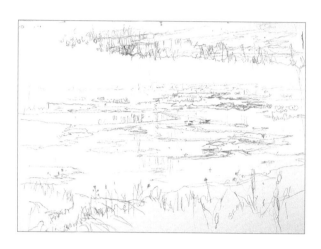

## 1 DRAWING TWO WAYS

There were two styles of drawing used here — detailed in the areas where masking would be applied, and non-specific and loose in all other areas to allow freedom when painting. By non-specific, I mean only large shapes were drawn to retain the design. I made sure the pencil lines were not too light or they would be lost when heavy washes were applied. Grade H pencils are perfect!

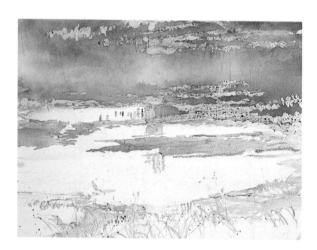

## 4 OBSERVING THE EFFECTS

When that flowing wash dried, all of the colors had merged to form the light coming from the sun, gradually becoming darker, changing both in hue and value. This technique can be used anywhere there is a single light source. Notice how the yellow runs into the red to create a beautiful orange, while the blue goes into the red to make violet. The blue and yellow never meet to form a green in the sky.

## 5 STOPPING FOR A LITTLE DETAIL

After removing the mask from the sky and woods, I softened some of the hard edges left by the mask with various lifting tools. Next, I designed the tree areas, using a combination of techniques — throwing paint, stamping smaller branches and, of course, conventional brushwork. When the paint was dry around the sun, I used a soft toothbrush and lots of water to make it all lighter, to turn on the sun. The mist from the ground? The watercolor did that when I was painting the sky!

# COLOR LOOSE

## WHAT THE ARTIST USES

**Support**
140lb (300gsm) Cold Press watercolor paper stretched on ⅜" plywood with butcher tape and staples.

**Brushes**
Round sables in sizes: #14, #12, #6 and #3; large and small Chinese brushes for throwing paint; riggers for applying masking; stiff brushes for removing paint

**Other Materials**
Spray Bottle

Plastic squirt bottles with needle tops

Endless pop-up facial tissues

Masking fluid

Toothbrushes

Palette or painting knife

Small squares of illustration board for stamping paint

Colored chalk for planning design

## 2 MASKING WITH DELICACY

Blocking off many areas with masking fluid enabled me to achieve fine detail and free washes at the same time. As always, when applying this fluid, I remembered that it was really the final details I was applying so I had to be delicate. A careless and sloppy application of the resist will ruin a good painting.

## 3 FLOWING WITH COLOR

Now for the fun! Because of my earlier careful preparation, I could be free while painting, allowing the watercolor to run wild. Over the dried masking fluid, I applied a Bismuth Yellow circle on and around the sun, then a wide circle of Winsor Red, then a circle of Cobalt Blue, creating a bull's-eye of bright primaries. I immediately held the painting vertically as I sprayed a lot of water from the edge, allowing all of the colors to run freely. Fast work was required here as I turned the board in quarter turns and continued to spray from the edges.

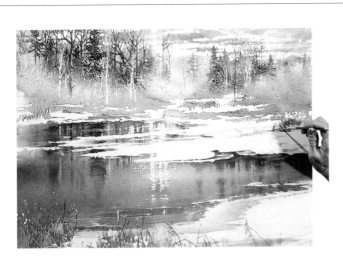

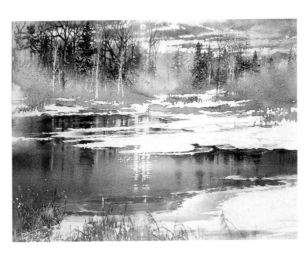

## 6 WORKING ON THE REFLECTIONS

To create the foreground water, I used essentially the same free-flowing technique in the same colors as before. First, I wet the paper from the horizon down. I then applied Bismuth Yellow below the sun, Winsor Red on each side and Cobalt Blue on each side of the red. I applied an additional band of a warmer blue, Cerulean, on the right to reflect the clouds above. Turning the painting on edge, I sprayed the water downward and kept turning the board from one side to the other until all colors merged.

After this wash had dried thoroughly, I added reflections by first re-wetting appropriate sections, then adding mixtures of darker colors from the rest of my palette. I sprayed these areas with water to allow the reflections to dissipate. When all was dry, I removed the masking and designed and painted the grasses.

## 7 GOING WITH THE FLOW

As you can see, the ice and grasses below the horizon evolved from beginning to end. I believe design is the most important element in building a painting, but when I allow the watercolor this much freedom, I find I also have to adapt the design to whatever happens as I go along. A few strokes and accents completed "Spring in the Marshes" (20 x 27½" or 51 x 70cm).

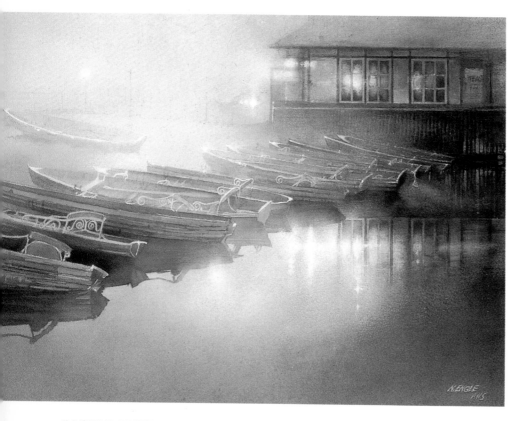

"MYSTICAL BOATS", 19 x 27½" (49 x 70cm)

It was before dawn on the shores of Lake Windamere that I found this line of rental excursion boats. The various lights and reflections at the scene were very confusing. It was actually hard to believe what I was seeing — light burning through fog, glowing in the air, reflecting in the water. I could see that if I painted it, I would have to try to make the three-dimensional light hang in the air. The scene was mysterious and the fancy boats seemed to be from a different time. Just for the moment, it seemed to be a magical place.

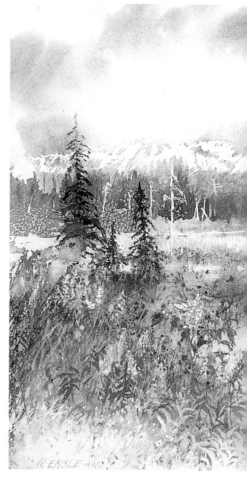

"POTTER'S MARSH", 24 x 35" (61 x 88cm)

Painting in Alaska, the subjects were so large I had to use a jumbo size watercolor paper. Everything there is on a large scale, including these wetlands. The mountains come right down to the sea here, so designing was easy. After protecting the white with a mask, it was basically painted in two large washes — first the mountain and background grasses all at once, then the foreground water and grasses. Finally, all the detail.

## TURNING POINT

The first major break in my career came about because I entered the American Watercolor Society Show in New York. *Reader's Digest* people saw my painting, contacted me to illustrate a story, and due to their circulation world-wide, 17 million people saw my work.

Several things happened after this that influenced my growth as a painter. I was asked to write articles about my work, I began teaching workshops, and talked to dealers who would ask "What are your goals for your work — how will it grow?" In other words, I had to articulate what I had been doing instinctively, and found this to be extremely beneficial. A chance encounter with the *Reader's Digest* Editor who said, "I could just fall into that painting", helped me to see what I was trying to achieve: to take the viewer into the painting.

Incidentally, I now advise all fellow artists to enter major shows!

"WILD RIVER MOOSE", 22 x 34" (56 x 86cm)

Spectacular sights are part of daily life in Alaska. Around every bend of this remote river were 10 more watercolors. Everything is wide open and wild for miles and endless miles. The only difficulty in designing a painting here is finding a vantage point and having to choose between gorgeous or stunning.

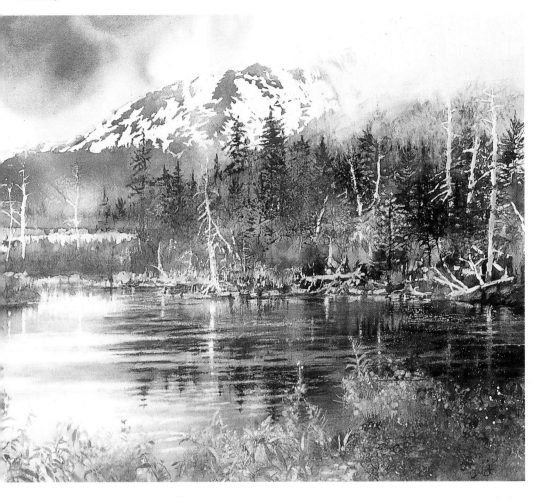

## ABOUT THE ARTIST

A native of Marquette, Michigan, Nita Engle attended Northern Michigan University, Roosevelt University in Chicago, and studied four years at the Art Institute of Chicago. She worked in advertising as an art director before becoming a full-time watercolor painter, producing illustrations for major publishers, from *Reader's Digest* to *Playboy*.

A member of the American Watercolor Society since 1969, she has exhibited there frequently and won awards occasionally. She received the American Artist Cover Award in 1984. Mill Pond Press has printed limited-edition reproductions of her work since 1981.

Nita teaches painting workshops in the US and abroad, and was the subject of a PBS documentary entitled *Wilderness Palette — Nita Engle in Michigan*. She also has a six-hour video painting workshop called *Action Watercolor*. Her work has appeared in many art books, and Watson-Guptill published her book *How to Make a Watercolor Paint Itself* in 1999.

Her work is included in museums and collections in the US, Great Britain, France and Japan. Contact with galleries is through Mill Pond Press.

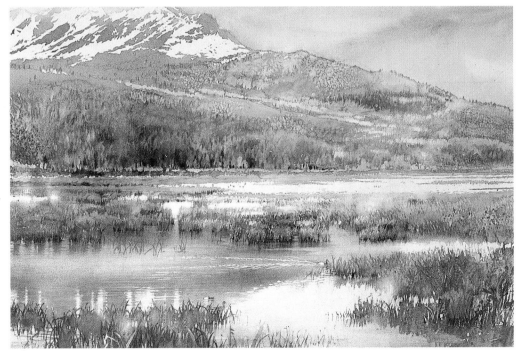

CHAPTER 8

# PHIL HOBBS SHOWS YOU HOW TO INTRODUCE DEPTH AND REALITY INTO YOUR LANDSCAPES

This British artist describes why details are the visual analogy for feelings. The idea is to immerse yourself in the subject for a while and let the telling elements speak to you.

In order to create a feeling of depth and reality in your work it is first of all necessary to identify what we mean by this statement. For me, it is trying to convey that elusive feeling of being there to the viewer. That sense of walking between buildings or trees with the warm sun on your back. Painting is a form of language and communication; the first step for any artist is to know what it is he or she wishes to say. Having decided that, and using the tools at our disposal, the act of painting is one of problem solving, finding the best way of putting things down. Begin with ideas and feelings, allow yourself to become the catalyst.

## ASK QUESTIONS

In an open landscape it may be a sense of mood that can be described with just a few well-placed washes. In a more intimate piece some aspects may have to be observed quite closely. It is observation that is the key, and we need to be alive to the questions, clues and answers present in the landscape before us. Questions such as, is the grass long or short? wet or dry? is the track dusty or muddy? translate in terms of paint on paper, in that quest to recreate three dimensions within two. Likewise ask is that edge hard or soft? that tone lighter or darker? that color warmer or cooler? The answers to these questions as we progress can be a visual analogy for particular feelings. The task is to convey these feelings to the viewer. He or she needs to be

continued on page 52

"YEW TREE FARM, CONISTON",
8 x 12½" (21cm x 32cm)
This has been one of my favorite painting haunts over the years. As the shadows move throughout the day the new compositions present themselves, up close among the buildings, or as here, from a distance with the hills as a backdrop.

These two small studies illustrate some of the different ways of handling the same subject under very different weather or seasonal conditions.

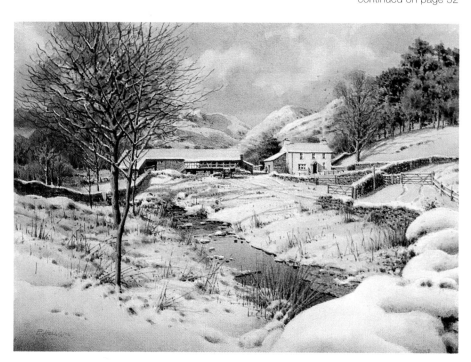

The winter painting relies much more on the large shapes of the snow-covered wall to lead the viewer's eye through the picture to compensate for the fact that the warmer tones are towards the middle ground. It is a good idea when painting snow, to limit white areas to the very highest of highlights.

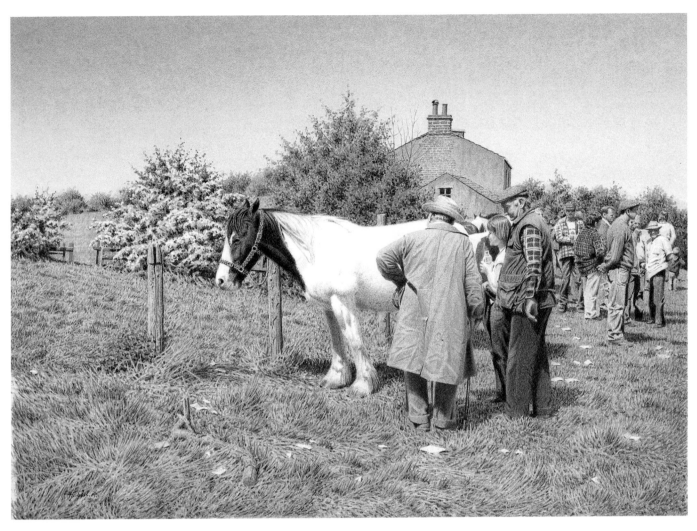

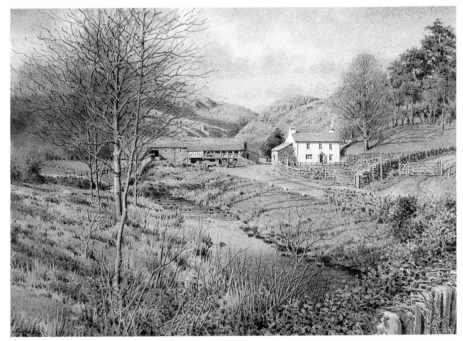

"APPLEBY HORSE FAIR",
11 x 15½" (28 x 39cm)

Appleby Horse Fair is naturally all about people and horses. It is necessary as a painter to immerse yourself in the atmosphere for a while and let the telling elements reveal themselves to you. I love to stand close by little groups as they wheel and deal; it is a great opportunity to observe body language. The realism here is created by the natural attitudes of the figures; they are allowed to tell a story.

Also the rendering of the trader's coat is important. Like a bank note, you might not know why, but you soon spot a fake. These garments have a certain familiarity about them.

The autumn picture relies much more on aerial perspective, the foreground being much warmer and darker. Notice too the reversal of effects in the river — in the winter painting the darker portion attracts the eye, whereas in the autumn picture it is the light area that is the focus.

# ART IN THE MAKING IDENTIFYING THE SHAPES

**B**irk Howe is so typical of many of the farms in the English Lake District with solid buildings of ancient origin nestling between the hills and mountains. There always seems to be a sense of calm masking an awful lot of hard work on these farms due in part to the steady way in which the farmers go about their tasks. On many occasions I have watched the sheep being sheared in the doorway of the barn in the middle distance. Even then, the men seem to find time to tip back their caps and cast their eyes towards the mountains as if there, somehow, lies the stuff that fuels their energy.

The buildings themselves give clues to their age and purpose, the old worn stone steps to wooden floored lofts or spinning galleries, the old pepper pot chimneys alongside more modern ones, the barns in their natural stone state and the farmhouses proudly white-washed. The only sign of labor at this time of day being various implements propped up at handy points throughout the yard amongst which the ubiquitous chickens peck and scratch.

This demonstration was done in the studio from information gathered on-site during visits on two consecutive days. As a subject it presents the artist with a number of ingredients useful when considering depth and reality. A variety of edges and surfaces, a well defined foreground, middle ground and background, several overlapping elements useful for creating counterpoints of light and dark, and a strong path into the picture.

**1** THE ON-SITE THUMBNAIL SKETCH
Having walked around and around the subject the first mark on paper is the thumbnail sketch, which helps to focus my thinking, sets the parameters and arranges the overall composition.

## WHAT THE ARTIST USED

### Support
140lb not watercolor paper size
14 x 19¾" (36cm x 50cm)

### Brushes
Round sable brushes #12,10, 8, 5 and 3

### Other Materials
Masking fluid, 2B pencil, plastic eraser, paper towels, plastic and porcelain slant-well palettes, large container of water.

### Colors

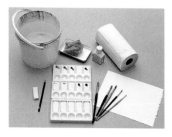

| Light Red | Cobalt Blue | Blue | Olive Green | Raw Sienna | Burnt Sienna |
|---|---|---|---|---|---|

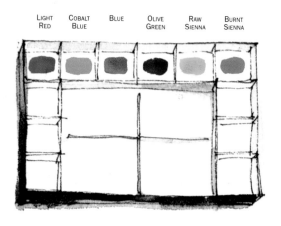

**5** MY FINAL DRAWING
Using a 2B pencil I made a careful and fairly accurate drawing on a sheet of 140lb not watercolor paper mounted on a board, giving enough information for me to continue confidently without wasting time on detail that would be obliterated with the first washes. Notice that I had already planned the figure and his dog.

(It is important at each stage of the painting to feel comfortable with what is on the paper. This allows the artist to concentrate fully on the next stage rather than worry about patching up mistakes — try and get it right.)

I was particularly conscious at this stage of the need to retain highlights and where necessary used a little masking fluid as insurance.

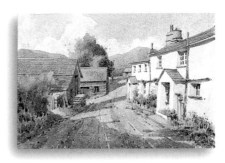

**2 THE ON-SITE WATERCOLOR SKETCH**

Using the thumbnail as a guide I produced a watercolor sketch, paying particular attention to the shadows, which would form an integral part of the composition. It is the large shapes that are important at the moment: any detail should be for information within or reinforcement of a particular passage. I often make notes at the edges of the picture at this stage.

**3 MY PREPARATORY DETAILED DRAWING**

Back in the studio considering my sketches and notes, I felt there was perhaps more to be made of the subject by taking a position further up the lane. Initially, I had worried that the results may have been too cluttered, but on reflection there seemed to be an opportunity to reinforce the original statement through repetition of shapes, such as the two porches and other objects by the foreground porch and by the old barn on the left. I returned and produced a slightly more considered drawing

**4 MY PRERPARATORY WATERCOLOR SKETCH**

Armed with my on-site drawing I made another fairly rapid watercolor sketch. With these and one or two photographs of the scene I felt ready to prepare for the finished watercolor. I believe it is a good idea to keep your thinking flexible and to be prepared to exaggerate a slope or a curve to better state a particular aspect of the scene. I was aware in this case of the curve of the track and the variety of edges and surfaces that would assist in my taking the viewer on a journey through the picture.

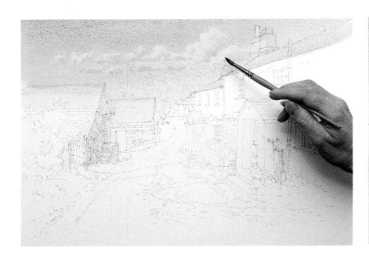

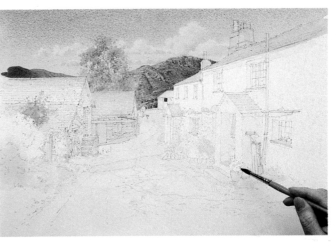

**6 THE SKY, ROOFS AND CLOUDS**

Using a number 12 sable brush I placed a warm wash of Raw Sienna over the lower half of the sky and the roofs of the buildings, gradating it with clean water towards the top edge of the paper. When this was dry I rewet the whole area and ran in a Cobalt Blue wash, gradating the wash to the horizon. While this was still wet I used a paper towel to lift out the shapes of the clouds. I used the same blue with a little Light Red to indicate the softer cloud areas, and then allowed the area to dry before I put in the slightly sharper cloud shapes.

**7 INTRODUCING THE TONES**

Having established the light area of the sky and being aware of the "white" buildings on the right I put in a dark area as a guide to achieving the right tonal values as I began to place the distant hills. Lightly washing in the middle ground tree allowed me to establish some color temperature. On dry paper I then flooded a warm wash throughout the rest of the painting, leaving out just the whitewashed walls and highlights.

continued from page 48

able to measure your footsteps with their eyes, take in what you experienced at particular points along the way. Use the tools at your disposal to guide them, reinforce the areas over which you wish the eye to linger, hint at the aspects you wish to skip over, let the viewer do some of the work.

## FIND THE CLUES

Look for clues to a story: abandoned boots, a broom. Clues to temperature through color and weathering, is this old or new? rough or smooth? Where you have people, involve them, they are not just decoration and do not forget the elements of surprise or shock, or even a little humor.

Depth and reality is not created by relentless detail. The overall impression must be made by the larger shapes and the smaller shapes then used to reinforce these, like the notes within a chord. Detail must be used like any other tool or technique, to support the whole.

### "CHICKEN BY THE OLD BARN DOOR", 23 x 19" (59 x 47cm)

Old barns such as this are getting to be something of a rarity in the countryside these days. Given the opportunity I make every effort to partake of these feasts of patterns colors and textures, often perched precariously atop a wall or piece of machinery to avoid the mud, or worse.

The task here was to create the feeling of three dimensions within a very shallow field a little like a trompe l'oeil. It is the various textures within the door, the wall and the foreground that give this painting interest. These textures are created using a whole host of techniques; spattering, dry-brush, glazing and so on until the effect felt right and I began to smell the farmyard.

The illusion of depth is achieved by such things as the leaning wooden posts and the shapes that they create, plus the carefully observed dark shapes within and around the door.

### 8 DEVELOPING THE STONEWORK, GRASS AND TRACK

I begin washing in areas of stonework in a fluid but controlled way using a fully charged #8 brush. With mixtures of warm and cool colors (Cobalt Blue, Light Red and Raw Sienna), slightly overstating them in areas that would receive a unifying wash later, I began to place areas of color in the grassy parts. I was careful to maintain some variety but still without any indication of detail. I decided at this stage to indicate a group of larger cobbles at the bottom right. This would provide some recession of detail and also give some weight to anchor the curving track which would be a major directional force within the composition. Mid-tones were suggested in the cottage windows, and so on, allowing me to see the framework before tackling the whitewashed walls.

### 9 INTRODUCING MOOD AND ATMOSPHERE

I was ready to start creating the feeling of the day and begin to pinpoint areas that were important to the overall feel; the warm sunshine late in the year, casting long shadows. A series of pale gray washes was laid in on dry paper leaving hard and soft edges to create highlights on the whitewashed walls. These were made up of mixtures of Cobalt Blue, Light Red and Raw Sienna. I began to develop textures in the foliage and the roadway using small brushstrokes, I applied the shadows as a glaze paying particular attention to the shapes they made, which whilst giving some clues as to the objects casting them, helped to give form to the underlying ground — note the repetition and reinforcement of shapes bottom right. I began to create reflections in the cottage windows. Like eyes they indicate life. A warm unifying wash was added to the barns on the left.

## TURNING POINT

Nearly 30 years ago now, fresh out of college, at the summer exhibition of a society of which I dreamt of becoming a member one day, I was standing gazing at a group of paintings by an artist that I particularly admired. Seeing him standing nearby I asked in awe, "How do you do it"? He looked at me, smiled and quietly, almost conspiratorially said, "It's all about understanding shape, Phil". At the time this reply sounded almost too simple, too profound. Recently however, at the annual exhibition of that same society of which I am now vice-president, I saw the same eminent painter looking at my work. As I approached, he turned and said with a knowing chuckle, "Go on Phil, how do you do it"? I could have cried, and perhaps should have said, that in part, it was because over the years during countless struggles I was able to hear a quiet steady voice saying, "It's all about understanding shape Phil". I didn't say it, as it was not needed; I just smiled.

## ABOUT THE ARTIST

Phil L. Hobbs was born in Yorkshire, England in 1953. He qualified as an art teacher in 1975 and later worked as an illustrator and designer for the Lake District National Park before becoming a full time artist in 1979. He lives and works in Ambleside in the heart of the English Lake District. Phil's work reflects the hidden as well as more obvious aspects of life in and around the countryside with the accent often on the play of light and the textural qualities of his subjects.

Working largely in pure watercolor in the true English tradition, Phil has gained an enviable reputation for the amount of light, depth and reality he is able to incorporate into his work.

He has taken part in many important exhibitions and exhibits regularly in the United States, at the Royal Institute in London, as well as annually at the Lake Artists Society of which he is currently Vice President.

He is represented in the USA by Ambleside Galleries, Grosse Pointe, Michigan, where there is a permanent collection of his work.

In England his work can be seen at the Hobbs Gallery, 1 Church Street, Ambleside, Cumbria LA22 0BU. Email: hobbs.gallery@virgin.net
Visit his website:
ttp://freespace.virgin.net/hobbs.gallery

**10** EMPHASIZING THE POINTS OF INTEREST AND ENHANCING CONTRAST

I continued working around the picture attempting to pull everything together. It is at this point that you can adjust emphasis, tighten or soften edges, push elements back or bring them forward.

The objects that would catch the viewer's attention and act as a stop or a pointer become apparent at this stage: the patch of sunlight through the gate, the chickens, the distant figure. I completed the figure and the shadows on the distant barn to use as a reference for the middle and foreground detail, attempting to make best use of the counterpoint.

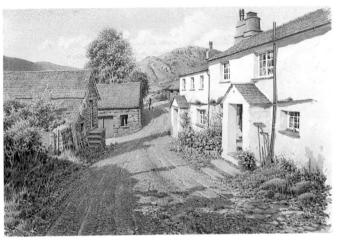

**11** FINISHED

Further shadows and modeling were applied to the cottages on the right, the mossy rocks and the foliage. The sunlit patch of grass and the chickens were next. The little dog was glazed back a fraction. Various other slight adjustments, together with little bits of incidental detail, completed the picture. I hope I managed to do justice to the scene in a considered way whilst maintaining some of the spontaneity of the original sketches.

# KIFF HOLLAND'S WAY WITH STAINING AND GLAZING

This artist believes the use of staining colors and glazes are vital to the success of a watercolor landscape.

As artists we grow with each work we attempt. During the last 30 years I have been a colorist, a realist, a value painter, an impressionist and a teacher. As a teacher you help someone paint in their own style while allowing them to borrow some of the techniques you have taught them.

My technique for painting landscapes can be divided into two parts. The background that sets the tone for the painting and the foreground that enhances and creates the focal point.

## THE BACKGROUND

Hills, mountains, distant forest and isolated spaces are painted in a series of glazes starting from the most distant object.

Using clean water I take my brush and wet the paper from

**"HEX RIVER, SOUTH AFRICA",**
20 x 25" (51 x 64cm)
I wanted to capture the dustiness of early winter. I also wanted to reveal the gum trees blowing in the wind and the first snow on all the mountains. The snow and the highlights on all the buildings were masked out. Background details were glazed. The masking fluid was removed from the mountains. An overall glaze — ranging from blue/purple at the top to Raw Sienna at the bottom was painted in. Vineyard details and gum trees were painted at the finish.

**"CROFTERS, SCOTLAND",**
13 x 20" (33 x 51cm)
This was a rare clear day on the way to Ullapool. The dappled landscape in sunlight and shade caught my eye. The rippled loch reminded me of Cotman's beautiful paintings of Dolgelly, North Wales. I wished to imitate it. Note that the clouds have semi-hard edges and soft, fluffy centers.

the object's horizon line to the foreground details. I add color concentrating only on the value I want on the most distant object. I wobble my paper to allow the paint to run freely over the wetted surface. I turn the painting upside-down. I soak up any drips that seem likely to occur. Then I wait for the paint to become thoroughly dry. Turning my painting right side up I repeat the process using the next object's horizon line as the extent of my clear water wash. I add color to the object's perceived value (and so on) until all background elements have been painted.

At this point I paint the sky. When completely dry I usually brush a clear water glaze over the entire painting. With dilute primary colors I add mood by painting the sky up to and over the background objects already created. In doing this, the edges are softened and aerial perspective is created.

## THE FOREGROUND

The foreground is painted generally from dark to light. I reserve all highlights with masking fluid. I try to ensure that there are enough darks to anchor my focal point. Cast shadows are darker than shade. Reflected light is seen in the shade. Enough texture is created in the objects close to the viewer to heighten his sense of three dimensions.

After removing the masking fluid I use a variety of toothbrushes, sandpaper, and erasers to soften edges and create texture. I then tint these areas, very sparingly. I believe that most of the color in water color is seen in shade and shadow.

# ART IN THE MAKING  GLAZING IN ACTION

**M**y wife Sally and I often walk along the sea wall in West Vancouver. At its western turn-around is Dundarave Beach, a perfect place to enjoy the setting sun and a beautiful location to create a painting. I took several photographs to capture the moment. The sun was galloping along and the shifting of the light was fast and dramatic.

## WHAT THE ARTIST USED

**Paper**
20 x 28" (51 x 71cm)
x 140lb (300gsm) Rough paper
stretched on a wood and
aluminum clamp frame

**Brushes**
#6 Round
#14 Round
2" flat

**Colors**

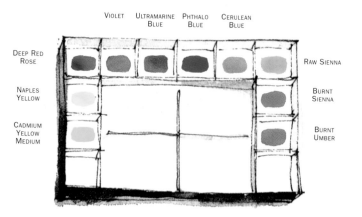

**1** THE PREPARATORY DRAWING
In the drawing all of my highlights were reserved with masking fluid.

**4** SHADOW AND SHADE
All the shade and shadow on the houses was painted. To hold the airiness in the painting I tried to use clear color rather than resorting to neutral grays.

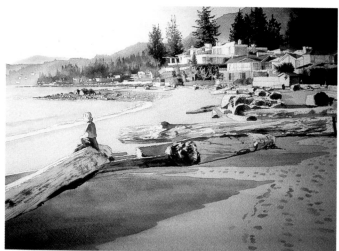

**5** THE FOREGROUND
The logs and shadows were painted next. The footprints were indicated. The woman sitting on the log was blocked in.

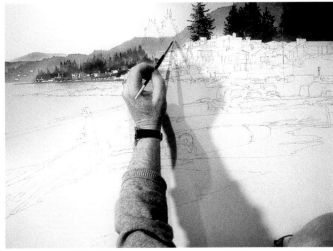

**2** FIRST GLAZES

The mountains in the background were glazed. In three separate steps, washes of increasing intensity were applied. I painted these with the image upside-down. Then I wet the whole landmass to the horizon of the mountain in preparation for painting that area.

**3** THE BACKGROUND

I painted the background trees, the sky, the sea and some local color into the beach. All of this was done in one continuous glaze. This softened the edges and heightened the sense of aerial perspective. I was also busy dry-brushing the dark conifers that would add drama to the sunlit houses.

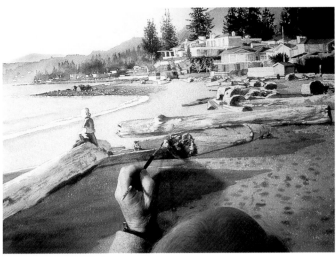

**6** DEPTH

The masking fluid was removed. This left the white paper starkly hard edged. I tinted some of these highlights to soften their impact and to create the illusion of depth. Very light glazes of Naples Yellow, Red Rose Deep, Raw and Burnt Sienna were used to add color to the sand. I also worked on the foreground shadows.

**7** FINISHED

To get to this stage I used sandpaper and toothbrushes to soften edges and to create the texture of the logs and beach. I then applied paint to these areas to recreate the right feeling. The finishing touches were added to the woman enjoying her moment of solitude. I called this "Dundarave Sunset".

"CLIFFS AT LIGHTHOUSE PARK, WEST VANCOUVER, CANADA", 13 x 20" (33 x 51cm)
Landscapes do not have to have sky in them. I was interested in the effect the sparkling sea and rugged coastline had on the two people who sat in quiet contemplation for over an hour. The "sparkles" on the water were all carefully masked out. I had to be patient.

"MOORAGE, SALT SPRING ISLAND, CANADA", 12 x 20" (31 x 51cm)
Early morning. A single sailboat. Grass burned yellow by the long summer sun. Distant water. I have found that reflections are at their best at the beginning and end of the day. Paint the reflection first and glaze the surface of the water last.

## TURNING POINT

At the beginning of my career as an artist in Canada I was showing my work at a small gallery in North Vancouver. I had sold a couple of paintings but was barely making ends meet. The gallery owner Pat Touche told me Alan Edwards had come in and left me a note. I had no idea who Alan was or that he was single handedly resurrecting the Federation of Canadian Artists.

On my next visit to the gallery Pat handed me the note and I read it. Alan praised me. He liked my drawing skill and my sense of the dramatic. He then pointed out some of my shortcomings such as poor composition, wrong values, muddy color and so on. I got a bit prickly.

Pat brought out three paintings by Alan, that she had just framed. I was awestruck at the magic of his art. My feeling of surliness was instantly replaced by a great joy at being recognized by an artist of his stature. Alan Edwards became my mentor and a friend. He underscored my determination to be an artist. He invited me to join the Federation of Canadian Artists.

"PIER AT SANTA MONICA, USA", 30 x 40"
(76 x 102cm)
This is great place for lovers to be, away from
the hustle and bustle and noise happening
overhead. I tried to capture the rhythmic thud of
surf and sea-sucked-sand. I painted with a lot of
masking fluid and used a toothbrush to spatter it
into the waves and barnacles as well. Note the
reflected light on the beams and how the
sunlight bends around the posts.

## ABOUT THE ARTIST

Kiff Holland was born in South Africa and
now lives in West Vancouver. He received
his formal art training at the University of
Witwatersrand and the Johannesburg
School of Art. On immigrating to Canada
in 1975, he was immediately captivated
by British Columbia's soft color and light.
In 1992, Kiff became a signature member
of the American Watercolor Society. He
won first prize in the 1993 Societe
Canadienne de L'Aquarelle in Montreal,
and received the annual Gold Medal
Award from the Federation of Canadian
Artists in the same year. Kiff is a past
president and senior member of the FCA.

He teaches in the Design Illustration
department of Capilano College and has
conducted workshops in France as well
as Canada and the USA.

In addition to those countries, his
work has been exhibited in Britain, South
Africa, Mexico and Australia.

His work can be seen at Harrison
Galleries e-mail
info@harrisongalleries.com
e-mail kiffholland@telus.net tel.

# CONSIDER ROBERT LOVETT'S VISUAL PATHWAYS

## You need an armory of devices to arrest the viewer's attention. The visual pathway is one of the best!

Artists are in a way, entertainers. A painting hanging with many others in a gallery must compete for attention and try to hold the interest of the viewer. Many factors contribute to this end, most important of which is good design, but that is almost too broad a statement. It can be simply an arresting color scheme, a strong tonal statement, clever technique or perhaps the appeal of the subject. I try using as many of these ploys as possible but there is one other strategy that I often incorporate into my paintings. I try to seduce the viewer with an easy and interesting entry into the picture — I call it a visual pathway. It should be designed to entice the eye into the subject and lead it to the center of interest. This is where it is imperative to provide entertainment. It can be mildly enjoyable or wildly exciting. Powerful contrast, vivid color, action or much detail are some ways to hold the attention. The viewer should feel compelled to linger for a while before wandering off to explore other passages of the painting, or worse, other paintings.

Some of the paintings that follow use the visual pathway while others present the center of interest up front, which grabs the eye instantly, without any foreplay.

**"ST PETERS, ROME", 14 x 17" (36 x 44cm)**

The entrance foyer of St Peters lends itself to a great interior landscape subject, with its high vaulted ceiling and tall columns. I liked the lighting effect with the sunlight streaming in and bouncing reflected light all through. Drawing was made easy because of the simple one-point perspective. The figures silhouetted in the doorway on the left and the sunny patch leading across to the Swiss Guards make an interesting focal point, which immediately catches the eye. I wanted to achieve a loose rendition with only a suggestion of the prolific detail.

I used 300lb (600gsm) Rough paper for its versatility. It allowed me to render those broken rough edges, hard edges and wet-into-wet washes as required. The main feature of the design is the strong horizontal band of the figures right across the picture, opposed to the repeating verticals of the columns.

# TO ENTICE AND CAPTIVATE

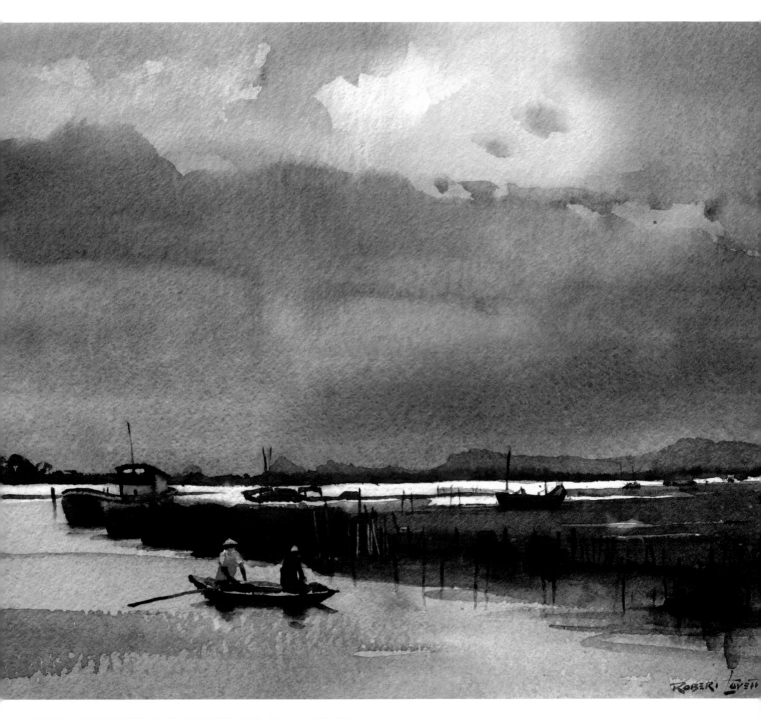

"EVENING ON THE SONG CHU", FABRIANO 300lb (600gsm) ROUGH

It was late afternoon and storm clouds were building. The sun momentarily broke through to light up the river downstream, presenting this dramatic image. I was only able to get a clip on my video camera but it provided enough information for this painting.

The approach is not really a visual pathway — it's more like a hop, step and a jump. The first thing that attracts the eye is the little rowboat in the foreground. From there it's an easy transition to the reed bed, and then you are zapped by the intense light and contrast of the far river and various boats in silhouette.

This was painted quickly in a very direct way with big wet washes and lots of wet-into-wet.

Tonal contrast and the strong horizontal are the key elements of the design.

# ART IN THE MAKING CREATING A VISUAL PATHWAY

These houses at Chau Doc in Vietnam are typical of many along the picturesque Mekong River. They connect to the riverbank with all manner of precarious structures to provide access.

The demonstration painting is a very obvious example of the visual pathway. The eye goes directly along the boardwalk, and what an interesting journey it is. Following a gentle curve it is crossed by many transverse wooden battens, with handrails and poles running parallel further accentuating the effect.

Having traveled up the pathway the eye is blatantly assaulted by the bright red shape, set partly within the cubic shape of the house. Apart from the obvious color contrast, the curved outline of the girl in red is in contrast to the very geometric shapes surrounding it.

The many negative dark shapes that highlight the poles and rails form a pattern that is repeated through a large part of the picture. The major boardwalk and house are set just off center and a smaller repeat is placed on the right side creating a nice informal balance.

The painting is predominantly blue and gray. I used several different blues to achieve this.

I wanted a crisp, hard edged approach to emphasize the pattern of the many poles and planks, and so on.

As much as possible I used large squirrel hair brushes with big wet juicy washes, only resorting to smaller sables for some of the details.

Although this is a complex subject it was treated in a simple way as you will see.

## WHAT THE ARTIST USED

**Support**
Full sheet Arches Soft 140lb (300gsm) stretched

**Brushes**
2" flat squirrel hair
#11 round squirrel hair
#10 and #2 round sables

**Other Materials**
Tissues
Masking fluid

**Colors**
Indigo
Cobalt Blue
Cerulean Blue
Ultramarine Blue
Burnt Sienna
Raw Sienna
Cadmium Red
Permanent Rose

**1** THE TONAL SKETCH
This sketch shows an all over mid-tone background and the main darks interconnected and spreading across the width of the picture about ⅔ up from the bottom. The whites are mainly the boardwalk and the poles. The roofs of the houses were toned down somewhat.

**2** THE DRAWING
I made a careful drawing, paying attention to the perspective. Eye level is at the apex of the main roof. This high viewpoint tends to de-emphasize the perspective of the boardwalk.

**6** A PATTERN EMERGES
Here you can see the pattern of the dark negative shapes emerging. Cobalt Blue and Burnt Sienna were washed over the face of the buildings, right over the masking fluid and across to the outer edges. It formed a shadow beside the building on the right and some interesting fence shapes on the left.

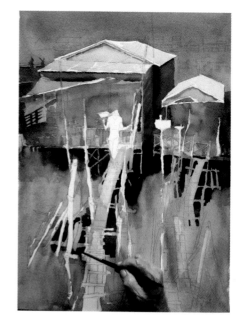

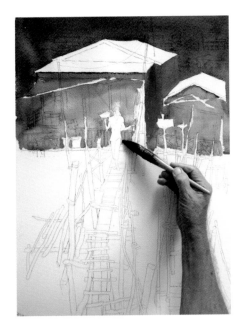

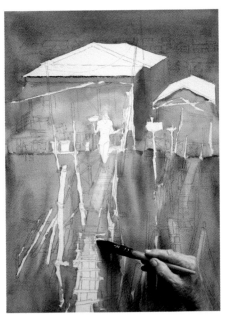

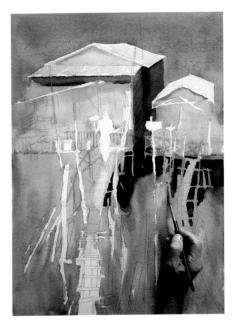

### 3 A TWO-PART WASH

The major wash was done in two sections making it easier to control. I prewet the sheet where the first wash was to go avoiding those areas to remain white.

The wash started off very strongly, mainly Indigo with a touch of Burnt Sienna. I used a large squirrel brush and just floated the color into the wet. As the wash came under the roofline I added Cobalt Blue, finishing with pure Cerulean Blue for the railing.

### 4 A VARIEGATED WASH

When the wash was dry, with a small brush I painted masking fluid over the Cerulean Blue on the intricate railings. I put in the large wash on the lower part of the sheet, first prewetting and avoiding the white poles. This was a more variegated wash using Indigo, Permanent Rose, Raw Sienna, Burnt Sienna and Cobalt Blue, allowing these colors to mix on the paper and run forming vertical streaks of color. The boardwalk was left white in some places and the wash was carried across in others using warmer colors and blotted off with a tissue.

### 5 THE SHADOWS

The shadows on the main building were washed in with crisp edges using Indigo, Cobalt, and a touch of Burnt Sienna. This wash was continued down and darkened with Indigo and Burnt Sienna to form the dark shadow under the buildings. The lower edge was softened with a moist brush. Elsewhere the edges were maintained hard and crisp. With a No. 10 pointed sable I proceeded to paint the dark negative shapes in between and under the various timber bits. Although these areas are quite dark I still have a very fluid wash with plenty of water.

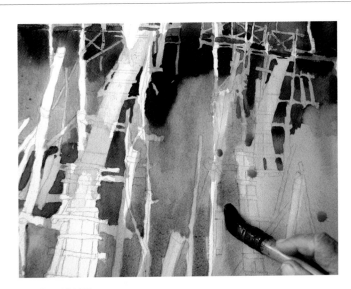

### 7 BIG WASHES

This shows my technique for applying the big wet washes with lots of water. This one is the main reflection of the buildings, extending halfway to the bottom

### 8 REMOVING THE MASKING FLUID REVEALED THE CERULEAN PATTERN OF THE RAILING

I painted the lady in red with Cadmium and Permanent Rose. The reds were repeated here and there to balance the red figure.

A dark shadow of Ultramarine Blue and Burnt Sienna under the awnings made the interiors of the houses recede. The boardwalk was detailed and some warm colors added. A few more details completed the picture, which you will see overleaf.

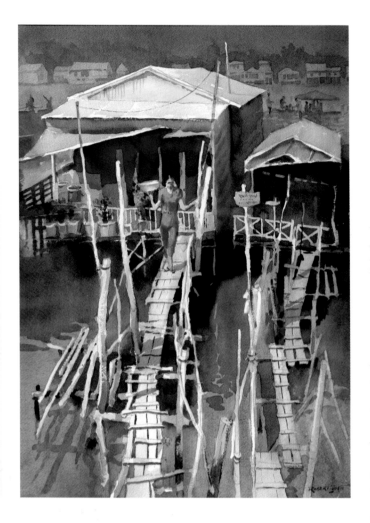

# TURNING POINT

At the age of 38, I made a decision to quit my secure and well-paid job as official artist to the Snowy Mountains Authority to become a full-time fine artist.

With three boys in high school and a mortgage, friends and colleagues all told me that it was the wrong thing to do. "Nobody can make a living from painting", they assured me. Being headstrong and foolhardy I went ahead but held a firm belief in my ability and determination to succeed.

I have never regretted that decision. Although there were a few tough times during recessions I have enjoyed a wonderful life doing what I love to do. It has enabled me to travel widely both in Australia and many other countries, always with a purpose. I am privileged to see these places from a different perspective, experience the culture and paint the landscapes and people.

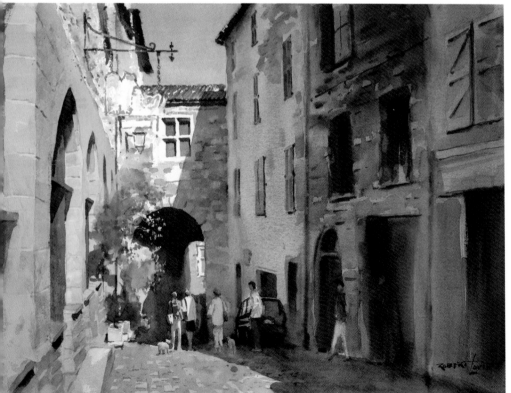

**"A STREET IN CORDES — FRANCE",**
20 x 27½" (50 x 70cm)

The buildings are crowding in, giving a feeling of confinement, relieved only by the visual escape hatches through the archway and the patch of blue sky. Fortunately, there is plenty to entertain and hold the attention without the need to escape. All the lines of perspective lead into the focal point where we have that interesting group of figures, the archway, the four square windows, the red tiled roof and the shadow falling across the stone wall.

The figures emerge from the shadow into the bright sunlight and contrast against the darkness of the archway. A teasing glimpse of what lies beyond the archway leaves us wondering, should we escape?

**(OPPOSITE) "AIX EN PROVENCE",**
20 x 27½" (50 x 70cm) 140lb (300gsm)

I used soft 300gsm paper stretched for this because this weight is ideal for clean transparent washes. Rough edges are limited but can be achieved.

The main features here are the column and the sunlit umbrellas. There are no subtle preliminaries here. You are right in there immediately.

Paintings must be inviting to enter no matter how this is achieved. We should not place any obstacles, barriers or unnecessary distractions to impede the eye from taking the correct path.

"FLOATING MARKET — MEKONG, VIETNAM", 20 x 27½"(50 x 70cm) 140lb (300gsm)

This backlit subject has powerful tonal contrasts. The vibrant colors of the scene are subdued because we are looking into shadow. The center of interest almost jumps out of the rectangle. After being accosted by the figure in the immediate foreground, the eye can travel back into the picture to explore the details of figures, merchandise and the boats. I love the way the sun lights up the muddy water creating the strong contrasts.

The large dark area on the left was treated as one mass, broken only by the sparkling highlights and balanced by the small boats and figures on the right.

This rough paper allowed me to drag a flat 1" brush across the surface to get that effect of light on broken water. The large mass was painted as one, varying the color wet into wet. Some of the highlights were preserved with masking fluid. See how the wave pattern counteracts the diagonal thrusts of the boats.

## ABOUT THE ARTIST

Robert Lovett was born in Sydney, Australia in 1930. He studied commercial art and design in Sydney and Anatomy and Sculpture in the USA.

From 1950 to 1968 he was official artist to the Snowy Mountain Authority. During this time he had a retreat in the mountains, a 800 hectare cattle property where weekends were spent working the cattle and painting. This is where he developed a love of the mountains, horses and cattle featured in his work. He was invited to work on location for the filming of the movie *The Man from Snowy River*. This culminated in an exhibition of 40 major paintings in the Sydney Opera House to mark the premiere of the movie in 1982.

Robert traveled widely and diversified his work. Painting landscapes and the human figure from many countries including The British Isles, Europe, Asia and the Pacific. He worked extensively in the USA for many years exhibiting in Arizona and California.

Robert then opened his own gallery at Marina Mirage Gold Coast in 1993. His paintings and bronze sculptures are in collections all round the world. The Australian government has presented more than 40 Robert Lovett paintings to Heads of State worldwide.

Robert is a member of the exclusive Australian Watercolour Institute and his work has appeared many times in *Australian Artist* and *International Artist* magazines. His book *The Art of Designing Watercolors* (International Artist Publishing) is an international best-seller.

After closing his gallery in 2001 Robert is now just painting for the sheer pleasure that it brings him.
Visit Robert's website www.lovettart.com

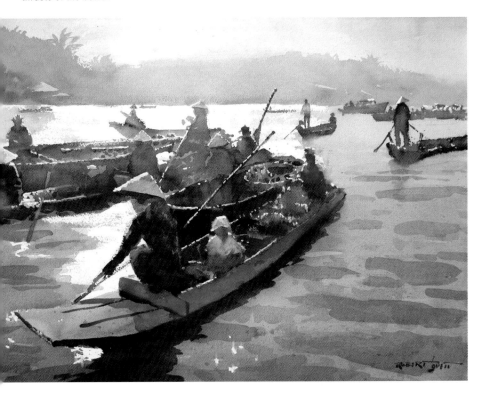

# EXPLORE MOOD AND LIGHT WITH BOGUSLAW

## How we express objects in our paintings is not nearly as important as what we try to express.

There is something fascinating about the ever-changing mood and light in the landscape. To capture this essence and render it convincingly in watercolors has always presented a worthy challenge for me. There are methods that help to achieve a particular mood in a painting but there are no specific techniques that produce a given mood. I have learned from studying Turner's watercolors that the use of a particular style should be dictated by what we want to express in a painting. We should not allow ourselves to become slaves of a particular technique. How we express things in our paintings is not nearly as important as what we try to express. The how (the technique) is the grammar, orthography and syntax part of the story we are conveying to the heart of the viewer.

### COLOR AND MOOD

Let us examine methods that help to express moods in landscape. To the greatest extent the mood of a painting depends on light, on values and the intensity of the colors used. The light influences mood by modifying colors, by sharpening or diffusing shadows and shapes, or eliminating shadows altogether (such as on a foggy or overcast day). As a general rule, to set a happy, dynamic, vivacious or rhapsodic mood — to name a few — requires more intense colors of purer hues. Mixing two or more pigments results in more subdued colors. The more we mix them the less intense they become, as they move toward eventual greyness. These kinds of colors are used to create moods such as melancholic, somber, gloomy, mournful and so on.

To illustrate the above I will compare two of my paintings: "The Shadows" (below) and the demonstration work "Mask's Farm" (demonstration overleaf). Both represent winter scenes, both are economical in complexity and both are painted almost in monochromatic blue, yet each represents a different winter mood. The mood of "Mask's Farm" conveys the stillness of a snowy day.

"Shadows," on the other hand, has a joyful mood with an almost kinetic quality of shadows rushing toward you. To achieve the mood in "Shadows" I (1) painted it in high contrast, (2) used intense, clear and rather dark blue colors, (3) made strong clearly defined shadows, (4) easily determined the location of a strong light source, (5) suggested strong illumination which creates a perceptible texture on the snow, (6) slight, progressive blurring of the shadows, from their source to the foreground gives them a kinetic quality.

The mood of quietude in the "Mask's Farm" was accomplished by the following means (1) Through subdued blue colors that almost approach greyness. (2) The location of the light source not indicated. (3) There are practically no shadows, just slight, diffused, darkening under the buildings' eaves. (4) The overcast sky, which is darker than the snow, has the discernible texture of a fluffy blanket, contributing to the feeling of calm and quietness. (5) The snow has no texture, only vague modeling in the foreground. (6) The weeds in the foreground, standing upright holding cups of fresh snow, also contribute to the sense of calmness.

"SHADOWS", 21 x 28" (53 x 71cm)

I was mesmerized by the long tree shadows created by the low winter sun on a clear and crisp day. In my mind I was already composing a cheerful painting with the shadows rushing toward me, inviting me to play with the light. It intrigued me to think how I could achieve such a mood, essentially using only four elements: the trees, the shadows, the snow and the light, with an added challenge of facing directly into the sun.

To reach my objective I decided to use strong, intense blue colors, high contrast, well-defined shadows cast by a bright, identifiable light source and a crisp, perceptible texture on the snow. To attain the illusion of movement I decided to start slightly blurring the shadows as they are reaching the immediate foreground. I have painted this using wet-in-wet washes, dry-brush and I lifted colors.

# MOSIELSKI

"PERCE ROCK", 21 x 28" (53 x 71cm)

It was the end of summer; next day we were leaving Perce (Gaspe, PQ). Feeling some obscure sadness for leaving this colorful, vibrant and bustling spot on the Gaspesian coast, I took a last stroll on the beach. It occurred to me that my own feelings were reflected in the surrounding landscape.

To induce similar feelings in the viewer I used muted colors. The sea was a grayish hue instead of its usual emerald or ultramarine blue. The normally brightly colored Perce Rock was bleared behind a bluish haze. The distant boats appeared abandoned at the moorings — not going out to the sea, the masts of sailboats behind the wharf were stripped of sails, there was not a single person walking or sitting on the beach or frolicking in the waves. Yes, this was the end of summer, but the warm colors of the beach strewn with thousands of colorful pebbles prevent us from feeling depressed about it, only just a little bit sad.

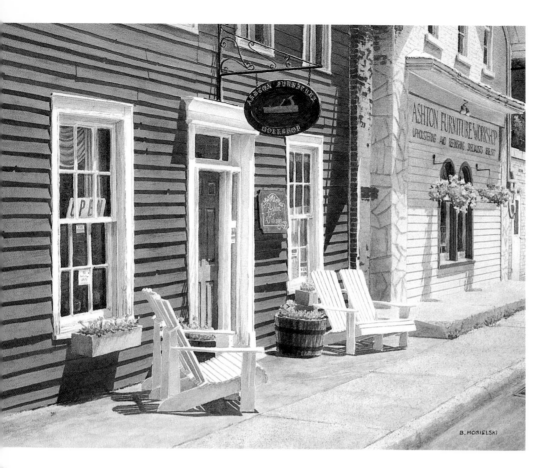

Walking around town on a summer day, I had the idea of creating a painting that would communicate to the viewer the heat and stillness of noon in a small, rural town. I decided to portray only a small fragment of the street — an antiques and furniture workshop.

To achieve the mood, I created the long, deep and sharp shadows pointing to the almost zenithal position of the sun. The lit surfaces of the creamy colored door and window frames, and the Adirondack chairs are glaring, bleached of any color. Normally, people sit chatting on the chairs. This time the vendor and customers preferred to be inside behind the closed door, away from the heat.

Contributing to the feeling of heat are the warm deep red and yellow colors covering almost one-third of the painting.

# ART IN THE MAKING SUGGESTING A QUIET MOOD

## WHAT THE ARTIST USED

### Paper
Waterford Cold Pressed 300lb (638gsm)
15 x 22" (38 x 56cm)

### Colors

ANTWERP BLUE   MANGANESE BLUE   ULTRAMARINE BLUE   BURNT SIENNA   PAYNE'S GRAY   IVORY BLACK

**1 TRANSFERRING SKETCH AND PREPARING PAPER**
I drew a grid on top of my small pencil sketch of the painting. That grid was carefully transferred to the dry watercolor paper, proportionally enlarged to fit the painting area. Guided by the grid, I carefully replicated the sketch onto the watercolor paper. Then the paper was carefully wetted several times with a sponge on the reverse side, making sure that water did not run onto the front of the paper. When the paper felt limp I delicately removed the water sheen using paper towels. Next, the paper was placed, dry face up, onto a ¼" mahogany plywood panel. Using a paper stapler I pressed staples through the edges of the paper into the plywood. I covered the edges with masking tape. (Masking tape keeps the edges clean and when removed leaves a pleasing white frame around the image.) After 5-6 hours of drying the mounted paper was stretched to prevent buckling when the wash was applied.

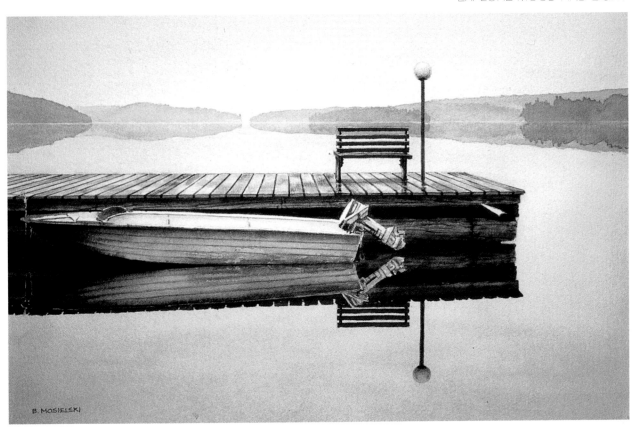

"FAREWELL TO SUMMER", 14 x 21" (37 x 53cm)

**2** PAINTING THE SKY USING THE DRY-BRUSH TECHNIQUE

I mixed Ultramarine Blue with Antwerp Blue and a touch of Payne's Gray and Burnt Sienna, constantly testing the color of the mixture on scraps of paper until the desired color was achieved. The mixture was diluted to somewhat less than medium density. After dipping a ¾" flat brush in the color I touched the brush against one of the flat sides of a full roll of toilet paper (yes, it has other uses!) which nicely sucked up the excess mixture so that only a small amount of paint was left. With an almost dry brush I covered the sky — using very short brushstrokes — with a patchwork of light color. I repeated the process several times until the desired texture and color value was reached. Consecutive brushstrokes were placed between previously laid, but dry areas.

**3** ESTABLISHING THE COLOR VALUES OF BUILDINGS

Using a #5 red sable brush and the color prepared for the sky, but with a little bit more Burnt Sienna added, I dry-brushed the distant hills. The dry-brush technique allowed me to precisely reach the desired texture and value. With the same #5 brush I put washes of color over the barn and other farm buildings. Again the color was mixed with the same pigments used for the sky but in different proportions and of greater density. These washes were allowed to dry thoroughly before I started dry-brushing the texture, some vague details, slight color variation and the diffused shadows under the eaves.

69

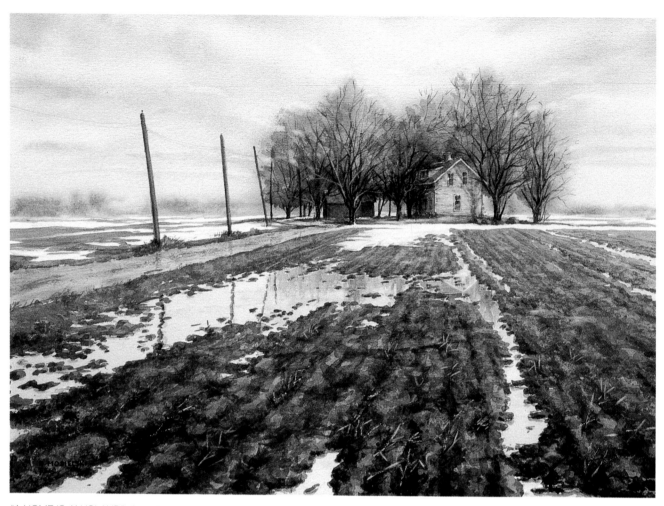

"A HOME IS AN ISLAND", 21 x 29" (53 x 74cm)

#### 4 WET-IN-WET GRADATED WASHES

I applied a gradated wash using the wet-in-wet technique and lifting colors from small areas. I prepared a relatively dense mixture of Manganese Blue (it has an excellent lifting quality) with some Ivory Black, Payne's Gray and Antwerp Blue. Using a 1½" flat brush and pure water I wet the snow-covered hill in the foreground and waited till the water sheen disappeared. With the same brush, this time heavily loaded with the pre-mixed color, I laid wet-in-wet, long, horizontal strokes, starting at the bottom. I progressively dilute the mixture with more water for each consecutive stroke until the last stroke was made with pure water. Then, firmly pressing a twisted paper towel into the wash, I lifted the wet color creating cups of fresh snow on top of the foreground weeds.

#### 5 MODELLING SNOW DRIFTS BY LIFTING COLOR

Carefully wetting some areas around the yet unpainted weeds, I lifted enough color with a paper towel to create the illusion of snow drifts. It was then that I reaped the benefit of using Manganese Blue. With #0 and #2 brushes I created textures on the buildings, defined details and painted foreground weeds. I placed a few color accents: red doors, some yellow hay visible through open doors and holes in the barn, some rusty tin on the wall of one building. Such color accents were important to prevent a gloomy mood from creeping into the painting.

# TURNING POINT

Like most of the people of the 20th century I used to perceive watercolor as an anaemic medium — an easier, sketchy way to lay the brush to paper. Watercolor insinuated inferiority of the medium as opposed to the more "serious" medium of oil. Using watercolor cast doubts on the ability of an artist and, needless to say, this was reflected in the attitude of many art collectors.

Then I discovered the great English masters of landscape of the late 18th and 19th centuries: Turner, Constable, Singer Sargent and Whistler, who demonstrated the richness, brilliance and subtlety of watercolor painting and put it on a par with other mediums.

When my allergy to solvents prevented me from working in oils I turned to watercolors. I painted, striving for radiance and luminosity, for expressiveness of feeling and mood. I wanted to create watercolors that would be not dismissed as inferior to oils. I knew my works would not be anaemic, interior decorator's props, but paintings that would be strong and subtle, clean and luminous in their own right.

# ABOUT THE ARTIST

Boguslaw Mosielski is a Canadian artist. He was born in Poland in 1939 and received his formal education at the University of Warsaw, Faculty of Architecture. Shortly after completing his studies he moved to Canada and accepted the position of Design Director in a large corporation in Toronto. Throughout the years 1965-1974 he attended the Mary and Roman Shneider School of Fine Arts in Actinolite and Toronto, Ontario. A period of learning and exploring various forms of art followed. He achieved international recognition designing contemporary jewellery; created sculptures in metal and clay; pursued artistic photography, but above all, he painted.

Boguslaw Mosielski has won numerous awards for his art and has exhibited in Canada and abroad. Interviews with the artist and reviews of his work have been published in magazines, newspapers and produced for TV.

His studio is located in Barry's Bay, Ontario where he is inspired by the beauty of the Madawaska Valley and the Algonquin Park area, the land of lakes and rugged hills at the foot of the Canadian Shield. Here he gets his artistic stimulus and strength.

**6** ERASING PENCIL LINES AND MAKING SMALL CORRECTIONS
Making sure the painting was thoroughly dry I carefully erased visible pencil lines using a white plastic eraser for paper and film. The eraser should be used gently to avoid removing pigments and disturbing the surface of the paper. When the unwanted pencil marks were removed I examined and corrected small details — such as bushes, tree branches, hydro wire, etc. The masking tape was removed with great caution, because otherwise some tape will strongly stick to the paper and the surface may tear when the tape is removed. Next I remove the staples using a knife blade.

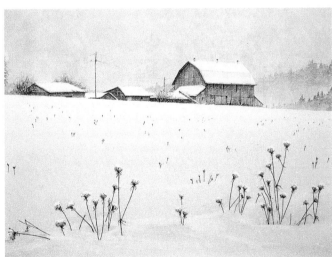

**7** FINISHED PAINTING "MASK'S FARM"
The mood of quietude was accomplished by using subdued blue colors that almost approach grayness. For this type of mood you cannot indicate the light source. There are practically no shadows, just slight, diffused darkening under the building eaves. The overcast sky — darker than the snow — has the discernible texture of a fluffy blanket, contributing to the feeling of calm and quietness. The snow has no texture, only vague modelling in the foreground. The weeds in the foreground, standing upright holding cups of fresh snow, also contribute to the sense of calmness.

# JOHN NEWBERRY REVEALS HIS SECRET SPEED

Here's your opportunity to tinker with a method that allows no second thoughts, no chance to change anything and no re-thinks back in the studio!

"PONTE SCAGLIGERE, VERONA", 9 x 13" (22 x 33cm)
This medieval bridge had very complicated levels and a variety of arches. It was painted against the light on a day with very high cloud.

To paint in watercolors outdoors and in one sitting, requires a fast, reliable technique. My subjects choose themselves, I never think twice about the composition. The only time I do not finish in one go is if the architecture is very complicated. When this happens, I complete the drawing in one day and return the following day at the same time for the painting.

I work at speed in the belief that everything then will flow to a unified whole. I think as fast as my hand will go, hoping that in the end I shall have a version that excites me as much as the view I am looking at. Thus, I am not trying to make "art": the art comes from the skill in using the medium.

There are no second thoughts, no chance to change anything and as a rule I never alter things back in my studio. Obviously this method has its disasters. Sometimes the picture is spoiled during the painting, sometimes it turns out to be dull when looked at later, but when successful, there is a drive and coherence that I cannot get in the studio working from memory and sketches.

continued on page 76

"PIAZZA DEL CAMPO, SIENA", 10 x 14" (25 x 35cm)
Wherever you enter the Piazza the sight is breathtaking. In this painting I tried to give the feel of the whole of this huge curved bowl of sunlight in late afternoon as the shadows crept across the foreground.

## WHAT THE ARTIST USED

### Support
140lb (300gsm) Not (smooth side), hand-stretched on thick card

### Brushes
Finest sable brushes
#10 round
#6 round
#3 round

### Other materials
Aquapasto thickening medium
Pencil and eraser
Cotton handkerchief as rag
Two water pots (one kept clean)
Something to sit on
Sharpened heel of brush
Finger or palm to control texture

### Colors

**T**his demonstration was done entirely on the beach, with changing light, changing tide, changing sky and with a variety of colors on the sea that moved and reflected the sky.

**1** CENTER OF VISION
These three drawings were done only for this demonstration. They show how important it is to know where the center of vision is in each picture and where you are looking throughout the painting of the entire scene. This picture includes about 140° wide angle, and it will have a different composition depending on where you look. Notice how the angle of the water's edge is very different in each drawing. Normally I do not do this type of analysis, nor do I consciously consider composition, but I do always draw in the eye level and decide on the center of vision. ▶

The palette is divided with a top row of dark tones and a lower row of lighter versions of similar hues. Thus Ultramarine Blue is above Cobalt Blue.

In each case the hues span the sequence of the rainbow from blue through to violet. The pigments are chosen for their permanence and to give an even range across the spectrum. In any one painting only a few pans are used, only those in color for this demonstration picture.

**4** DARKS AND FINISHING SKY
The darks were stated with a medium brush on dry paper. Different mixtures of Phthalo Blue and Caput Mortuum gave blue darks in contrast to the nearer hot darks with Alizarin Crimson Permanent and Quinacridone Gold. Any pure strong colors such as the blue on the boat were put in with as much intensity as possible.

When these darks and the blue cloud patches were both dry, I applied the second stage of the sky by painting a wash over the entire area using a very pale mixture of Cobalt Blue, orange and white. This was graded so that the top was slightly lighter. While this wash was still wet a damp cloth was pressed on to lift off lighter areas. A graded wash like this is most easily done with the picture upside-down so that paint does not collect along the horizon.

Finally, I concentrated on the boats, putting in as much detail as I can see and strengthening the darks. Details

# SPEED UP YOUR WORK

## 2 DRAWING

The only kind of drawing I do for a watercolor is a faint pencil outline to place the main areas. These lines disappear as the painting progresses, or may be rubbed out later if they become obtrusive in very light patches. In this example, the lines have been made darker than usual for emphasis.

## 3 MAIN AREAS AND CLOUDS

Graded washes with large brush and dry paper were used for the two big areas, sea and beach. The beach changes from mauve-gray in the distance to a stronger orange in the foreground in one wash, which is fairly dense with aquapasto added. Texture was obtained by pressing with the palm and drawing with the heel of the brush. Likewise the sea must advance from the horizon, changing from blue with increasing orange to make it greener. Aquapasto in the mix enabled lines to be drawn in to suggest waves and the breaking soft edges.

against the sky, masts and cabins were put in with fine brush. The picture was pulled together with darks in the waves and seaweed on the shingle. The waves breaking on the beach were tinted in Cobalt Blue with white, scraped through for fine touches of foam.

## 5 FINISHED — "BOATS ON THE BEACH AT DEAL", 9 x 13" (23 x 33cm)

The finished picture having taken about an hour to complete works in so far as the sharply tilted beach drives away into the distance. The boats sit on the skyline as dark silhouettes some way back. The sea recedes convincingly towards the distant cliffs and simultaneously out to the horizon and, above all, the alive sky is appropriate to the atmosphere.

"ARCHE SCAGLIGERE, VERONA",
9 X 12¾" (23 x 33cm)

"ARCHE SCAGLIGERE, VERONA",
9 X 12¾" (23 x 33cm)
The medieval family tombs, some with fantastic carved tabernacles above them, are in an enclosed courtyard with a wrought iron lattice fence around the outside.

# TURNING POINT

Having made the change from architecture to painting in my student days, my turning point came later in a visit to a gallery in Oxford, which was carrying some work. I was given an exhibition and a job by Kyril Bonfiglioli. This job became selecting, cataloging and mount-cutting for the gallery's annual exhibition of good 19th century watercolors. I studied paintings of all periods and styles while I cut the mounts and did the wash borders around them. I was able to hold exhibitions of my own work in the gallery once a year for many years and to build up a large circle of friends and customers.

"SYDNEY HARBOUR BRIDGE,
SOUTH PYLONS",
9½ x 14" (25 x 35cm)
This view across the road and rail bridge does not show any of the magnificent harbor far below, but I found standing next to the racing traffic high above the city trying to give the full impact of the two pylons and the great curved bridge of steel beyond, very exciting. Some of the texture came from pressing with the palm onto paint which was still wet.

continued from page 72

## HOW IT WORKS

To achieve speed my technique is, briefly, as follows. I sit on the ground with all my materials spread to hand. After a pencil outline I start in on the main dark areas, and if there are cast shadows I state them throughout the picture early on so that they are consistent with the position of the sun at one given moment.

Next, main patches of pure color, such as clothes, are put in, leaving the very bright sunlit areas to the last. The sky is usually painted in one go, wet throughout, to avoid any hard edges.

76

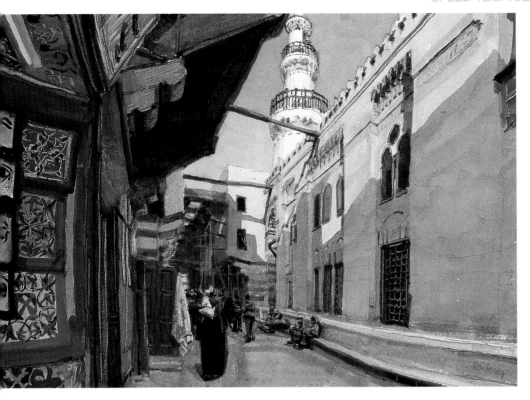

"MOSQUE OF MAHMOUD EL KURDI", 9 x 13" (23 x 33cm)
**This narrow street in Cairo was lined with shops where tailors sit to make the complex appliqué patterns of arabesques.**

## ABOUT THE ARTIST

I had started drawing buildings and painting landscapes at age seven. A scholarship to Cambridge University enabled me to study architecture for three years, but I changed to the degree course in Fine Art at Newcastle with Lawrence Gowing and Victor Passmore. Then in 1963, I began to teach drawing and life painting at the Ruskin School in Oxford and continued as a full-time Lecturer in Fine Art until early retirement in 1989.

During these Oxford years I exhibited there regularly and also in some of the London societies, but my election to the Royal Watercolour Society in 1989 gave me a London base where I could show pictures four or five times a year at the Society's Bankside Gallery.

Apart from the RWS, I have had solo exhibitions with several London galleries but my regular exhibitions are now with Duncan Campbell, Thackeray Street, Kensington.

A feature article on my work has appeared in *International Artist* magazine.

# TOM NICHOLAS SHOWS HOW TO INJECT IMPACT

You can have the best of both worlds
when you juxtapose transparent
watercolor with opaque gouache.

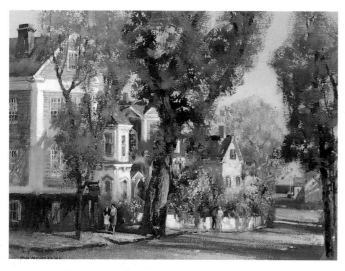

"SPRING, NANTUCKET", WATERCOLOR AND GOUACHE,
21 x 29" (54 x 74cm)
Using opaque gouache and a fan brush can really bring out the sense of
dappled light in a subject such as this. Notice how soft the gouache looks,
yet it still contrasts beautifully against the transparent passages.

I love the translucent quality of pure transparent watercolor, but
sometimes I like to balance it against a more opaque look.
I think the contrast of the two can often make a stronger
impact on the viewer.

For the first 15 years or so in my painting life, I worked
exclusively in transparent watercolor. Having always loved
drawing, transparent watercolor seemed the best choice for me
because it's the vehicle most closely related to drawing. As time
went on, however, in order to strengthen my watercolors and in
my desire to extend the medium, I began to work with oils.

Working with this opaque medium opened up a new world
to me. I have since applied what I've learned to watercolor by
sometimes incorporating opaque body color — called gouache
— into my repertoire. I use the transparent tube watercolors
for the early stages of the painting, then add more and
more opaque colors as the work progresses. In this way
I can leave or cover transparent areas if desired, giving
me greater options.

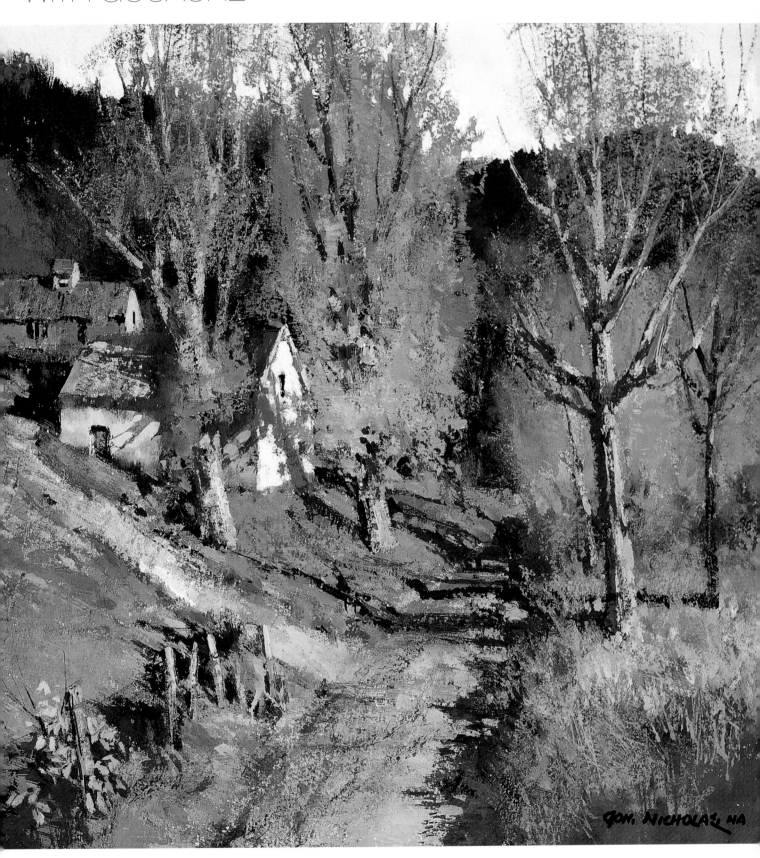

"HILLSIDE FARM, VERMONT", WATERCOLOR AND GOUACHE, 14½ x 20" (36 x 51cm)
An autumn scene like this in the hills of Vermont is filled with bright, rich, intense color. Here, adding a
touch of gouache to the final layers of the painting helped me capture that intensity.

I develop my watercolor/gouache paintings much as I would an oil painting, working from thin washes to heavy, opaque passages. Texture, color variation, shape variety and pattern are foremost in my thoughts. Above all, I constantly ask myself how to best express my priorities in order to put what I feel as well as what I see into the subject.

## WHAT THE ARTIST USED

**Transparent watercolors**
Cadmium Yellow
Raw Sienna
Cadmium Red
Burnt Sienna
Sepia
Cobalt Blue
Ultramarine Blue
Prussian Blue
Olive Green
Hooker's Green Dark
Ivory Black

**Gouache colors**
Raw Sienna
Burnt Sienna
Cobalt Blue
Violet
Cerulean Blue
Permanent White
Zinc White

**Paper**
17½ x 17½" (45 x 45cm),400lb (840gsm) Cold Press, taped to my board with heavy, 2" wide masking tape

**Brushes**
Both bristle and sable; rounds, 1"and 2" flats, a large wash brush, several fans

**Other material**
Painting knife
Sponges

**1** CREATING A LIGHT DRAWING
I began by covering my 400lb (840gsm) Cold Press paper with a wash of Ultramarine Blue and a pinch of Opaque White. Once dry, I used a thin stick of vine charcoal, sanded to a fine point, to block in my subject. Vine charcoal creates light lines that can easily be removed or adjusted.

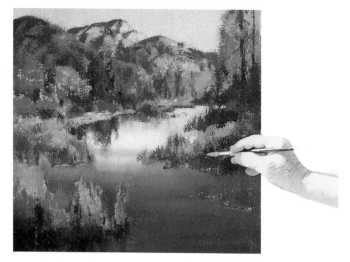

**4** STRENGTHENING THE STRUCTURE
Next, using a smaller brush and heavier paint, I gave the embankment more weight and texture and added slight reflections in the water. In observing the overall composition of values and shapes, I decided to strengthen the background, both through value and color, which gave it a more lavender cast.

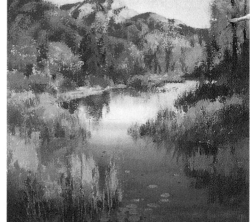

**5** ADDING SUBTLE DETAILS
In placing the lily pads, I took care to create a pattern and direction that would suggest a surface plane moving back in space. I continued working back and forth with color and value intensity, delineating more and moving the painting forward.

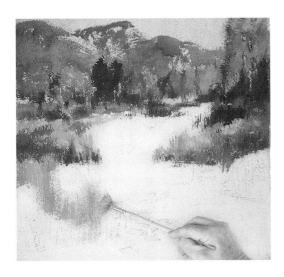

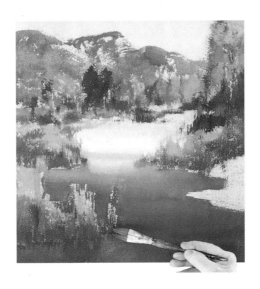

**2 SUGGESTING FORM AND TEXTURE**
Starting from the background mountains, I began to mass in the subject, being very concerned with the patterns and larger shapes. I used more opaque paint and a fan brush as I went along to suggest the textures. Note that I left the water area alone so that the embankments would come forward decoratively and comfortably. The strong vertical of the upper right corner gives stability to the receding composition.

**3 FILLING IN THE GAPS**
Switching to a flat brush, I laid down a gradated wash to suggest the marsh water moving back in the distance. As I moved forward, I tried to preserve the decorative character of the marsh grass. It's as if I were making notes at this stage that I would conclude later.

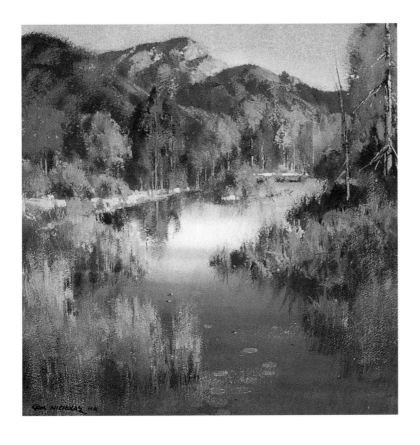

**6 MAKING FINAL ADJUSTMENTS**
To complete "October Marsh, Jackson Hole, Wyoming" I added tree trunks to the distant trees and adjusted the sky for greater luminosity.

Knowing when I'm finished really has to do with what my purpose is. Nature provides me with subjects, but I have to decide what I'm going to do with that subject. When I feel that what I've done expresses my feeling for the subject, and also says something about nature's characteristics, then I've completed the work.

"LOW TIDE, POLPERRO, ENGLAND",
20 x 28" (51 x 71cm)

Having lived on the US coast for the past 40 years, I've developed a particular fascination for low tide subjects. Coastal England was no exception. Following the large sky and water washes, I added my strongest darks and completed the painting with middle and light tonal values and textures.

## TURNING POINT

In 1960, while teaching for the Famous Artists School in Connecticut, I was asked to demonstrate for the Rockport Art Association in Rockport, Massachusetts. I did not know that trustees for the Elizabeth T Greenshields Foundation were in the audience. I was asked to visit them the next day, and they offered me and my wife Gloria an all-expenses-paid one-year traveling grant to England, France and Spain! Being an outdoor painter I painted on site nearly every day. Upon our return, we sold out my first solo show at the Grand Central Galleries, New York City, quit our jobs and moved to Rockport where we have had a gallery for more than 40 years.

"DUSK, HONG KONG", 20 x 14" (51 x 36cm)

Having experienced the hustle and activity of Hong Kong, this subject was a change of pace. Omitting a horizon line suggested an oriental screen. Then I chose to work with watercolor only to achieve certain effects. First, I established a graded wash from warm color to cool, top to bottom. To create the granulated texture of the water, I used a mixture of Raw Umber and Ultramarine Blue, which appears grainy on this hand-made paper. As I painted the junk, shacks, figures, reflections and so on over the first wash, I wiped out some areas to create the lightest values.

"VILLA D'ESTE, ITALY", 28 x 21" (71 x 54cm)
I don't always feel the need to combine gouache with my watercolors. With this subject, textural variation was my point, which I was able to achieve by applying transparent watercolor in a variety of ways with a number of brushes and other tools, such as a natural sponge.

Since becoming a professional artist nearly 50 years ago, Tom Nicholas has received a stunning 242 awards for his work, 38 of them Medals of Honor! He is a Signature Member of both the National Academy and the American Watercolor Society. He is as accomplished with oils as he is with watermedia, thus it's no surprise that he's been invited to hold 35 solo exhibitions in every region of the US.

A one-time student of the School of Visual Arts in New York City and a former instructor at the Famous Artists School in Westport, Connecticut, Tom now has work placed in numerous private and public collections, including the Springfield Art Museum, Springfield, Missouri; the Farnsworth Museum, Rockland, Maine; the Butler Institute of American Art, Youngstown, Ohio; the Greenshields Memorial Museum, Montreal, Quebec, Canada; the Hispanic Society of America, New York City, and many more.

He's currently represented by the Tom Nicholas Gallery, Rockport, Massachusetts; Robert Wilson Galleries, Nantucket, Massachusetts, and Sarasota, Florida; Argosy Gallery, Bar Harbor, Maine; Texas Art Gallery, Dallas, Texas and the Bay View Gallery, Camden, Maine.

# JULIETTE PALMER PRESENTS THE EXCITEMENT OF

Consider this process of delineating and separating random and varied masses to achieve a heightened reality.

M y aim is to conjure from simple materials a delectably seductive image that still carries the tingling excitement I felt at my first sight of it. I want to magic into being, a vivid and compelling reconstruction. To do this I employ my natural instincts, my learning, my alert sensibilities and trained observation.

If an in-situ painting is not possible (time, weather, situation) drawings or photographs set me on my way. In the studio, using pencil, water, pigments, brush and paper, I attempt to achieve my goal, first by making a basic drawing to establish the composition in the space available and work out convincing proportions and the perspective of the scene. Next comes the washing-in of color areas. Then the modeling of masses, the

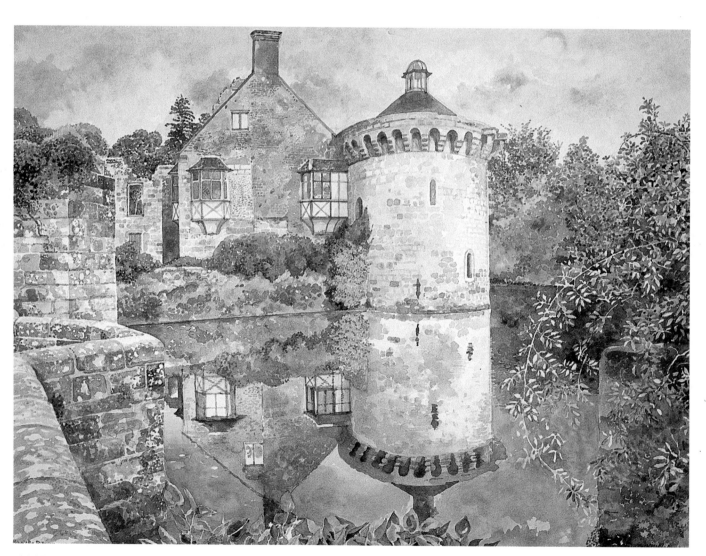

"SCOTNEY CASTLE MOAT", 22 x 30" (56 x 76cm)
In England in October, with warm mellow sunshine, there is more interesting color to be found in the foliage (Cadmium Yellow and Indian Red with Burnt Sienna in the greens). The limpid reflection gives a lovely blue (Cobalt Blue and Ultramarine Blue). The basic drawing is the key. Old walls with mottled lichens and mosses were all built up with round sable brushes. The trailing wild rose was painted in negative to reveal leaf and stem shapes in the remaining white paper. No resist was used.

# RANDOM MASSES

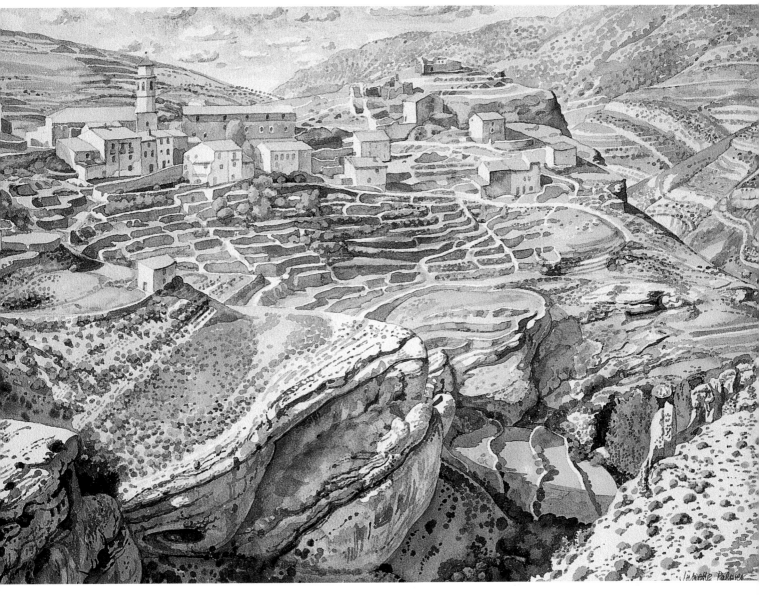

"CANADA DE BENATANDUZ", 16 x 22" (40 x 56cm)

building of tonal contrasts, gradations and emphases. I eventually reproduce a kind of heightened reality — the scene is slightly more ordered and sharpened.

In my demonstration sequence I draw attention to the working means of separating and delineating neighboring masses of irregularly growing plants, bushes and trees. I achieve these effects by the appropriate use of soft blendings of color running towards sharp edges.

I enjoy tackling an abundance of detail, indeed a complexity of components. If it is all natural growth I feel there needs to be some formal structural elements to counterbalance the seeming random waywardness of nature, or to hold the composition together, as do the arcade and steps in my demonstration garden picture.

Having been born and bred in the English lowlands, I am utterly fascinated by wild precipitous terrain and the ancient habitations it supports. There are amazing landscapes in Spain and I used a high key palette to suggest the blazing light, even though it was late afternoon. The blue (watery Indigo/Ultramarine Blue) shadows are long. They reveal the rugged relief of the scene, yet they are luminous because of the brilliance of the reflected light. As usual with my work, the drawing is the essential underlying factor.

**I**n this demonstration sequence I put wet, light colors onto dry paper. My paint application was generally transparent. I worked in smallish areas rather than big loose swathes. I did not make a big splash of wet-into-wet, but I did like the effect of colors or tones flowing together in small areas. I set out to capture the glory of a flowing garden. I intended to make sense of an abundance of growth. I consciously delineated and separated some of the crowded masses by emphasizing some divisions and extremities and modeled with my tones and colors to suggest volumes.

## WHAT THE ARTIST USED

### Brushes

#5, 6 and 7 round sable brushes

Paint box with double palette lids and pans refilled from tubes

Jars of water

Paper tissues

2B pencil

Soft eraser

Wax crayon

### Support

Hot pressed 260lb (410gsm) watercolor paper

### Colors

| | |
|---|---|
| Lemon Yellow | Violet |
| Cadmium Yellow | Ultramarine Blue |
| Naples Yellow | Cobalt Blue |
| Yellow Ochre | Prussian Blue |
| Indian Red | Cerulean Blue |
| Burnt Sienna | Emerald |
| Vandyke Brown | Sap Green |
| Cadmium Red | Viridian |
| Alizarin Crimson Permanent | Ivory Black |
| Magenta | Payne's Gray |
| Permanent Rose | |

**1** FREEHAND UNDER DRAWING

I began with a freehand drawing, scaled up by eye from my single or multiple 7 x 5" (18 x 13cm) photographs, observing the rules of perspective, or heightened perspective for drama. If the elements are not correctly placed or proportionate, the completed work will not be a convincing representation. (In the past I used to make a detailed drawing, of a manageable size, of my subject in site.) Later, in the studio, using enlarged photocopies, I traced the drawing over a light box onto my watercolor paper. I avoided erasures and dirtying of the paper, because this results in a more wooden drawing.

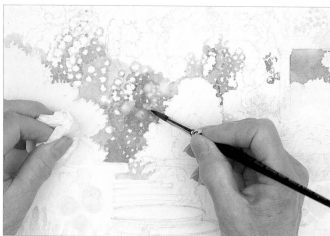

**4** LIFTING COLOR OUT

I had been too heavy-handed with an overall area of dark green and wanted to lighten it. With a brush wet with clean water, I worried away at the color and mopped with a tissue to lift some out. The soft smudgy look that results when you do this can sometimes be used to beneficial effect over larger areas, or to soften hard edges. Where my pencil drawing was too noticeable I could erase it later — even through dried paint!

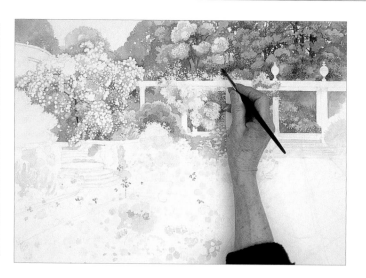

**5** DELINEATING SMALL MASSES

I enjoyed outlining the profuse white cascading rose sprays in palest apple and mauvey-greens, deepening to grayed Viridian. Then I pushed on with the dark background screen of trees. The cumulus of foliage was realized by brushing puddles of the lightest tone I would use, leaving white sky spaces between. Then I darkened around those cushiony areas to indicate shadowed depths. Likewise, I made other plant clumps lighter on the upper dome and darker underneath. Leaf shapes were outlined, running dark against light to affect an irregular roundness of the form.

**2** ESTABLISHING PART OF THE STRUCTURE

I began my painting wherever the fancy took me. I chose to paint a dark area of foliage lying behind the trellis walk, thus establishing the important horizontal grid. It was an easy start to fill in an area with restricted boundaries. I kept a sharp edge to the outer line (wet against dry) and a flow within, to blend color and tone (wet into wet). As it quickly dried I outlined leaf sprays in sporadic clumps with darker, varying color.

**3** WAX CRAYON RESIST

I was eager to paint the wonderful yellow climber on the trellis. It was fun to do. I used a children's wax crayon to draw the fluffy sprays. Pale green paint running to darker for the accented depths was applied gently, not recklessly. I was still thinking about the shape of the sprays and fine arching connecting lines where I left the paper white. Then I enjoyed picking out a dark area way behind that would throw the nearer clumps forward.

**6** COLOR MIXTURES

Were the dark trees too dark? It was difficult to tell when there was still an area of white paper. I placed the strong garden step shapes and continue to paint more plant groups. I contrived varieties of color. Some apparent greens veered to ochre, some to rust, others to blue, turquoise and lime. I needed clean water for the clear pure color of flowers. My pigments were Permanent Rose (for rose pink) and delicate red and orange, magenta, violet and crimson and their mixtures — delicious!

**7** OVERALL EFFECT

As I worked I kept the composition in mind — the main rhythms and connections and the overall balance of colors and tones. The completed picture is all abundance and profusion, spaced by more rigid lines. Even the diagonals of the paving hold the composition together. The foliage supporting the rose blooms was predominately light in color because I feared that dark, rich shadows and depths would have outweighed the summery, flowery impression that I wanted to convey.

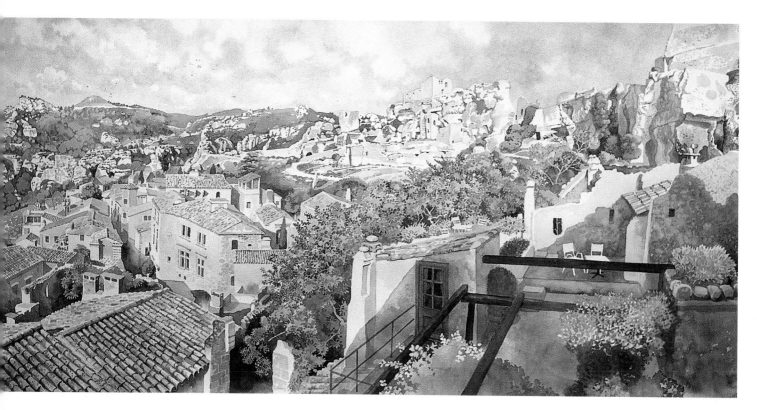

**"LES BAUX"**, 20½ x 42" (53 x 107cm)

I am elated when I view a panorama like this in les Alpilles, Provence, France. The view is of geology and history. I see the mined ore-yielding rock, the defending castle, the dependent village and its use today. The painting technique is just a patient, loving build-up of fresh paint, clarifying shapes with soft warm afternoon-lit colors (the sun behind me). I added a touch of Indigo in the shadows and for drama a vivid blue shadowed corner. Some light foliage was painted in negative, and some brought out with opaque Process White.

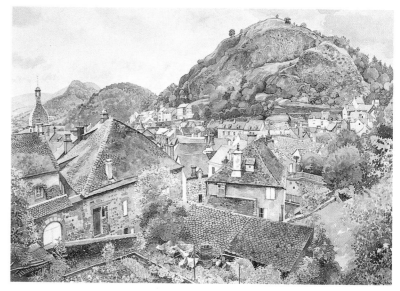

**"MURAT ROOFTOPS"**, 19 x 28" (48 x 71cm)

Another high view showing a complexity of buildings with dominant hills. This is a lush green landscape in the Parc de Volcans, Massif Central, France. The colors are cooler because of local materials like the blue slate roof tiles (lauzes). It was fun to put colors together to suggest the weathered stone materials. The perspective was allowed to tilt to give the feeling of looking down and being within the view. Some rich dark pencil was used to draw in the tile pattern. Once again there is an exciting undulating skyline. I observed the rule of simulating distance with paler, more watery colors.

## TURNING POINT

I have always been a draughtsman, painter and visualizer. It has been second nature for me to create images and play with a pencil and brush to reconstruct wonderful experiences. As a child in the 1930s, and growing up under the restraints of World War II years in southern England, I read and then wrote and illustrated stories to entertain sisters, friends and myself. I learned to draw all kinds of observed objects and

creatures with a fond curiosity. I first exhibited at age 15, with sketchbook pages of children, horses and cats at our local Art Club, where my father, an amateur, was a member.

After Art School and teaching, my first real work achievement, after a long period of disappointment, was getting my first children's book to illustrate, for Hamish Hamilton, publishers, London. Once started many others followed.

Becoming a mother was a setback for a short while, but another marvelous turning point came later, when Marni Hodgkin at Macmillan, London, welcomed my own book, after I had tried twelve other publishers. Five other titles followed that I conceived, designed, wrote and illustrated. This all gave me tremendous satisfaction, and boosted my self-regard.

"ALCALA", 18½ x 27" (48 x 69cm)
Spain again. An old town clings to the contours and a castle ruin perches on a pinnacle, providing an exciting skyline. I like to emphasize the height and depths. The flock of sheep was introduced from another photograph, taken in the same village, to sweep across the foreground and curve in a downward plunge. The sun does not always beat down hotly and here among the mountains the light is soft and the colors gentle. The blue of the shepherd's jacket contrasts with the muted terracottas, greys, ochres and greens.

## ABOUT THE ARTIST

Juliette Palmer is an elected Member of the Royal Society of British Artists. She studied at the South East Essex School of Art and the Institute of Education, London University. In the 1950s she worked as an art teacher, display designer and for a commercial art studio.

Since 1980 her paintings have been exhibited at the Royal Academy Summer Exhibition, and consistently at the Royal Society of British Artists; the Royal Institute of Painters in Watercolours; the New English Art Club at the Mall Galleries, London; the Royal Watercolour Society at the Bankside Galleries, London and the Royal West of England Academy in Bristol. Her work has been repeatedly selected in major National Competitions. Her awards include the Laing Painting Competition in 1996; the Travel Prize, Royal Watercolour Society in 1996 and the St Cuthbert's Mill Prize, Royal West of England Academy in 2000.

She was Director of the Woburn Festival Visual Arts Exhibition from 1996 to 1999 and again in 2001.

Juliette has exhibited in solo and group shows in many commercial galleries in Britain, USA, Japan and she keeps a quantity of work for viewing at her home/studio.

An article on her work appeared in *International Artist* magazine.

# HERMAN PEKEL SHOWS YOU HOW TO SIMPLIFY

You don't need more than two washes to capture the statement, shapes and tonal values.

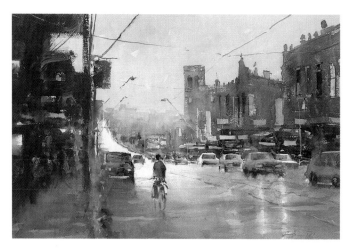

"WET DAY CAMBERWELL", 22 x 30" (60 x 76cm)
Wet street scenes always appeal to me because of the reflected lights from cars, neon lights, and so on. This painting has a fairly strong composition with a large dark on the left. My main inspiration for this painting was the movement.

I believe watercolor has some wonderful attributes. I also believe the most important thing in a watercolor is simplicity of technique. Most students and amateur watercolorists just try too hard even after the painting is almost lost. The hard part for me is always before I start. An essential technique in watercolor is to have no more than two washes. This gives clarity of statement, shapes and tonal masses. I like to look at my paintings and see exactly where the brush has been.

A lot of students and beginners will go over the one brushstroke numerous times. Instead, I think if you establish a design and a reason for the painting prior to commencement the work will ultimately be a lot more powerful. In some mediums, for example, acrylics, a painting can evolve and just happen. But for watercolors it is the exact opposite. If I don't have a precise idea of the work then I almost try and visualize the painting before I start. In fact, sometimes the image is so clear I can actually see the finished work on blank paper. These ultimately become my best works because everything is resolved.

I see painting watercolors a bit like driving a motor vehicle. When you first learn to drive a car you are so concerned with not crunching gears. You are so preoccupied with the brakes, the steering wheel, and so on, that you lose sight of the most important thing — the traffic! Applying this idea to watercolor once you get over the technical hurdles, such as design, tones, shapes and color, you can deal with things that really matter — passion and emotion!

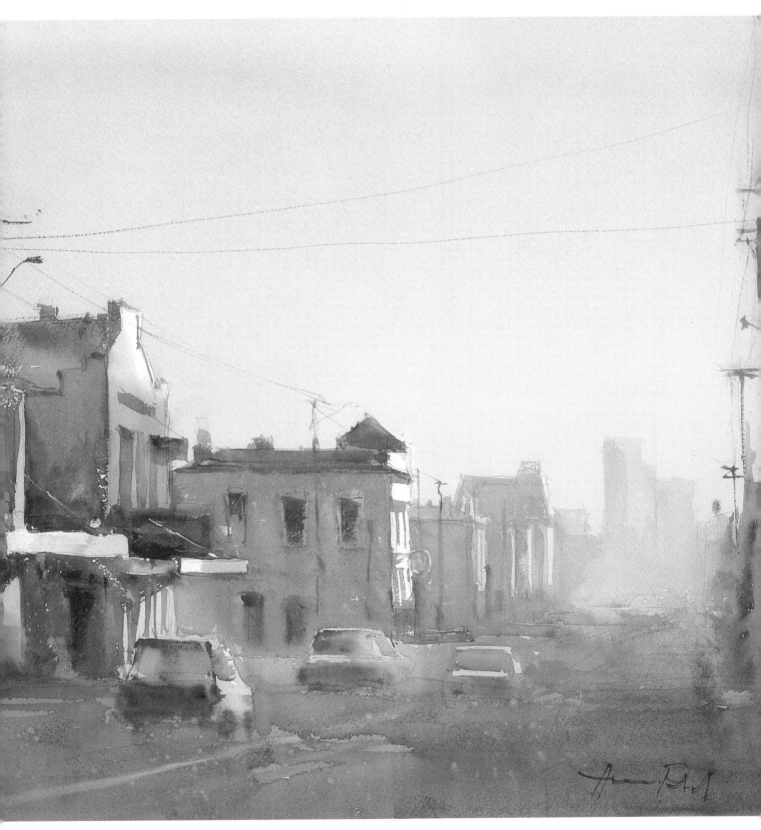

"JOHNSTON STREET", 22 x 30" (60 x 76cm)
This painting is about light and atmosphere just as the sun sets — an artist's favorite time to paint.

## WHAT THE ARTIST USED

**Support**
Saunders 300g rough
(full sheet)

**Brushes**
1 mop brush
1 large rigger

**Colors**

ALIZARIN CRIMSON PERMANENT | CERULEAN BLUE | ULTRAMARINE BLUE | VIRIDIAN | RAW SIENNA | BURNT SIENNA

### 1 MAKING A START

I started off by drawing lightly in 4B pencil but lately I find I have been using a large rigger with a neutral non-staining color to draw. I also find I can draw better with a brush than a pencil. I was very conscious of the main shapes.

I put on plenty of Cerulean Blue sky color, starting from the top and blending into the green, Raw Sienna and a touch of Viridian. I also tried to leave accidental white areas which the paint didn't cover. (They usually turn out to be houses.)

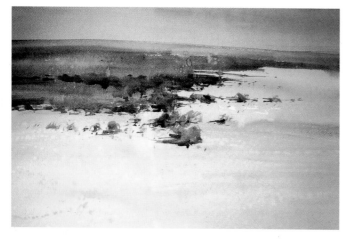

### 4 CREATING TREE SHAPES

As I worked forward I used a little bit more dry-brush to create interesting tree shapes.

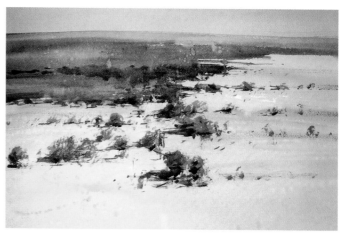

### 5 LINKING THE DARKS

Most of the trees were painted. I linked these with shadows. It always helps if you can link the darks.

**2** ONE COMPLETE WASH
The whole sheet was covered in one clear wash. I always let this thoroughly dry.

**3** INTRODUCING THE HORIZON LINE
Once the paper was dry I used Ultramarine Blue and a touch of Alizarin Crimson Permanent to create the background to the horizon line. As I worked forward into the painting I added more Raw Sienna. Again, I was very conscious of the shapes.

**6** INTRODUCING THE FOREGROUND SHADOW
Using the large brush, I put in the foreground shadow to unify the painting.

**7** FINISHING OFF
With thicker paint, predominantly Ultramarine and Raw Sienna, I added the foreground trees and then added darks as thick as cream just before the trees dried.

Adding the tree in the foreground on the left provided a strong vertical against all those horizontals. This painting has a definite foreground, middle ground and background.

"HIGH STREET ARMADALE",
22 x 30" (60 x 76cm)
In this painting there is no light at
all except for the car lights. I think
the most important part of this
painting is the silhouette between
the buildings against the sky.
Without that hard edge, the painting
would not work. The telegraph
poles were painted in one stroke.

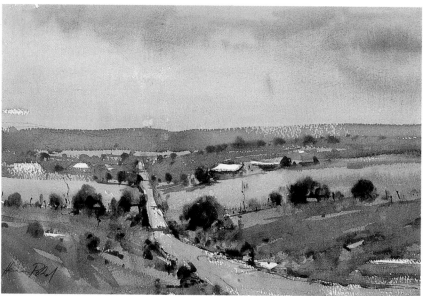

"THE ROAD TO JUNEE", 15 x 22" (38 x 60cm)
This little sketch was painted on site whilst traveling
to Bathurst with Joseph Zbukvic and Alvaro
Castagnet (both featured in this book). I think the
road in the center creates a powerful composition.
I try to find a reason for painting. For example, color,
mood, light, and so on, except this one; we were sick
of driving and just needed a break. But I think it still
works.

## TURNING POINT

My turning point began when I was 10 when
I won a painting contest at Eastland Shopping
Center.

While undertaking a Fine Arts Degree at
Phillip Institute of Technology, I was brought
into close contact with such artists as Dale
Hickey, Jeff Makin and Clifton Pugh which
helped me cultivate an appreciation of
contemporary art and experiment with
abstract impressionism while still focusing
on realist urban landscapes. This influence is
still seen in my work today. I consider this

also a turning point in my career as it gave me
another style to consider.

I hope my paintings are not just
illustrations but reflect a deeper insight into
the subject. Some of my paintings may reflect
the beauty that I see in nature and the passion
of using paint whether transparent watercolor
or opaque oil paint. A painting with integrity,
well done, speaks for itself. In order to do
well one must be totally passionate about
medium and subject!

## ABOUT THE ARTIST

Herman Pekel was born in
Melbourne, Australia in 1956
to Dutch parents.

As a child he would hop
on his bike and accompany
local artists such as Roger
Webber and Ernest Buch-
master out on painting trips.
He can remember painting out
on location with these artists
and knew even then at the
age of 13 that he wanted to
be an artist. "The smell and

"STUDY IN PURPLE & GOLD NEAR CANBERRA", 22 x 30" (60 x 76cm)
The painting was done on site, whilst driving from Canberra to Melbourne. This painting relies very much on light and color and the patch of sunlight on the far bank.

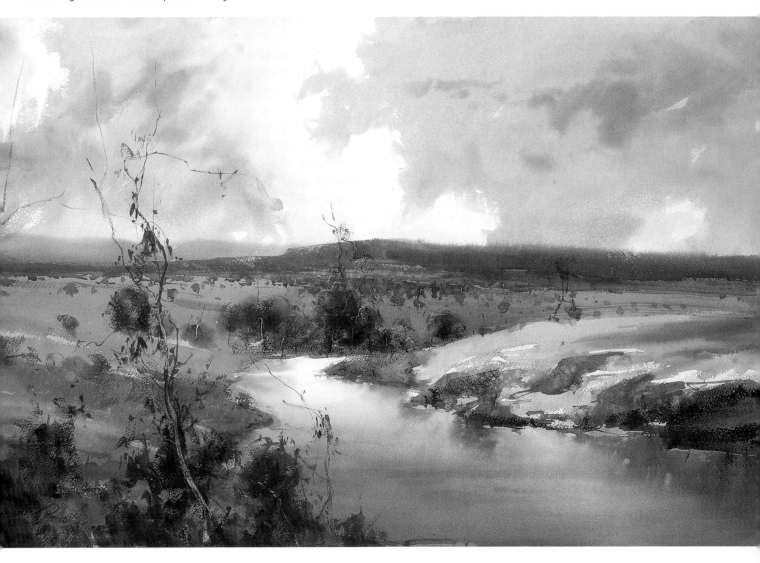

feel of my first set of oil paints was one of the most exciting moments of my childhood, and then to paint on location in early spring was beyond comprehension!"

Herman showed a prodigious talent, winning his first major art award in 1973 at the age of 17 and continuing to win awards with almost monotonous regularity since then.

In 1981 Herman obtained a Fine Arts Degree from the Phillip Institute of Technology.

Herman has won the much coveted Camberwell Rotary Watercolor Prize in 1995, 1993 and 1989 as well the Camberwell Travel Study Scholarship in 1989. As well as these notable prizes Herman has won approximately 90 awards.

His works are featured in the books "Australian Impressionist and Realist Artists" featuring Australian Artists and compiled by Tom Roberts and "120 Years of Watercolourists" by the Australian Realist Artists. His work has appeared many times in *Australian Artist* and *International Artist* magazines.

Herman's works are represented in many private and corporate collections throughout Australia and overseas.

# EXPERIMENT WITH VIVIAN RIPLEY'S GESSO UNDER

## Here's how to create edges, rich color effects and restore the light!

I love to paint the landscape because I am truly a lover of the outdoors. I am also a lover of watercolor, and as such, I like to try different approaches, including various papers and surfaces and ways of applying the pigment. Since I'm not content to paint in a non-evolving style, this experimental attitude keeps me growing and developing.

Although the paintings shown here illustrate a variety of different approaches, I especially enjoy painting on a watercolor paper coated with one application of acrylic gesso. Since watching Don Getz do this a few years ago, I've used this technique many times and learned some helpful pointers. For example, I never paint wet-in-wet on a gessoed surface. In general, my painting applications have a minimum of water. The ratio of water to paint remains about the same throughout the process. Also, I always use soft brushes such as sable or part sable and part synthetic. This allows me to make one or two strokes and have the paint adhere. Varying the pressure on the brush (mostly keeping it light) proves beneficial as well. Too many strokes or using a stiff brush will lift up any paint underneath, although there are times when I want to lift the paint to restore light areas. On the gessoed surface, I've found I can create a variety of edges, even in the areas where paint has been removed, and I can achieve some rich color effects, even with a limited palette.

In spite of my experimentation with various approaches and techniques, I am constant in my adherence to the importance of light and shadow in the composition and the use of unique color and color combinations to achieve my goals.

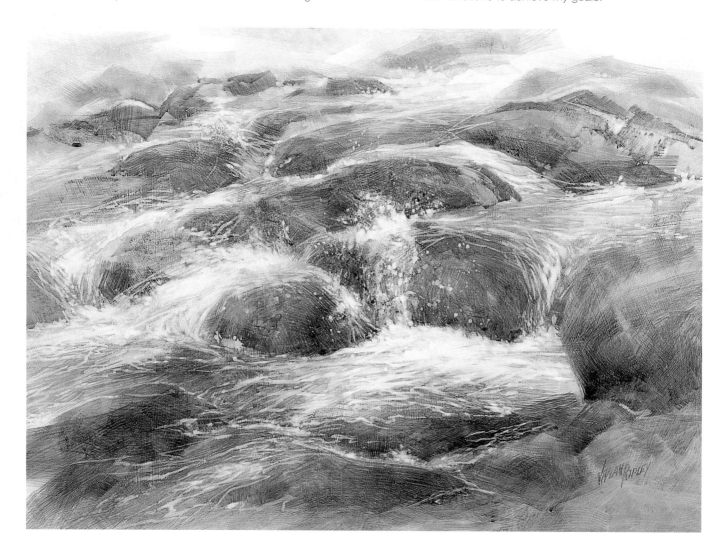

# PAINTING METHOD

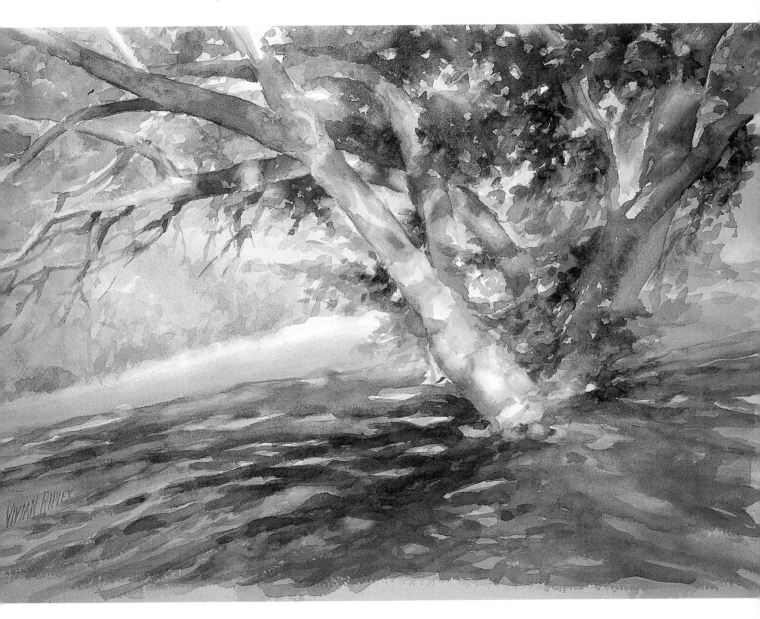

(OPPOSITE) "SERENITY II", GESSOED WATERCOLOR PAPER,
14½ x 21½" (36 x 55cm)
Inspired by the moving water of a mountain stream in the Great Smoky
Mountains, I wanted to achieve depth in the picture plane with the water
flowing toward the viewer. Water spray and highlights were lifted from the
gessoed surface. I am especially pleased with the transparency I achieved
in this top award winner at the La Cloche Art Show in Ontario.

"SUMMER SHADOWS", 300lb (638gsm) COLD-PRESSED PAPER,
14½ x 21½" (36 x 55cm)
I was fascinated by the light and shadow pattern created by this rather
ordinary tree near my home. I wanted to create interesting colors in the
shadows while achieving depth. Colors were mingled and layered in this
approach, basically wet-on-dry.

# ART IN THE MAKING WORKING WITH A GESSO UNDERPAINTING

I am intrigued by the colors seen through moving water of various depths as it rolls over rocks on a lake or river bed. I thought the gessoed surface would be perfect for this kind of scene since the areas of white or extreme light can be lifted out of the washes.

## WHAT THE ARTIST USED

**Support**
Strong 14¼ x 18¼" (36 x 46cm) watercolor paper covered with one coat of acrylic gesso applied with a 1½" flat nylon brush and allowed to dry thoroughly

**Brushes**
1½" flat; 1" flat; ½" flat; #12 round; #4 round

**Other materials**
Paper towels
Old toothbrush for spattering
Small, flat scrubber

**Colors**

QUINACRIDONE GOLD | ORANGE LAKE | PERMANENT VIOLET BLUISH | ULTRAMARINE BLUE DEEP | SAP GREEN | BURNT SIENNA

**1 STUDYING THE REFERENCE**
I took this reference photo at the far western shore of Manitoulin Island, Ontario, in Lake Huron where waves often crash on massive rocks near the Mississagi Lighthouse. The area is a favorite place for me — unspoiled and often isolated. I liked the subject I found, but I thought I could capitalize on the colors just hinted at in the reference and I wanted to show more movement in a diagonal layout.

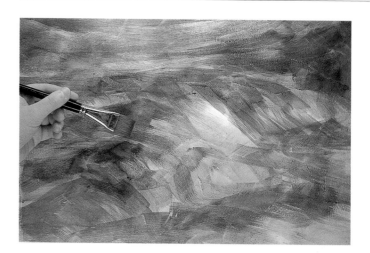

**4 CREATING A BASE OF RICH COLOR**
Using a 1½" flat and then a 1" flat, I layered in Quinacridone Gold, Orange Lake, Sap Green, Ultramarine Blue Deep, Burnt Sienna and Permanent Violet Bluish in that order from roughly light to dark. As I painted, I was thinking where my darks would be and of what hue. I used small amounts of water and if one color went over another completely, I allowed the initial layer to dry first to preserve transparency. Strokes were quick and free.

**2 MAPPING VALUES AND DIRECTION**

In a quick, small value sketch, I just indicated the placement of the darks. I wanted to stress a dark diagonal from upper right to lower left, while allowing the water to travel from upper left to lower right.

**3 GETTING STARTED**

Just for the purposes of this demo, I first indicated the main forms with Raw Sienna lines painted with a rigger, although I could have used any color. These painting lines will disappear with the first layers of paint.

**5 DANCING WITH LIFTED TEXTURES**

In this step, I utilized several fun techniques. I lifted or pulled out lights through the painting by slightly dampening one of several tools — toothbrush, #12 round, #4 round, ½" flat or scrubber — and lifting out the paint to varying degrees. I also dragged rough paper towels across a few areas lightly spattered with a damp toothbrush or a brush. Sometimes, I even used my fingers to smear a damp stroke and create movement. While creating all of this texture, I also established the forms.

**6 SHAPING WITH ACCENTS**

In this final step, I used Ultramarine Blue Deep, Burnt Sienna and Permanent Violet Bluish to create the darkest areas, to finalize the forms and to establish depth. Each color was painted with one or two strokes, only over dry pigment underneath. To create soft edges, I used a light pressure on the brush. Then, once again, I pulled out a few lights with the #12 round and the ½" flat or scrubber to reshape some of the water movement. I accented small light areas with Quinacridone Gold. When finished, I particularly enjoyed the color vibrancy and combinations created with this limited palette work that I called "Breakers".

"SAINT PAUL CIMETIERE, FRANCE", GESSOED WATERCOLOR PAPER,
14¹/₂ x 21¹/₂" (36 x 55cm)
Exhibited at the Ohio Watercolor Society Traveling Show, I painted this on location in September, 2001, just outside the cemetery gate where Marc Chagall is buried. I was intrigued by the bright light emanating from within the cemetery, which sits on a hill with the Mediterranean in the background.

## TURNING POINT

One of most rewarding experiences of my career was the month I spent as Artist-in-Residence at Harper's Ferry National Historical Park in August, 1999. It was quite a luxury for me to have the opportunity to paint free of other responsibilities, where I could take time to let paintings evolve as well as immerse myself in the rich history of the area and feel a real connection to the national past. I completed seven paintings there in several different media. Of course, I returned home with much reference material for future works. I highly recommend the residency programs in the US national parks.

A second transformative experience was a two-week painting trip to southern France in September, 2001, with a small group of fellow artists from Ohio. Painting became an absolute necessity to our wellbeing as we heard of and experienced the September 11 tragedy. We worked mainly on location in Renoir's garden and in the towns of Mougin and Saint Paul. It was a wonderful, rewarding experience among a very caring people. We all felt renewed by our unique painting experience in a very safe environment.

"ROCKS AND WILLOWS", GESSOED
WATERCOLOR PAPER, 14¹/₂ x 18" (36 x 46cm)
This is a free and loose interpretation of a drawing I did outside. I decided to use only three colors (Winsor Violet, Cerulean Blue, Cadmium Yellow Lemon) and liked the hues I achieved as I followed my darks and lights. This was exhibited at Watermedia 2003 in Houston, Texas.

"GREAT MOUNTAIN LAKE", 280lb COLD-PRESSED PAPER, 17$\frac{1}{2}$ x 23$\frac{1}{2}$" (45 x 65cm)

Great Mountain Lake is located in the La Cloche Mountains of the Killarney Provincial Park in northern Ontario. It is known for its beautiful clear water and this picturesque sheer, shimmering quartzite cliff from which vast vistas provide a feast for the eyes. I've made several trips to this lake via several lakes and connecting portages with this master backwoodsman and friend pictured in the canoe. The work includes several techniques: wet-in-wet, wet-on-dry, much glazing in the forest areas, dry-brush, some calligraphy on the cliffs and a small amount of masking for the canoe and sun sparkles on the water. A cool temperature pervades, but I wanted some warmth visible in the quartzite and surrounding shadows in this painting exhibited at the Ohio Bicentennial Watercolor Show. I hoped to create a feeling of wonder about this wild and remarkable place.

## ABOUT THE ARTIST

Vivian Ripley is an accomplished artist of quite varied subject matter. Yet, inherent in all of her works is the beauty and emotion of color and how it is affected by light and shade. She works in watercolor, pastel, acrylic and colored pencil, sometimes combining media.

She currently makes her home in Columbus, Ohio, but grew up in Cincinnati, Ohio, with an intense interest in the arts. After earning an advanced degree in piano performance, she added a very serious involvement in the visual arts. She has been professionally active in both group and individual shows, regional and national, since 1975. Some

of them include: the Ohio Bicentennial Watercolor Show, the Ohio Watercolor Society's Traveling Show, Watermedia 2003, National Oil and Acrylic Painters Society, Pastel Society of America, Pastel Societies of North Florida and the West Coast, New England Fine Arts Institute and the La Fond Galleries National Pastel Competition. She is a Signature Member of the Central Ohio Watercolor Society, the Ohio Watercolor Society and the National League of American Pen Women.

Painting on location is particularly rewarding to this artist. "The whole body and its senses are involved with nature

because of the urgency to depict an ever-changing scene," says Vivian. A favorite area is Ontario, north of Georgian Bay, where the artist travels at least twice yearly. In July, 2001, Vivian was Distinguished Artist and Juror for the La Cloche Art Show, Whitefish Falls, Ontario, a show she has been involved with since 1982.

Vivian is represented by Sudbury Art and Frame, Sudbury, Ontario, and The Michael Orr Gallery, Columbus, Ohio. Her paintings are in collections in the United States, Canada, France, England and Japan. To see more of her work on the web, please visit www.artinview.com.

# BOB RUDD SAYS NATURAL PAINTINGS DON'T HAVE

By mixing the natural with elements of interpretation you can enhance the drama of the landscape.

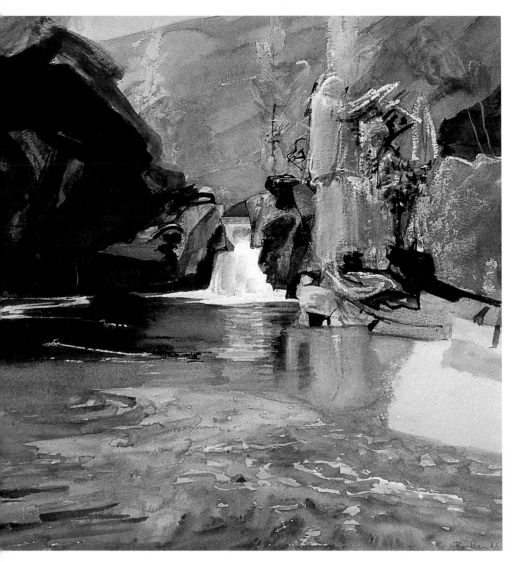

"ROCKY POOL, RIVER PATTACK, SCOTLAND", 21 x 21" (53 x 53cm)
I enjoy compositions that are at first glance symmetrical but which have tension created by the differences from side to side. The cascade almost divides the subject in half. Chinese white was painted straight from the tube and also mixed to make opaque color and texture in the rock face on the right. Black Indian ink was used on the left. Gentle diagonals in the water and at the top of the painting connect the two sides. I couldn't resist painting the river exactly the way it was.

L andscape can be amazing and I am inspired to paint from it over and over again. My aim is to capture the essence of a place and the excitement I felt when I was there.

I find it easier to consider the painting away from the subject. I work in the studio in sketchbooks and on the final painting from photographs and drawings made on location. Nature and formal ideas about the image I am going to make are the stimulus for the painting. The painting is a portrait of a particular location but is, at the same time, autonomous with a life of its own.

The artist has to contend with small scale, and a tonal range on the two-dimensional surface, which is only a fraction of that in nature. In an effort to compensate I try to make as much contrast and variety as I can with the materials and means available. I use color strongly and choose from about 100 pigments. Black Indian ink and white unpainted paper mean I can achieve the maximum range of tone. Using watercolor with varying amounts of water and different kinds of brushes helps to produce a range of marks and treatments. I contrast naturalistically rendered passages with loosely interpreted and freely invented ones. My concern is to make images with as much impact as possible. The unexpected juxtaposition of elements and treatments or the irrational mark can be an aid.

# TO BE PREDICTABLE

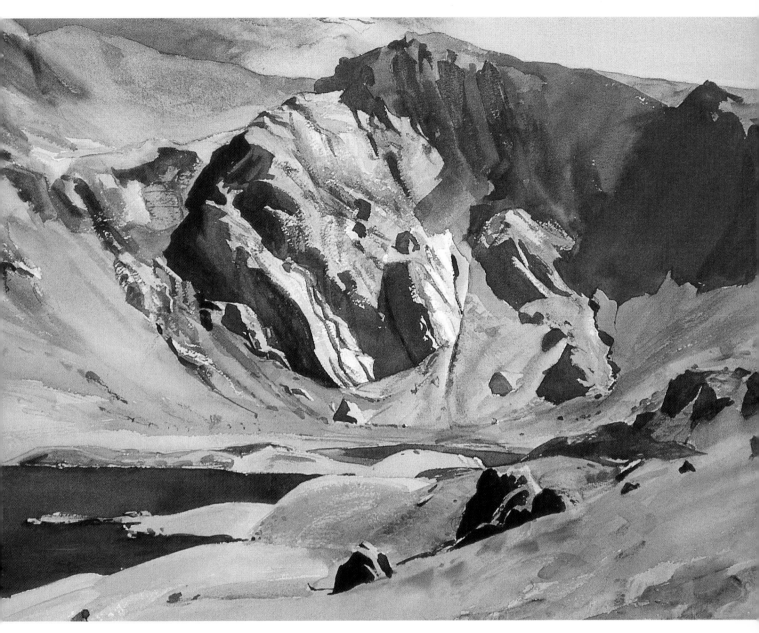

"GLYDER FAWR, SNOWDONIA", 21½ x 29½" (54 x 74cm)
The landscape is all around and it is often hard to find a view that represents the whole. Here the sweep of ochre on either side hints at the big U-shaped valley beyond the picture frame. The view was stunning and I tried to record the forms and quality of light by careful observation of tone. The rock forms seem to cascade down the mountainside in front of the viewer, while the water looks mysterious and solid.

## WHAT THE ARTIST USED

### Support
100% cotton acid free watercolor paper, 21½ x 29½" (53 x 74cm) 300lb (638gsm), Rough

### Brushes
Round finest Kolinsky sable, #4 and 6

Round sable and prolene blend, size 18

Flat Chinese bristle varnish brushes, 1" and 2" wide

### Other Materials
Several white porcelain and plastic palettes

Lots of white tissues

Masking fluid applied with a rubber tipped Shaper and old brush

Indian Ink

Five large glass water pots

Natural sponge

### Colors
Cobalt Blue

Cobalt Blue Deep

Cerulean Blue

Ultramarine Blue

Indanthrene Blue

Cobalt Turquoise Light

Viridian

Cadmium Yellow

Yellow Ochre

Gold Ochre

Quinacridone Gold

Winsor Orange

Bright Red

Light Red

Venetian Red

Brown Madder

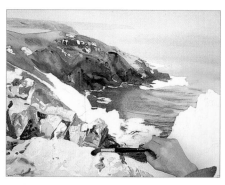

ONE OF MY SCENE PHOTOGRAPHS

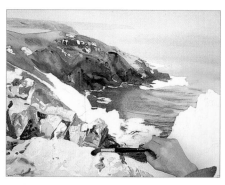

#### 4 DROPPING IN COLOR
As the preliminary wash was drying, Cobalt Blue, French Ultramarine Blue with Viridian and Cobalt Turquoise Light were dropped in. In the near sea the colors were laid next to one another on dry paper and allowed to merge. I often used a tissue to remove excess color or soften an area.

#### 5 WORKING WITH STRONG, BRILLIANT COLOR
The headland was painted mainly wet-in-wet in one process, but I added drawing and texture as the paint dried. While trying to describe the form I was also working as freely as possible with attention to mark making and quality of the surface. I used a large number of pigments for their qualities of brilliance, transparency, opaqueness as well as color. These were Yellow Ochre, Gold Ochre, Light Red, Venetian Red, Quinacridone Gold, Raw Umber, Indanthrene Blue, Cerulean Blue and Brown Madder.

#### 6 CREATING TEXTURE
The use of masking fluid and dry-brush watercolor created texture in the lighter areas of the rocks. I painted the abstract shapes as accurately as possible. If you get this right rocks appear as if by magic.

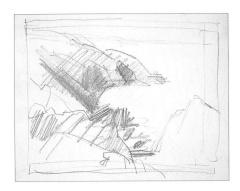

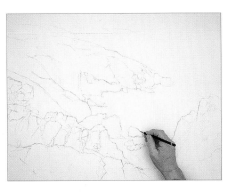

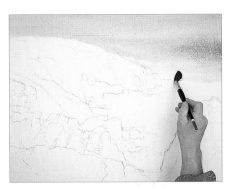

**1** CHOOSING THE BEST COMPOSITION
Thumbnail sketches were made in the studio from my photographs. These drawings explored the dramatic possibilities of the subject and helped me to decide on the overall composition. I selected this view because I liked the way the foreground rocks jut diagonally upwards and the cliffs beyond sweep in the opposite direction. These thrusts contrasted against the flat sea make a strong image.

**2** TRANSFERRING THE SKETCH
Having chosen my composition I made an accurate and detailed pencil drawing working from several photographs. I referred back to the sketch regularly to remind me of my original idea. I paid particular attention to the details in the foreground rocks.

**3** THE FIRST WASH
Initially I like to work on white paper on one area at a time. My goal was to paint at full strength, doing as much as I could in one session. I used masking fluid to define the shape where I needed to concentrate on controlling the large washes for the areas of sea and sky. I wet the paper at the top in order to give myself time to paint them. The first wash was a mixture of Cobalt Blue and Bright Red.

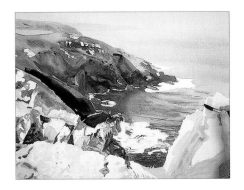

**7** ADDING THE ELEMENT OF SURPRISE
It was essential for me to let the painting evolve stage by stage and not attempt to visualize the final solution. The painting was beginning to look predictable and to counteract this I introduced the slash of Cobalt Blue deep and black Indian ink. The clean yellows and diagonal bands of color on the right gave sparkle to the picture and contrasted with the treatment of the other nearby rocks.

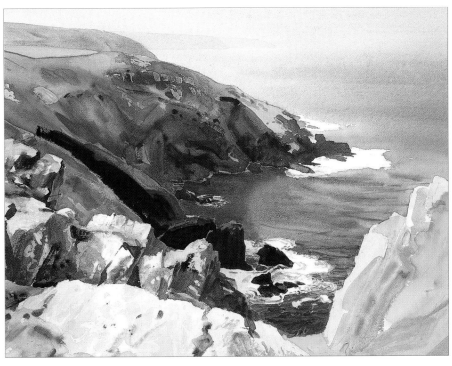

**8** FINISHING OFF
The foreground was completed using blues and mauves, to connect the new strong blue into the color scheme. The strength of the composition depended on balancing all the formal elements in the final stages and took a long time. The orange cliff on the left, for example, was too strong against the other bright colors and had to be reduced. In this case, many of the early washes in the sea and far cliffs survived virtually unaltered into the finished painting. On the other hand, the middle distance on the left had several modifying layers. I called this "Robin's Rocks, Cornwall".

"WHITE SPOUT, GLEN NEVIS,
SCOTLAND,"
*21½ x 29" (53 x 74cm)*
The drama of this landscape is intensified by the contrast of the shimmering, brightly lit foreground and sombre mountains beyond. This change of mood is repeated in the sky.

The eye is swept into the painting by the river to explore the middle distance, waterfall and mountains. The touch of yellow on the left lifts the picture and helps to direct the viewer on the journey around the painting.

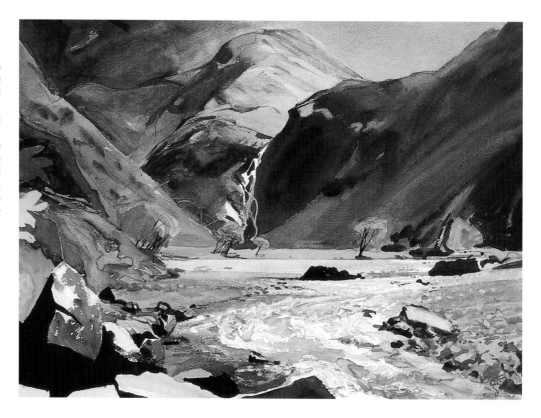

"ENGLISH WATER MEADOWS", 21½ x 21½" (54 x 54cm)
I wanted to capture the atmosphere of a hot mid summer's day in the Wiltshire countryside. The mass of trees looked heavy and dark against the sunlit vegetation that surrounded it.

Some textural drawing was applied in masking fluid at the beginning. Large areas at a time were painted wet-into-wet and added to as the paint dried, producing a range of hard and soft contrasts. After the masking was removed these areas were colored in to make accents and focus the painting.

## TURNING POINT

The way I paint is to an extent, a result of looking back at my sketchbooks some 20 years ago when I started to explore watercolor. This work was, and still is, produced as a kind of doodle, almost unconsciously, while thinking about an idea or searching for compositional possibilities. The most important thing I learned about it is that nothing matters, and that anything might happen when painting with watercolor. I am not making finished work. I can make as much mess as I like and am free to follow my hunches, however unreasonable. These sketches, I discovered, were often exciting and stimulating. This made me realize how important the unconscious mind is in the process of painting. As a consequence I trust my intuition more and am not so afraid of following my feelings even when they seem irrational and there is a risk of losing everything.

106

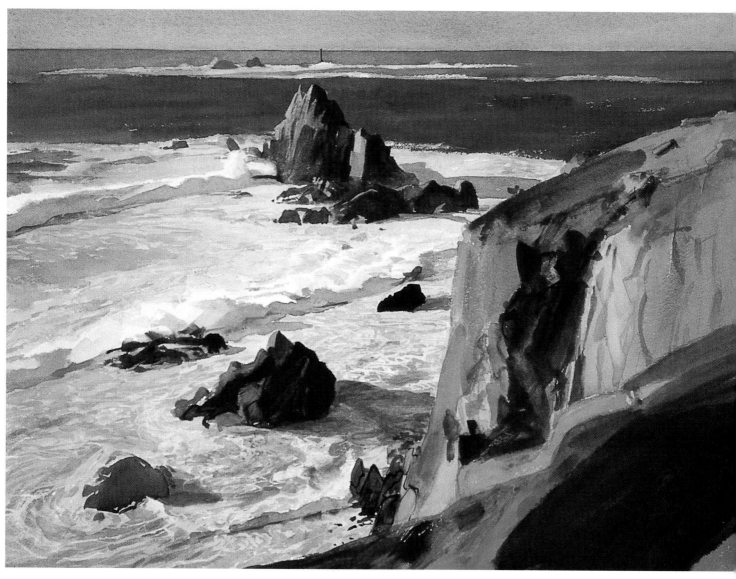

"SURF AT LAND'S END, CORNWALL",
21½ x 29½" (54 x 74cm)

Warm colored rocks in the cool sea and blue in the near cliffs help to connect the two. The waves echo the diagonal slopes of the cliff top and foreground. The painting needed these connecting elements to make a unified whole. It also needed contrast, not only to articulate passages, but also to add tension and interest. In this painting the naturalistic depiction of the surf was contrasted with the freely painted cliffs. The splash of red in the foreground adds vitality to the picture.

## ABOUT THE ARTIST

Bob Rudd was born in Suffolk, England in 1944 and he studied at the Bath Academy of Art between 1969 and 1973. He became a member of the Royal Society of Painters in Watercolours in 1995. He now lives and works in Wiltshire.

He has exhibited extensively at galleries in London and throughout the UK, including solo exhibitions in London, Edinburgh and the Isles of Scilly, collecting prestigious awards along the way.

His work is displayed in private and corporate collections including the new parliamentary buildings in Westminster and the House of Lords.

# HOW JEAN UHL SPICER USES COLOR FOR MOODY

Nothing sets a painting apart like a clearly communicated mood. The good news is that mood is easily achieved with the right colors.

"WINTER BLUES, PENNSYLVANIA", 14 x 21½" (36 x 55cm)

Here, I wanted to capture the sensation of bright sunshine falling on a cold winter setting. I wanted you to hear the air crackle. Working on a piece of dry Cold Press paper, I painted a light wash of yellow across the bottom of the sky. Then I added blue to finish the sky, touching a little blue into the damp yellow. I continued with a limited palette of blues and reds for the buildings. Simplicity is the key.

When gathering research for my watercolor landscapes, I am not only interested in the architecture but also the atmosphere. Is there something I can find to best express the mood I feel?

Quite often, the mood is most clearly captured in the lighting and weather — the components of the place's atmosphere. So, when deciding how to express a mood, I typically start by selecting one of the following: bright sun with clear light, rainy day, fog, twilight, cold snow or hot temperatures.

Once I have chosen the mood/atmosphere, I select only the colors that will best describe that choice. Considering myself a colorist, it is tempting to use all of the 12 transparent pigments I usually keep on my palette. But it is amazing the moody effects I've found I can achieve by limiting myself to a few carefully selected transparent colors.

Another way in which I stress atmosphere is to simplify the shapes, patterns and details. I am not interested in photo realism or in seeing every bit of detail that presents itself. In fact, I believe these can detract from the mood I'm trying to convey. Instead, I emphasize only those elements that will make viewers feel as if they could walk through the landscape.

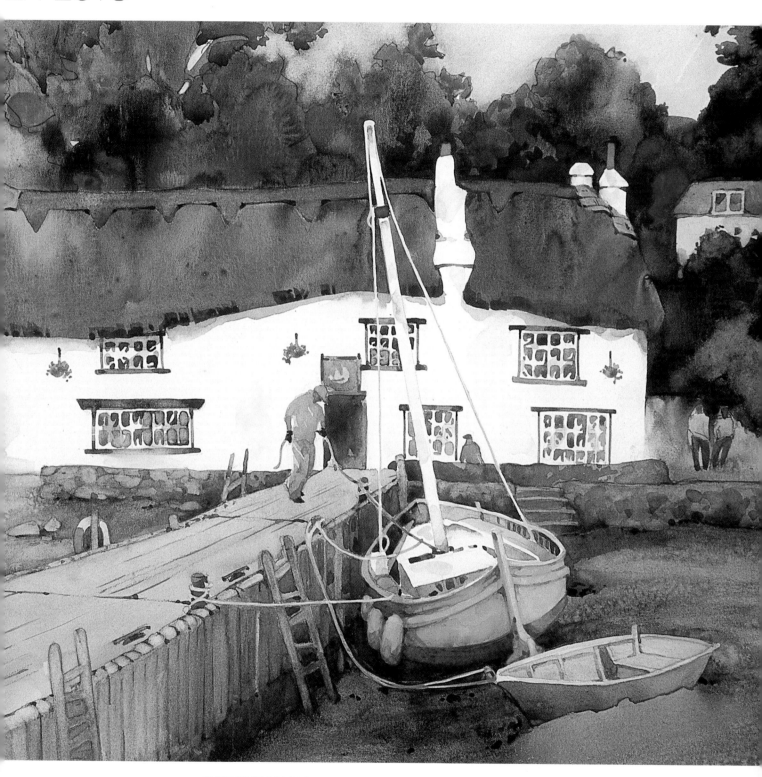

"PANDORA'S BOX PUB, ENGLAND", 14½ x 21" (36 x 54cm)

This scene in England had a storybook quality to it. I used a palette of warm, bright colors here, but felt that they supported the vivacious mood I was seeking. I also decided to create a lot of textures to describe the elements, and thus chose a smooth, Hot Press surface on which to flood all my colors. I let the paper do the mixing.

# ART IN THE MAKING CREATING MOOD WITH ONLY 5 PIGMENTS

In this demonstration, you'll discover how just five pigments can join together to capture the allure of a lighted window in the midst of a dark, snowy landscape.

## WHAT THE ARTIST USED

**Support**
140lb (300gsm) 15 x 22"
(38 x 56cm) Cold Press paper

**Brushes**
#14 round
#10 round
#7 round
#1 sable/squirrel fine-point liner

**Other materials**
White metal palette
Large water container
Paper towels
HB pencil
Stapler for stretching the paper
White tape

**Colors**

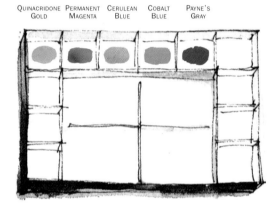

**1** RESOLVING SHAPES AND COLORS
I often start with a 7 x 10" (18 x 25cm) sketch as a way of resolving my compositions. In this case, I put down color and value to give myself a quick idea of how well my limited palette was going to work. It is easy to make changes to the sketch, and I always assume I will make further improvements as I develop the actual painting.

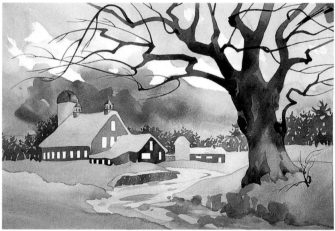

**4** CREATING DEPTH WITH VALUE CHANGES
Here, I used Cerulean Blue and Cobalt Blue to paint in the background snow, adding Quinacridone Gold in some areas to reflect the fading light. I added Permanent Magenta to the mix to cool the snow as it came forward. More variations of this mix, only darker and cooler, indicated gradual changes in the ground plane as I moved into the foreground. Darker strokes of blue and Permanenet Magenta created a shadow cast by the tree to come.

**5** MIXING A DARK DARK
Next, I used warm and cool combinations of all five of my colors to paint in the distant row of trees, leaving small gaps between the strokes to give that area some air and space. Continuing with the darkest possible mixture of those five pigments, I used a big brush to put in the tree trunk and branches. I then switched to a fine-point liner, which is the perfect tool for making dashing strokes that dance across the paper like gnarled tree limbs. The hardest part was holding back so as not to over-decorate.

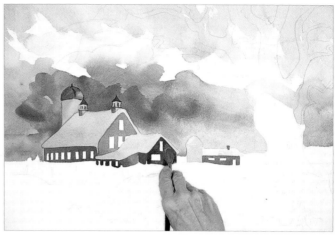

**2** ACTIVATING THE SKY

Starting at the top of a dry piece of Cold Press paper, I worked Cobalt Blue down in wide, diagonal brushstrokes, leaving open shapes for the clouds. I wanted an active sky so I added blues and Permanent Magenta below the clouds in sweeping strokes, letting them mix into the wet sky color. I darkened the value around the barn shapes to emphasize the rooftops. A little yellow suggested the fading light near the horizon.

**3** MOVING TO MIDDLE GROUND

I used the same sky colors to paint the barns, only in lighter values on the roofs for contrast and darker values on the buildings themselves. I painted around the windows to preserve the whites. The value of these dried washes would help me gauge the snow color and values in the next phase.

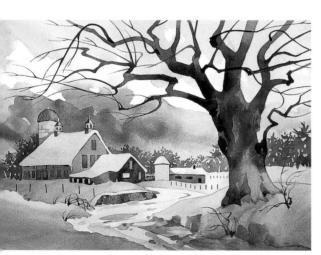

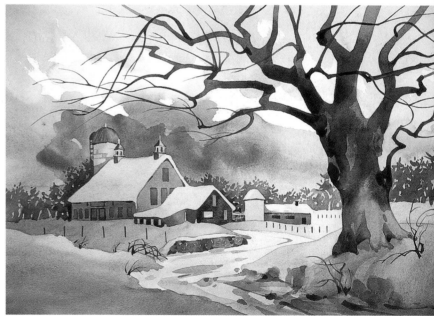

**6** REFINING THE IMAGE

At this point, it was time to add a few details and make some adjustments. First, I decided to darken the foreground snow a bit more with a glaze of blues and gray that would enhance the lighter snow in the background. Next came several finer details, although not many were needed in this active painting. I put in the warm yellow light in the window to pique the viewer's curiosity about who lives here, and used the fine-point brush to paint in the little bushes, varied ground posts and a few tiny branches.

**7** ACHIEVING MY GOAL

This limited palette certainly helped me do what I set out to do — to paint a snow scene that was quiet and cold, yet still welcomed you into the painting with a little warm light. Just a few last branches and dark accents in the cast shadow were all that I needed to complete "Winter's Evening Light".

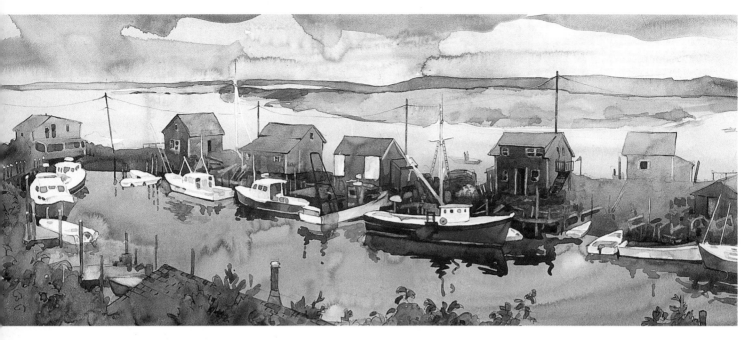

# TURNING POINT

The turning point in my career came when I attended my first painting workshop. I studied with several professional painters there, and realized what a great opportunity a workshop can be. I loved meeting and working with other artists from different locales. I soon decided that this was where I belonged. I entered the workshop world as an instructor, which has taken me to foreign lands and allowed me to meet great people who share my art world. And teaching keeps me learning — a workshop is a knowledge exchange between student and teacher.

"MENEMSHA, MASSACHUSETTS", 10 x 23" (26 x 59cm)
Visiting this working fishing village on Martha's Vineyard, I felt a mood of dampness due to an impending storm. I chose the Hot Press surface and decided on a limited palette of various blues and greens to get that damp feeling. Over a charcoal pencil drawing, I applied a little masking fluid to preserve the white boat shapes, which would have been too hard to paint around otherwise. The bright whites among the color palette suggest the cool tone of the painting without getting too dull or drab.

"ST GEORGE SUNSHINE, BERMUDA", 15 x 22" (38 x 56cm)
I wanted to capture the beautiful light and shadows that were present on this side street of St George. Transparent colors were used in light, warm washes over most of the shapes. Cool shadow shapes were glazed over the wall and in the tree shapes. Notice the complementary colors of yellow and purple that dominate the painting. You can really feel the heat of the sun here.

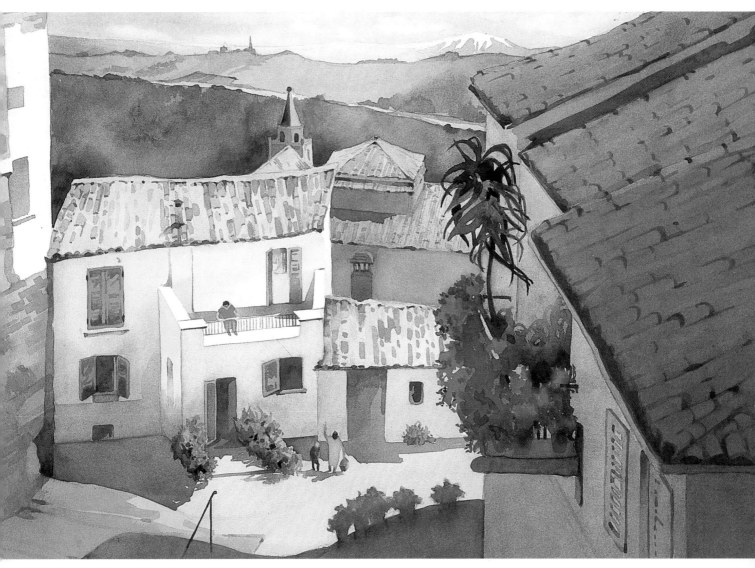

"LORETA APRUNTINO, ITALY", 15 x 22" (38 x 56cm)
On a trip to Italy, I color-analyzed the locale and found that orange, gold and sienna prevailed. Painting on a dry Cold Press paper, I used the rich, warm colors on most of the buildings. I added the dark, cooler roof shapes to offset the warm tones. The focal point is, naturally, the lightest light next to the darkest dark. An unusual vantage point and the inclusion of figures add to the interest of this atmosphere-laden painting.

## ABOUT THE ARTIST

Born and raised in Philadelphia, Jean Uhl Spicer later spent several years living in California before moving to Havertown, Pennsylvania. Her travels from coast to coast have helped form her adventurous spirit.

Jean studied at the Philadelphia University of the Arts, and privately with noted professionals. Jean is now a sought-after lecturer and instructor for organizations like the American Watercolor Society in New York during their annual exhibit. She conducts national and international painting workshops in many locations including Australia, England and Bermuda.

Jean's works have been included in national juried shows, winning her many prestigious awards. She is a Signature Member of the American Watercolor Society; the National Watercolor Society; the Pennsylvania Watercolor Society; the Philadelphia Water Color Society; the Western Colorado Watercolor Society; the Catharine Lorillard Wolfe Art Club and the Baltimore Watercolor Society. She has served on the board of directors of the Philadelphia Water Color Society and the Rittenhouse Square Fine Arts Annual. Jean has also served as a juror for many national exhibitions, most recently for the AWS.

Jean is listed in *Who's Who in American Art*, and her work has been published in a variety of art instruction books and magazines. She is currently represented by Ethel Sergeant Clark Smith Gallery in Wayne, Pennsylvania, where she has an annual show each November.

# ROBERT TILLING INVOKES THE ELEMENT OF CHANCE

## Here's where you get your teeth into large, bold, expansive washes!

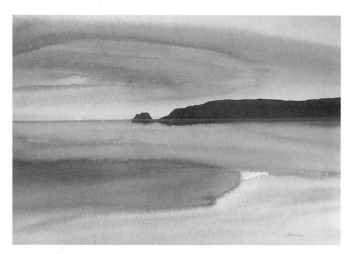

"ACROSS QUAISNE BAY, JERSEY", 20 x 26" (51 x 66cm)
Painted with very few bold and loaded brushstrokes to create a calm spring high tide during early evening in summer.

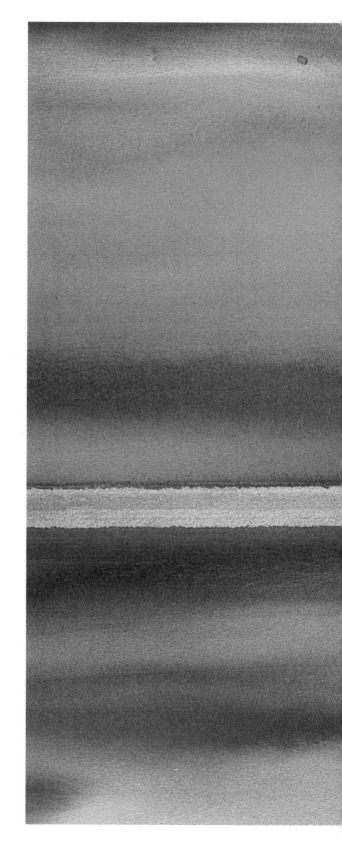

Although I greatly admire and enjoy looking at watercolor paintings from all periods that are highly detailed and controlled, I prefer to work in a bolder and more expressive manner.

As a student I hardly used watercolor and I did not really start to work with the medium until I was about 30. I was attracted to the fluidity and freshness of watercolor. It gave me the opportunity to work spontaneously and to achieve interesting textures that I could not obtain with other media. I particularly enjoyed the results of the many accidental textures and colors that working in a fast and dynamic manner offered.

All of my larger watercolors, on paper size 23 x 30" (58 x 76cm) are produced in my studio, and I often stretch (on block board supports), as many as twelve sheets of paper to work on at the same time. I like to work on a number of paintings simultaneously, and many are often abandoned because a great deal of chance is involved in my work, and there can be many disasters. It is important to be very generous with materials because much of the paint ends up on the studio floor! I work very fast using large brushes and large pots of paint, sometimes using up three or four tubes in just one pot. The element of chance is great and always very exciting to watch.

Before I start a work I have a general idea of what I am trying to create; perhaps a time of day and a place. Then I select drawings that I have made in the landscape to support the idea. The choice of color is vital and I often work on a number of paintings in the same color scheme. I am interested in light, open space, atmosphere where both memory and observation play important roles. The way I work is very physical, dynamic and difficult to photograph, but I hope my demonstration will give an indication of what I do.

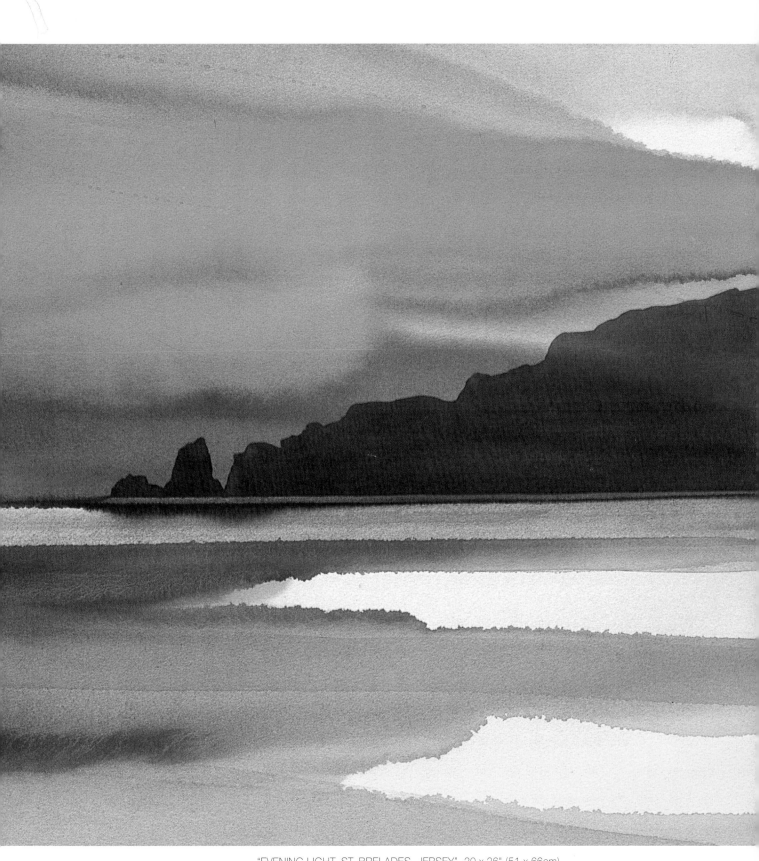

"EVENING LIGHT, ST. BRELADES, JERSEY", 20 x 26" (51 x 66cm)
This was an evening of intense and dramatic light with the unusual headland silhouette adding interest.

## WHAT THE ARTIST USED

**Support**
22 x 30" (56 x 76cm) Not surface 140lb (300gsm)

**Brushes**
Large sable mop and #6 sable

**Colors**
Vermillion
Naples Yellow
Cadmium Red
Sepia
Cobalt Blue
Cerulean Blue
Ultramarine Blue
Phthalo Blue
Turquoise
Payne's Gray

**1** AN ANGLED BOARD IS A MUST
The board was at an angle of about 30°. Using a large sable mop brush I painted a thin wash of a mixture of Cerulean Blue with a touch of Cobalt Blue. I worked with fast strokes covering as much as possible very quickly. This takes away the brightness of the paper and makes the surface very fluid — speed is important.

**4** MERGING THE COLORS
As soon as the bold strokes were complete and before the colors ran down the paper, I very quickly placed the board almost vertical allowing the colors to flow and merge down the paper. This can be the most exciting aspect of the painting. I had to watch carefully what happened and when I thought there was an interesting blend I placed the board back at 30°. At this point I stopped and allowed the painting to dry overnight.

**5** ADDING ELEMENTS
When the painting was completely dry I selected a headland from a sketchbook. I drew out the shape then painted in with a strong mixture of Ultramarine, Payne's Gray and Sepia.

RESULT

**2** THE FIRST MOMENT OF CHANCE
The bottom portion was painted with equal speed and here I was using pure Naples Yellow applied with a large sable mop brush. I touched the blue with the Naples Yellow and here is the first moment of chance and accident!

**3** SPEED IS OF THE ESSENCE
Again, using a large sable mop brush with the board still at about 30°, I placed sweeping strokes of a mixture of Phthalo Blue and Payne's Gray, Vermillion and Cadmium Red and a final stroke of Turquoise. It is vital to really load the brush with very well mixed color. Again speed is very important.

**6** BLENDING ELEMENTS AND BACKGROUND
While the headland shape was still very wet I painted (using the large mop brush), a wash of thinly mixed Naples Yellow. As the brush was drawn under the headland the color ran down giving a suggestion of reflection. Again this was an exciting and chancy moment.

**7** ALL THE ELEMENTS COMBINED
The final result: "Distant Headland, St. Ouen's Bay, Jersey".

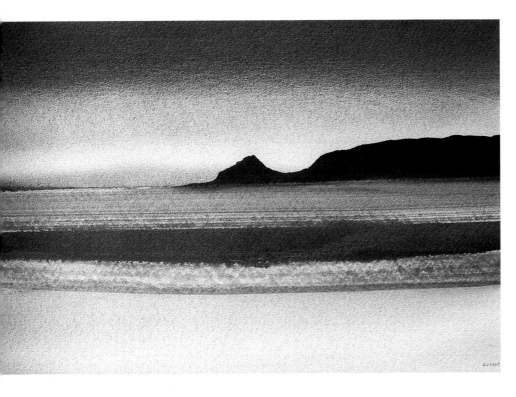

"LATE EVENING, ST. OUEN'S, JERSEY",
20 x 26" (51 x 66cm)
This is the same subject as in my demonstration painting, which I have painted many times and never tire of. Here I tried to suggest the very last evening light with a calm high tide.

## TURNING POINT

I have been very fortunate throughout my career to have had wonderful teachers and supportive fellow artists. I was greatly encouraged by an outstanding watercolor painter, the late Frederick Sands, to take an interest in working with watercolor. He suggested that I send my work to the Royal Institute of Painters In Water Colours annual exhibition, held every year in London. I first had my work selected in 1974 and I was elected a member of the Royal Institute in 1985. There certainly has been a great deal more interest in my work since then, having been invited to show in a number of exhibitions and to illustrate my work in many books and magazines, particularly *International Artist*.

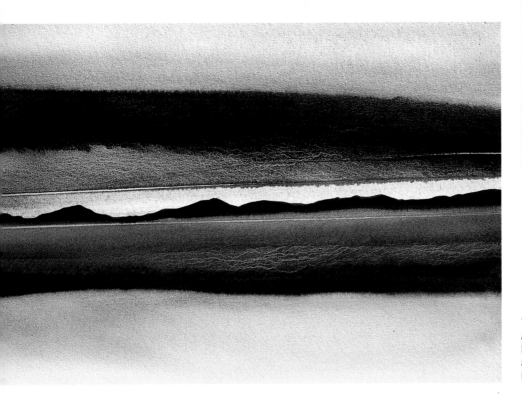

"DISTANT STORM", 20 x 26" (51 x 66cm)
A violent storm was approaching with a distant bright light on the sea. I attempted to paint an almost abstract work with a simple palette and bold brushwork.

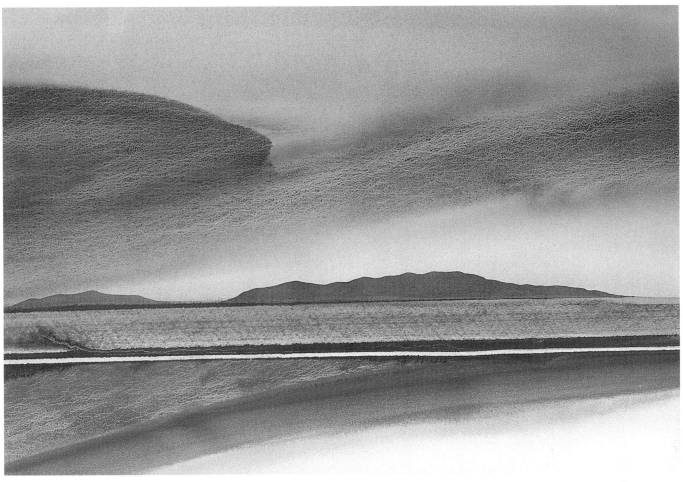

"DISTANT ISLAND — PASSING RAIN", 20 x 26" (51 x 60cm)
This represents just moments after a rain storm at low tide. I cut everything
down to near abstraction.

## ABOUT THE ARTIST

Robert Tilling was born 1944 in Bristol, UK. He studied architecture, art and art education 1961-1966 in Bristol and Exeter, being greatly encouraged by artists/teachers Peter Swan and Derek Lawrence.

He taught full time from 1966-1997 in London and Jersey, Channel Islands. Robert retired from teaching during 1997 to concentrate on music journalism and painting.

He has held over 30 solo exhibitions at venues including the Bristol Arts Centre; Exeter University; Barbican Centre, London and the Jersey Arts Centre. Has had work selected for various mixed exhibitions including the Royal West of England Academy, Bristol; the Royal Academy Summer Exhibition, London; the Royal Watercolour Society Open Exhibition, London and the Contemporary Art Society, London.

Robert has won a number of awards including the medal for the most outstanding work by a non-member at the Royal Institute of Painters In Water Colours Annual Exhibition, London during 1985, and the member's prize in 1994. He was a major prizewinner at the 1989 Cleveland International Drawing Biennale. He has illustrated books and prints, for among others, the poet Charles Causley and comedian Spike Milligan.

His work is held in many private and public collections and he has lectured widely both on art and music including the Tate Gallery, London.

His work is solely represented in the Channel Islands by Studio 18, St. Helier, Jersey. In the UK, it is represented by the Shell-House Gallery, Ledbury, Herefordshire, and the Look Gallery, Helmsly, York.

# MARILYN TIMMS DEMONSTRATES HOW TO GET

## You have to put the right pigments in the right order. Read all about it!

L ayering watercolor paint can have either good results or poor results, depending on the pigments used, the order in which they are used and how they interact. In this chapter I will demonstrate my techniques for producing rich, luminous color using multiple glazes of transparent watercolor.

Beginning with an underpainting with a 2" flat brush, (using transparent, non-staining paints in primary colors such as Aureolin, Rose Madder Genuine and Cobalt Blue) on well-stretched paper, it is possible to create maximum warmth and luminosity — putting the light in the scene.

I start with the weakest color first, often Aureolin. The secret of achieving maximum luminosity is to allow the paper to dry thoroughly between primary washes. This works best when there are few defined shapes at this stage, so the white paper becomes imbued with a warm glow. Once the underpainting layers are dry, I use a round soft sable brush, and softly lay in the middle values using granulating paints (Ultramarine Blue, Yellow Ochre, Cadmium Yellow, Cadmium Red, Cerulean Blue), letting the large design emerge and the shapes begin to form. At this stage, there is not much detail, and no dark values. Some lifting or scrubbing out of errors is possible because all of the paints used so far can be lifted off fairly easily.

Finally, the powerful darks are painted in using a smaller round brush and staining paints (like Alizarin Crimson and Prussian Blue).

My technique of beginning with luminous paper then adding a layer or two of softly granulating forms and ending with dramatic, rich darks makes for crisp, fresh landscapes filled with warmth and color.

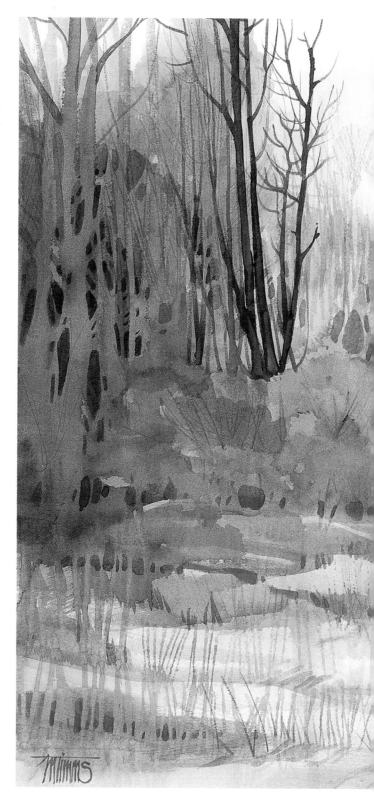

"BESIDE THE FRASER", 15 x 28" (38 x 71cm)
Patterns on patterns, negative painting in layers and luminous color are the strengths of this recently painted forest panorama. To create a scene that has fallen snow but is warm and welcoming was a challenge.

Starting with light, very soft layers of wash, each successive layer became a little darker and more distinct until, finally the dark, sharp tree forms finished the landscape. While the washes were still wet and juicy, I used the handle of a 1" flat brush to scratch in many of the finer distant branches and the foreground reeds poking through the snow. For many watercolorists, resisting the temptation to paint the darkest trees until the last second in a backlit landscape like this one can be difficult, but it is essential in order to keep the finished painting crisp and fresh.

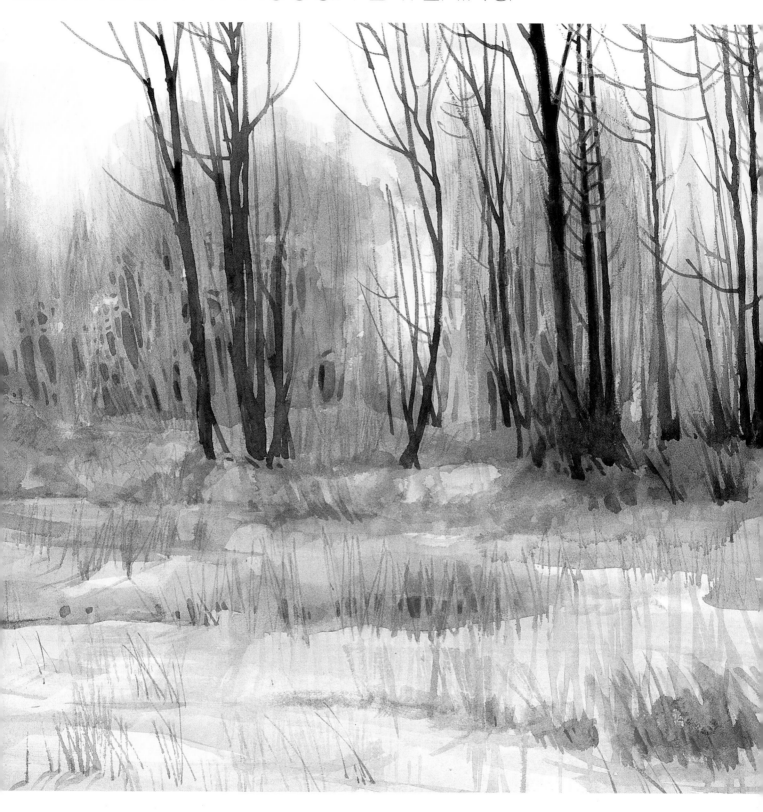

"SPRING THAW", 22 x 30" (56 x 76cm)
The rambling fence and simple color combination give power to this dramatic ink and watercolor. Working with Burnt Sienna, Yellow Ochre and Cobalt Blue, dry washes were layered from light to dark on dry paper with the white of the paper carefully painted around, then each piece of color was outlined, using a permanent ink fine point pen.

## TURNING POINT

A casual evening stroll led to a major turning point for me both in my career as an artist and in my life. Three years ago, I recall having another one of many discussions with my husband Dan about the lack of a gallery here in our city (Vancouver Island). There were several here 10 years ago but, one by one, they disappeared. Later that evening, we walked by the old bakery downtown and, lo and behold, there was a scrap of brown paper in a corner of the window saying "For Lease" and a telephone number. We phoned that number and our life has never been the same since. Having a lovely, uptown venue for my artwork has been wonderful but the best part of this lucky break was being incredibly motivated to paint. Every day, I am enriched by positive feedback from strangers who stop by and comment on how much they appreciate my work. My students peek in often and they look for and expect that I will have accomplished something since they were last in the gallery. Finally, it means a great deal to me that I can help and support other artists in my community as well as myself — and all because of a casual evening stroll.

# ART IN THE MAKING  CREATING A WARM GLOW WITH LAYERS OF

## WHAT THE ARTIST USED

**Support**
140lb (300gsm) medium, stretched

**Brushes**
2" flat wash brush
1" flat wash brush with scraper handle
Hand tied french round sable
#12 round sable

#8 round sable
#6 round sable
#4 round sable

**Other Materials**
Small cosmetic sponge
Paper towels, tissue
Waxed paper, torn into rough shapes

**Colors**

ALIZARIN CRIMSON PERMANENT  ROSE MADDER GENUINE  ULTRAMARINE BLUE  PRUSSIAN BLUE

CADMIUM RED MEDIUM
YELLOW OCHRE
CADMIUM YELLOW PALE
AUREOLIN

COBALT BLUE
CERULEAN BLUE
BURNT SIENNA

**1** THE SCENE
This photo was taken in September 2002 at Ford Cove, Hornby Island in the Northern Gulf Islands of British Columbia, Canada. Each September, I bring a group of artists here for an extended weekend workshop — part on location, part in the studio — taking advantage of a favorite location.

"THE DOCK AT STAG BAY",
18 x 24" (46 x 61cm)

This view from the kitchen window on Hernando Island brings back many memories. The windowed border and stretched perspective create a dynamic and new look to this island landscape. Wonderful luminosity was achieved from a saturated underpainting on dry paper using a wide (2" flat) brush, Aureolin and Rose Madder Genuine. These early soft shapes were then carried forward to about middle light value with fairly thin washes that were softened with a damp sponge at the edges to remain indistinct. Once dry, the taped window was created, then the remainder of the values were layered with heavier, unsoftened washes, avoiding the white areas.

# PAINT

## 2 THE LUMINOUS UNDERPAINTING

There was no preliminary pencil drawing on the surface because I wanted to keep the paper pristine.

Using a 2" flat wash brush, Aureolin and Rose Madder Genuine on dry prestretched 140lb (300gsm) medium paper, a luminous underpainting was created. The medium light value washes of color were softened at the edges with a wet brush.

## 3 INTRODUCING FORM

A little more definition of form and texture was achieved by dropping roughly torn waxed paper shapes into unsoftened washes of Burnt Sienna and Cobalt Blue. The pigments were mixed right on the dry paper surface to achieve the most luminous color possible and applied with a fairly creamy consistency. The waxed paper was left untouched until dry to allow maximum texturing to occur.

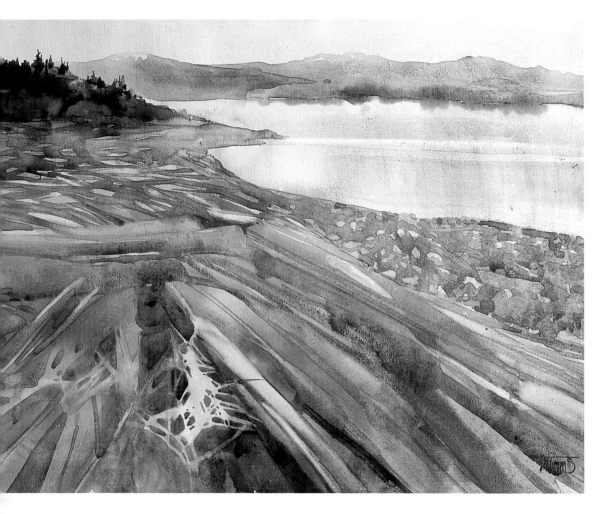

Texture and movement are
the key to the success of this
earthy painting. Painted on
stretched 140lb. paper that
had been covered with two
thinned layers of acrylic
gesso, this watercolor was
a delight to do.

Because the layers of
gesso act as a resist, little of
the watercolor pigment (other
than the staining paints) is
able to soak into the paper,
creating the most wonderful
swishing granulation through-
out. Slathering on the paint
fairly thickly (but not gummy-
thick), recovering the lighter
areas (sky, foreground high-
lights and a few pebbles) was
achieved by lifting off the
paint using a damp round
brush and tissue. The final
darks were painted using just
gummy staining paints with
little liquid.

## 4 USING THE RIGHT PIGMENTS

Once the waxed paper was removed, the shapes that lead into the
composition were defined with Cobalt Blue, Burnt Sienna and Rose Madder
Genuine. Using these finely ground pigments allows the previous texturing
with waxed paper to remain and show up through the succeeding layers of
paint.

## 5 DEFINING THE FORMS AND SUGGESTING DISTANCE

This layer of fairly thin washes winds around and negatively through the
previous one, defining the distant forms and much of the overall design of
the painting. Using opaque paints, the major shapes were established with
cooler colors in the distance, then deeper and overall warmer colors in the
foreground to enhance the sense of space. Landscape painters have long
known that the human eye loses its ability to see the full color spectrum
when objects are farther away therefore, changes in color temperature
enhance the impression of receding forms.

## ABOUT THE ARTIST

Canadian artist Marilyn Timms lives on Vancouver Island in the scenic Comox Valley with her husband Dan, where she maintains a beautiful downtown art gallery/studio. She is a respected instructor who is in demand to teach workshops and seminars locally, regionally and throughout North America. For more than 30 years, she has been perfecting her ability to draw and paint. After many years of life drawing, she found her passion for painting with traditional oils on canvas. As fate would have it, a severe allergy to the binders used in oils forced her to look at other mediums, including the newly marketed acrylic paint, pastels and finally, watercolors. A weekend workshop in watercolor technique was all it took and within a very few years she was winning awards. Recently, Marilyn was awarded the Barse Miller Memorial Award at the American Watercolor Society 136th Annual International Exhibition, New York City, NY, USA.

Her paintings have been exhibited in the Societe Canadienne de l'Aquarelle Annual Watercolour Exhibition, Brossard, Quebec, Canada; the Canadian Society for Painters in Watercolours Open Water Juried Exhibition, Toronto, Ontario, Canada; the Northwest Watercolor Society Annual International in Washington State, USA; the San Diego Watercolor Society Annual Exhibition and others. She was awarded full signature membership in the Federation of Canadian Artists in 1993 and maintains that status.

She is represented in Canada by Timms Fine Art Gallery in Courtenay, BC; Heritage House Gallery, Langley, BC; Maple Ridge Art Gallery, Maple Ridge, BC; Eclectica Gallery in Sylvan Lake, Alberta, and the Federation Gallery in Vancouver, BC. She takes part in the Van Dusen Flower and Garden Show each June in Vancouver, BC along with the Art Expressions event in Calgary, Alberta each October. More of her works can be seen on her web site at www.timmsfineart.com.

## IMPORTANT NOTE

In order to attain clean layering of paint, my palette contains no premixed paints like Payne's Gray, Hooker's Green, Black and the like because they combine different types of paint (such as staining with sedimentary) and don't layer well.

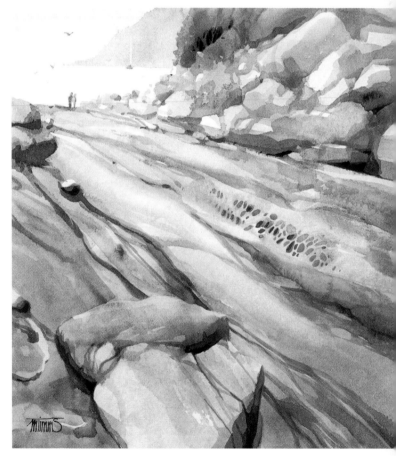

**6 GETTING INTO DETAILS**

Here, the process turns to working in the physical details that make this place unique — wind carved sandstone, interlocking rock formations, seagulls and people strolling in the distance. Using creamy paint, these small washes of Yellow Ochre, Ultramarine Blue, Alizarin Crimson and/or Prussian Blue create the drama and interest in this landscape. Thin Cobalt Blue washes were used to gray down some of the more intense sweeps of color to get a natural feel.

**7 COMPLETED PAINTING**

Luminosity and a sense of space and place make this an intriguing landscape. The square format emphasizes the diagonal flow in the design —putting us right there in the scene, yet pulling us back into the distance. The underpainting creates a warm glow that fuses up through every layer of paint, so much that you can almost feel it. Texture and the almost sculptural forms give us a hint of the natural beauty of this sun-warmed island. "Ford Cove — Around the Corner" was finished.

# BERNHARD VOGEL SUGGESTS DEPTH WITH COLOR

When your subject fills the frame try
this Austrian artist's solution for giving
the illusion of depth.

**P**ainting is one of the greatest and most marvelous secrets of life. If a painting succeeds, it is an indescribably lucky condition, a creative process, a unity with nature, an overachievement. Everyone who has this feeling, will become addicted to the experience.

Neither the striving for perfection, control of technology nor the release of the creative process is the goal. It is rather the opposite. One uses the gift of characteristic ego and knowledge, proceeding in a condition of tension, and allowing everything to occur without expectation. In the moment of creative process, the work appears, and one is more like a mediator or spectator. The brush paints by itself, or so it seems. It is as Lao Tse defines, a handling without handling: the highest activity in the highest relaxation. In spite of this apparent inactivity, one is totally exhausted thereafter. This exhaustion results from the unconscious expense of power. This is real, honestly lived through creativity. It is a continual migration between two worlds. So that a good picture can emerge, the painter must leave the real, humanly intelligible world behind, even if only for a few instants. This ability is initially fairly easily gained, but sometimes the energy expense may be in vain. Paul Cezanne said, "If I think when painting, everything is lost".

I am often asked, how this or that effect is produced and/or why I selected this color or how long I need for a picture. I can answer these questions simply but not sufficiently. If a good picture emerges, I could not reconstruct it, it is like a gift, it happens. It is not necessary to explain creativity. Naturally this condition is only possible with the necessary technical equipment, that one automatically appropriates for oneself in the course of time, through influences, study and experience. The act of painting one learns only through painting. Freedom is very important, freedom of knowledge, ability and thinking. Creativity is about trying new things, accepting risks — to surprise, not to concentrate on errors. A good picture must have faults. One does not recognize good pictures because they are skillfully made, but rather because they release a soul vibration, which is a condition of creativity shared with the viewer.

"LANDSCAPE NEAR QUIRICO D'ORCIA, TUSCANY",
22 x 30" (56 x 76cm), 300lb (638gsm)
The most beautiful sights in Tuscany: hills and cypresses. Many layers, structures, dry phases, washouts and brushstrokes but only two main colors were important to give this picture a secret life of its own.

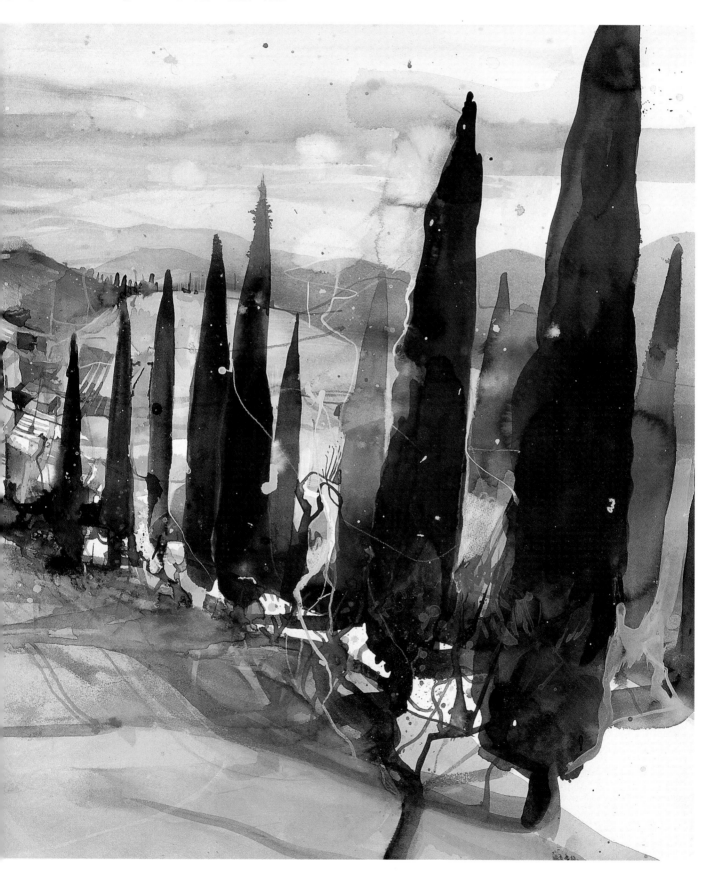

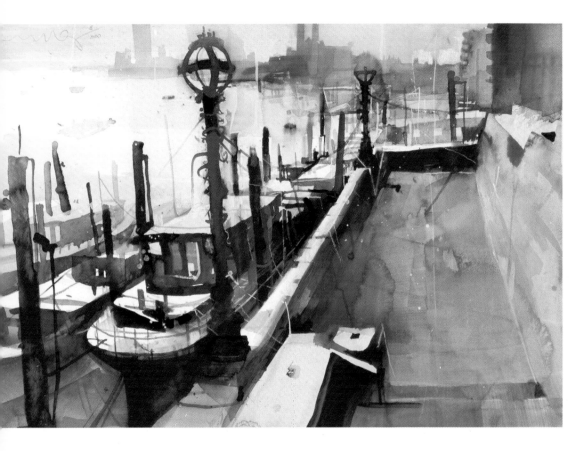

"CHELSEA HARBOUR,
LONDON",
15 x 22" (38 x 56cm),
300lb (638gsm)
The reason I chose this subject was the strong foreground with the boats and the light masts, an exciting middle ground with the curve in the river and a smoothing background with the gray houses in the backlight. It was important to reduce the sky to get the right composition.

(RIGHT) "LANDSCAPE NEAR SPITZ, WACHAU, AUSTRIA",
15 x 22" (38 x 56cm),
300lb (638GSM)
I painted this landscape in the early springtime. Everything was very transparent and I had a lot of structures in the vineyards to play with. The decision to sit here was dictated by a great composition which starts with a small road and the grapevines, and ends in the distance with a fantastic curve of the Danube. To increase the depth I used mostly yellow and blue tones.

## TURNING POINT

The creative longing, dormant in me during a commercial course in the family business, found its release after a serious motorcycle accident. I was searching for a means of expression, trying and experimenting with all technologies, in a watercolor workshop. This was my first intensive studio course in Toledo with the medium of watercolor. Firstly, by seeing the many pictures of the other painters, the wide spectrum of this technology was revealed before my eyes. It was love at first sight. Since this revelation, I have worked primarily with watercolor combined and supplemented with drawing and printing.

At this time, it was also my good fortune to live in Salzburg. In the '80s, when strong impulses in the form of displays of many important watercolorists were inspiring. Salzmann, Hradil, Kruckenhauser in order to name only some, influenced me very much, and for that I am very grateful. Study in the Summer Academy in Salzburg, of life drawing and other studies were additional spurs to my career.

## ART IN THE MAKING CREATING

The scene was the Foro Traino in Rome on a summer afternoon. There was a sunny atmosphere with strong light. The challenge of this subject matter was to get depth in the picture because everything was near, and had the same color. So I decided to paint the columns blue with strong shadows to make a strong counterpoint to the churches.

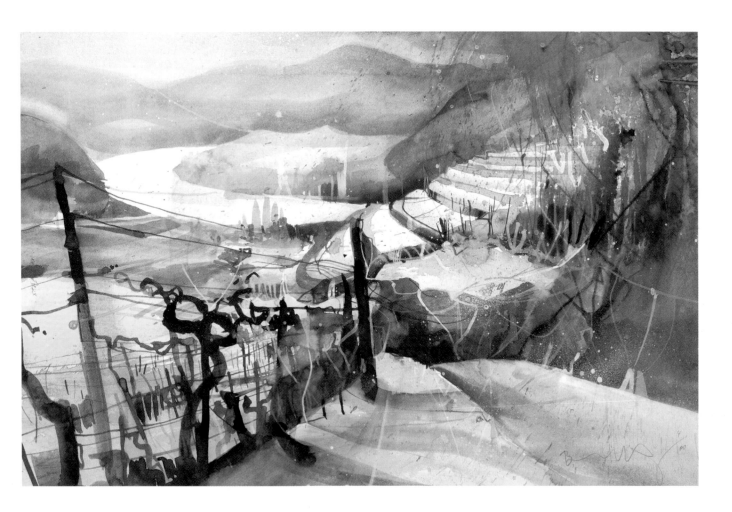

## EPTH WITH STRONG COLOR

**1** MY FIRST STAGE
I was inspired by the great atmosphere and the light in the dome-shaped architecture.

**2** ALTERING REALITY TO SUIT MY VISION
I began with the olive trees in the left corner with strong and wet brushstrokes. To get the composition right and exciting I altered the domes on the right.

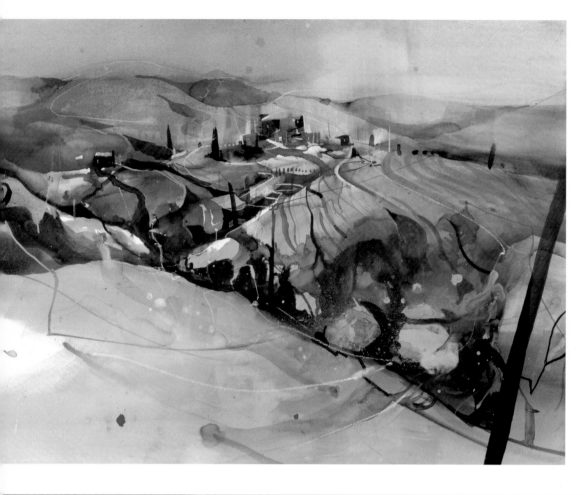

"LANDSCAPE NEAR MONTALCINO",
22 x 30" (56 x 76cm),
300lb (638gsm)

I wanted to put very strong colors in the foreground and was inspired to use May Green with Prussian Green which gives a brilliant, excellent, green. The violet in the back makes the landscape complementary and mystic. The diagonal in the composition makes the picture exciting.

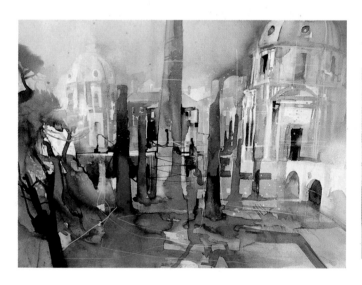

**3** WORKING WITH A REFERENCE

As usual, I filled the paper with the main objects and used these as a reference to orientate everything else.

**4** INTRODUCING STRONG CONTRAST

Everything was tinted with warm yellow colors. To get the right atmosphere and depth into the watercolor I painted the columns and shadows in strong blues. This gave the picture the strong meaning I had intended.

## ABOUT THE ARTIST

Bernhard Vogel was born in 1961 in Salzburg, Austria, where he still lives and works. He has been winning prizes for his painting since 1987 when he won the Government Art Award. A string of prestigious awards followed. He was a Finalist in the 2000 Singer & Friedlander Art competition in London and won First Prize the same year at the Südwestdeutscher Aquarallpreis.

He has had solo exhibitions every year since 1988 in well known galleries in Vienna, London, Cologne, Saint Tropez, Hamburg, Berlin, Munich, Hanover, and Paris. His most recent solo exhibition was at the Bruton Street Gallery, London.

Bernhard's work is held in the public collection of the Albertina, Vienna; The Rupertinum, Salzburg; AKH Vienna; Bayer, Leverkusen; British Gas; Government of Burgenland; Government of Salzburg and the Lienz Museum.

Visit his website
http://www.bernhard-vogel.at/home.html

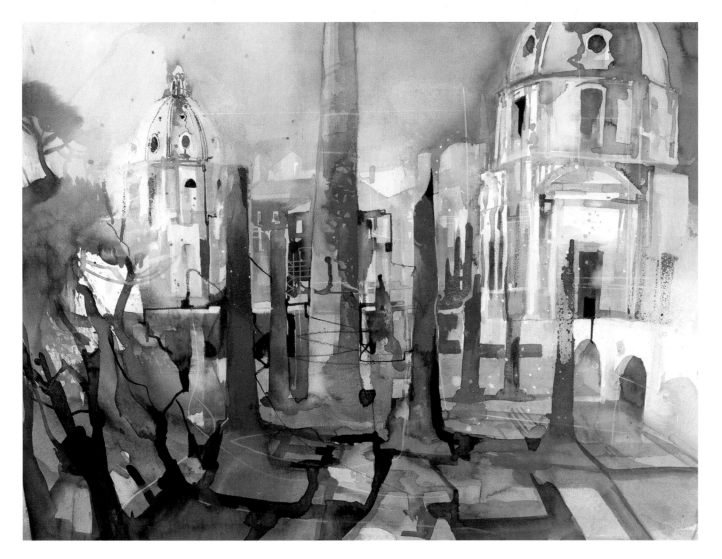

**5** FINISHED "FORO TRAIANO 10", 22 x 30" (56 x 76cm)
The most important thing when painting a realistic subject is to change the reality — to reduce or to increase it.

# JOSEPH ZBUKVIC CAPTURES THE EMOTION OF THE

Feel it! Paint it! There's nothing like being on site to get the creative juices working overtime. And as this Australian artist says, there is no better teacher than Mother Nature.

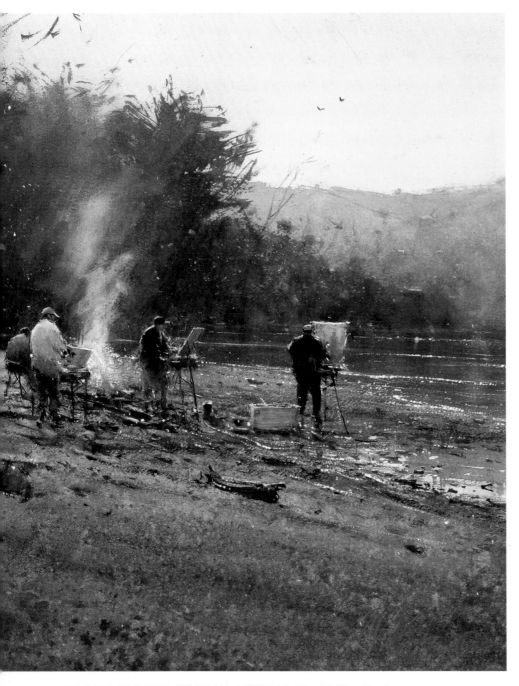

"AS GOOD AS IT GETS, GUNDAGAI, AUSTRALIA", 28 x 22" (72 x 56cm)

**W**hen faced with the subject first-hand, on site, we have to observe it quickly and reduce the amount of superfluous detail while maintaining major shapes. There is simply no time to paint each brick. We are forced to simplify in order to capture the moment before the light changes. Back in the comfort of the studio we tend to return to manners and learned tricks of the trade and work to a formula. The other big problem with studio work is that it is usually done from photographs. While these are an excellent reference material, the photographs simply rely on optical and chemical process: they are far removed from emotion.

I believe outdoor painting recharges your creative battery. I can always tell when it's time to go into that great studio outdoors and I then do it — come rain or shine. It is not easy! Sometimes I return after driving for hours having not found a subject, and yet at other times I find one just around the corner! It has to do with the quality of light. The same subject can look amazingly different at a different time of the day. Many times I finish painting

Every winter I partake in a painting excursion with my painting mates. We enjoy these journeys immensely and believe it or not, work quite hard. (I do admit we have just a few beers at the end of the day.) This subject presented itself on the bank of the Murrumbidgee River. I actually started painting the late light on the river but after the painting was complete it appeared somewhat empty. It became obvious that my fellow painters would make an excellent subject. While I was doing this one of them lit the obligatory campfire which provided a perfect foil for the hard edges within this subject. Of course it also cooked our dinner!

One could argue that this would probably make a better oil painting subject due to so many darks. I think I managed to overcome this by

introducing the evening light reflection on the water.

The first wash was placed over the entire painting creating that warm glow. The second wash created the distant hill followed by the sand. When this was dry I painted the darker trees and the water reflection, making sure I left highlights throughout the picture. The figures were carefully placed to lead the eye through the composition. The smoke breaks up the dark shape of the trees in the background. I used opaque paint after I rewetted the area. I also used the dark bits of driftwood and rocks as a lead in.

The title is self explanatory because I cannot think of a nicer thing to do than to paint side by side with my best friends at such a wonderful location at such a magic moment.

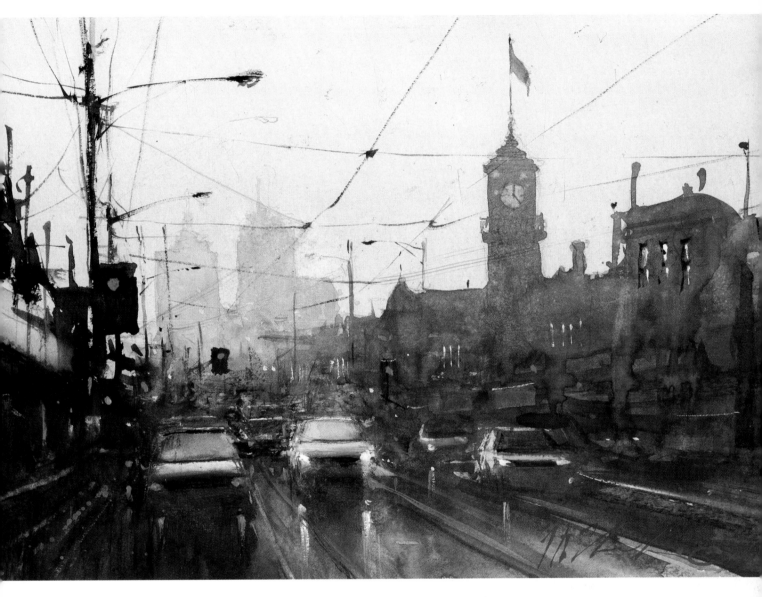

what started as a dawn subject and when I look at my painting and compare it to the by then, sunlit, mid-morning subject, I thank my lucky stars that I was there when the light was at its best.

Of course, there are the unwanted instant critics, the rain, wind and other distractions that make the already difficult job so much harder. However, I believe those artists who are addicted to working outdoors can understand when I say that no studio painting, no matter how grand, can have the magic of plein air work.

"WET EVENING, MELBOURNE, AUSTRALIA", 10 x 13" (26 x 33cm)

One of my favorite street scenes in Melbourne is not far from my home. This painting was done while seated in my car using the steering wheel as an easel! I quite often do this, particularly when it's raining. It is actually quite comfortable and one can listen to the radio and even have heating and drying facilities! Curious passers-by also can't bombard you with their usual array of questions, such as: "Are you an artist?" I have never found an answer for that one!

The first wash of Cobalt Blue and Cadmium Red took care of the sky. This was increased dramatically to create the road surface, taking care to avoid the highlights for the cars. I used the car heater to dry this.

The second wash started with the softer buildings in the distance using a slightly stronger mix of Ultramarine and Cadmium Red. This was increased dramatically for the closer buildings, particularly the ones on the left.

The final darks for the cars and reflections completed the major shapes in this painting. Using a small brush I quickly established the power lines and street lamps. Traffic signals and car headlights were painted with opaque paint while the painting was still wet in order to achieve soft edges. The evening atmosphere was further enhanced by lifting the pigment for the glowing clock face on the Town Hall.

# ART IN THE MAKING PAINTING AN INDOOR LANDSCAPE

**I** found this subject at the fish market in Venice. The red awnings hung over the archways cast a wonderful red glow on everything inside. The wet floor was also reflecting and accentuating this effect. I made a very quick sketch on location and knew there was a great painting waiting to be done.

Because of the necessity of photographing the sequence I did this demonstration back in my studio, where I had the luxury of a hairdryer to speed up the process.

## WHAT THE ARTIST USED

**Support**
Medium texture paper allows greater flexibility.

**Other materials**
Big water container

**Brushes**
I use a good range of brushes but always use the largest brush for large shapes, medium brush for medium shapes and small brush for small shapes.

**Colors**

| | |
|---|---|
| Lemon Yellow | Burnt Umber |
| Cadmium Yellow | Burnt Sienna |
| Raw Umber | Cobalt Blue |
| Cadmium Orange | Ultramarine Blue |
| Vermilion | Cobalt Turquoise |
| Scarlet Red | Cerulean Blue |
| Carmine Red | Horizon Blue |
| Permanent Magenta | Opaque White Gouache |
| Cobalt Violet | |
| Permanent Violet | |
| Neutral Tint | |

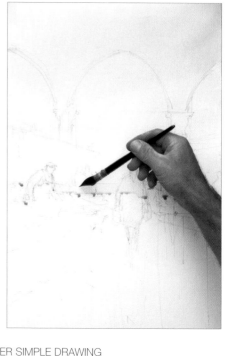

**1** THE FIRST WASH OVER SIMPLE DRAWING
I kept my initial drawing very simple and loose. These days I need less and less drawing support before I begin painting. This way I am free to explore and create shapes as I paint rather than strictly follow a tight drawing.

The first wash was merely a stain of warm Cadmium Red with just a hint of cool Cobalt Turquoise for the light coming in. I allowed this to dry totally before beginning the next stage.

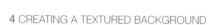

**4** CREATING A TEXTURED BACKGROUND
I created a beautiful rich wash for the orange background. Then I sprayed some water from my atomizer to create some lovely texture. Notice how I ran the darker wash over the top half of the main figure.

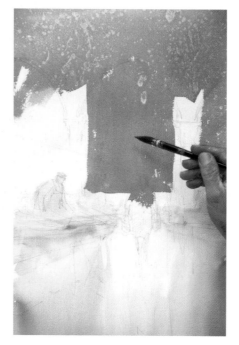

**5** INTRODUCING SOME RICH DARKS
The dark archways were painted next using a thicker mixture of Neutral Tint and Burnt Umber. When necessary I add colors to keep everything interesting. Notice the dry-brush strokes in the counter-top area.

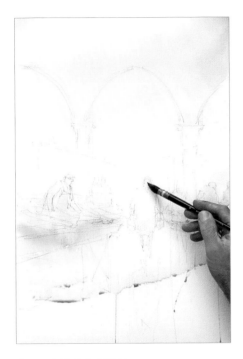

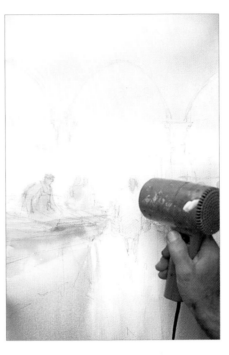

**3** DRYING OFF
The face of the main figure received some color and then I dried the paper off with my hairdryer.

**2** THE SECOND WASH
The red awnings were washed in using pure Cadmium Orange. I worked the wash over the figures and right down the page.

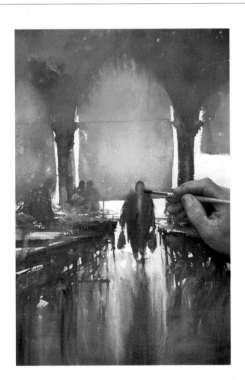

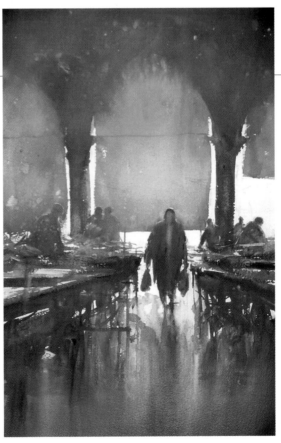

**7** FINISHING OFF
I added small detail and highlights throughout the painting, paying particular attention to that all-important figure.
  The result was a misty, moody, colorful interpretation of that rainy day in Venice.

**6** CONNECTING AND UNIFYING THE PAINTING
The bottom half of the painting was integrated with the whole through connection with the pillars and figures. The wet floor reflections were created by rewetting the area first, dropping in pigment and letting it run.

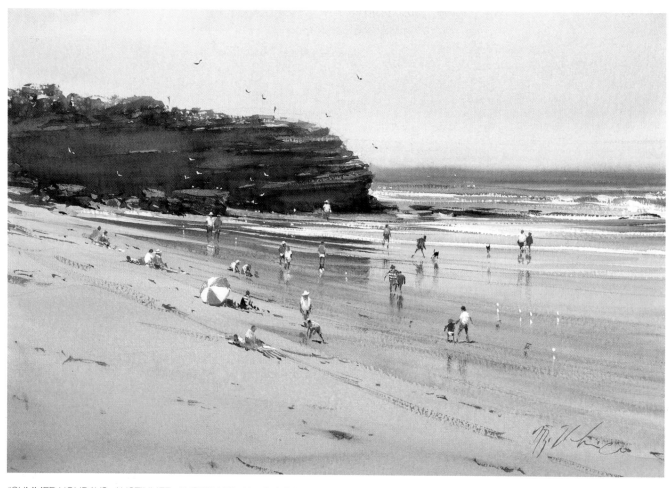

"SUMMER HOLIDAYS, AUSTINMER, AUSTRALIA", 14 x 21" (36 x 53cm)

Australia is blessed with beautiful beaches with perfect surf rolling on to clean sand. In this painting I wanted to achieve that feeling of summer holidays when the beach is crowded with people. If you imagine this painting with just a lonely fisherman walking along it would totally transform the mood of the scene. By placing the figures in a staccato manner and using primary colors I produced a busy but also relaxed atmosphere.

I started by washing the sky with Cobalt Blue, introducing Cadmium Red until the horizon was almost pure Cadmium Red. While this was still wet I indicated the soft horizon with Cobalt Blue and Ultramarine. As I reached the waves I introduced Cobalt Turquoise making sure not to lose the white for the waves.

The sand was continued almost in the same wash changing the colors into warm Raw Umber, Cadmium Red and Cadmium Yellow. Once the initial wash was dry I painted the headland using Raw Umber, Burnt Umber and Cobalt Turquoise to achieve hard edges.

The figures and umbrellas were painted last of all using opaque paint where necessary. The placement of the figures was of outmost importance. They had to lead the eye through the composition and be grouped in a pleasant manner.

## TURNING POINT

I can say with all confidence that the biggest change in my career was caused when I discovered plein air painting. While I cannot say the precise moment or the year that this occurred, I can say it was a slow revelation. It became obvious through the change in my work. There is no better teacher than Mother Nature.

## ABOUT THE ARTIST

Joseph Zbukvic was born in Zagreb in what was formerly Yugoslavia. The Zbukvic family emigrated to Australia in 1970 following political unrest. There, Joseph studied at Deakin University, Melbourne, graduating in 1974 with a Diploma in Art, majoring in Industrial Design. During this time he discovered watercolor and achieved instant success in art competitions, winning his first major award in 1975.

After becoming Arts Advisor to the Victorian State Government Department of

"FINAL EFFORT, MELBOURNE, AUSTRALIA", 52 x 68", (135 x 1702cm)

This large powerful image is one of my favorite paintings from my Equine Series. It was mainly painted from memory! I did use reference from many sources but it's quite obvious that one could not stand at this vantage point without being trampled by the horses! This was precisely the feeling I wanted to achieve. This time the painting worked out exactly how I wanted it to, which is a rare occurrence for a watercolorist. I just love those bits of turf flying through the air!

This was another two wash painting. The first wash took care of the sky and grass area. The sky was painted with Cobalt Blue and Cadmium Red and the grass with Cobalt Turquoise, Cadmium Yellow and Cadmium Red. The buildings were painted after this using a slightly stronger sky wash.

The horses and jockeys came next. I started with the distant horse because it was weaker in value compared to the front horse which was merely black and definitely the strongest tone in the picture. I used as many primary colors as I could for the jockeys to brighten the painting. I tried to leave as many highlights as I could while doing this, however some were achieved by the use of opaque paint. I don't shy away from using opaque paint because I think that the end justifies the means.

Finally, the flying bits of turf and mud were splattered using a large brush! I must admit that I held my breath while I did this! As luck would have it, it all worked out perfectly.

Health, Joseph became a full time professional artist, quickly establishing himself as a leading watercolorist.

He was Vice President of the Old Watercolour Society for three years; was invited to join the Australian Guild of Realist Artists; he is a member of the Victorian Artists Society and is one of the Twenty Melbourne Painters Society. In 1998 he was nominated and accepted for membership of the elite Australian Watercolour Institute. He occasionally teaches art at Charles Sturt University, Mitchell College of Creative Arts.

Joseph has traveled widely in search of subjects, and on his return to Zagreb in 1990 was made artist in residence at the Mimara Museum of Fine Art.

He has won over 200 awards, including the coveted Gold Medal for Best Painting in Show in the Sun-Herald Camberwell Rotary Art Exhibition 2001 — making history because this was the first time a watercolor has won the award.

Joseph's work is held in the collections of important regional galleries in Australia and in numerous municipal and private collections worldwide.

His work has appeared regularly in *Australian Artist* and *International Artist* magazines and his first book entitled *Mastering Atmosphere & Mood in Watercolor* published by *International Artist Publishing* had to be reprinted only three weeks after its launch.

# ZHONG-YANG HUANG COMBINES WESTERN DESIGN

This Chinese Canadian artist calls on ancient Chinese ideas about working with wet and dry brushwork.

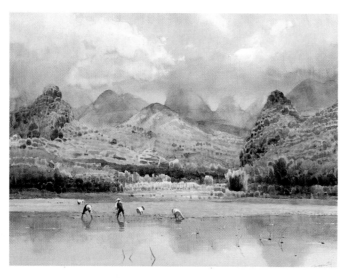

"THE CLOUD PASSING THE RICE FIELD", 22 x 30" (56 x 76cm)
I saw peasants laboring in a rice field in Southern China. The field, the mountain, and the sky made a dreamlike scene. I used the wet-on-wet method using a 2" flat brush to make layers of washes suggesting a moist atmosphere.

**M**y approach to painting in oils and watercolor has grown from my extensive tuition in China and Canada. When painting with watercolor I combine two different cultural disciplines. One is the discipline of Western painting, the other is the Chinese brushwork discipline.

I adhere to the Western design principles of shape, color and tone to suggest three-dimensional objects. But I also practice Chinese brushwork. I particularly admire the great Chinese calligrapher, Huai Su, who lived during the T'ang dynasty (618-907 AD). He said in his theory: a great brushwork in calligraphy is a combination of wet and dry strokes. The wet brushstroke can be related to the human bone (skeleton). When the wet method is applied you have to build up some dry texture (muscle). When the dry method is dominant you have to use a big brush to wash out some wet texture. Consequently, my watercolor method is to work using wet and dry strokes, to build up the "muscle" and "bone" with perfect proportions of harmony.

I believe that the artist's mood can be expressed with charming results using this method.

"LEBRET", 22 x 30" (56 x 76cm)
Lebret is a peaceful spot in the Qu'appelle Valley in Saskatchewan. When the doves flew over, I felt that the path and the crosses would lead me up to the heavens. In an attempt to convey that thought I applied bright, pure color.

## WHAT THE ARTIST USED

**Support**
Hot Press watercolor board

**Brushes**
1½" Flat
⅜" Round
Chinese Brush #3 Round

**Other Materials**
Spray bottle
Plastic paint containers
Paper towels
Razorblades

**Colors**

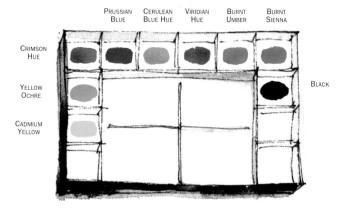

CRIMSON HUE
YELLOW OCHRE
CADMIUM YELLOW

PRUSSIAN BLUE | CERULEAN BLUE HUE | VIRIDIAN HUE | BURNT UMBER | BURNT SIENNA

BLACK

**1** MY PENCIL DRAWING
I start a pencil drawing as lightly as possible; too heavy a pencil line will reduce the pure quality of color. I carefully drew the building and trees in the composition.

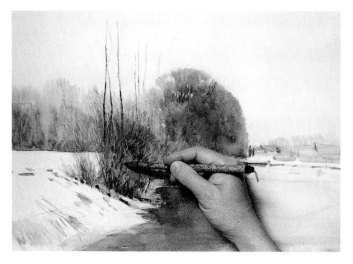

**4** WORKING INTO THE FOREGROUND
I used a free, vivid dry brush stroke to depict the front bush, and foreground, and to introduce a warmer tone.

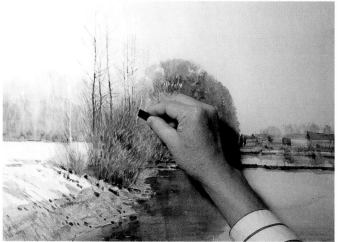

**5** APPLYING TEXTURE AND DETAIL
I built up the texture and depicted the detail on the foreground bush and tree. I used a razorblade to scratch out the white post, the tree, and the snow on the river bank. Then I added the little birds using a #3 round brush.

# ACHIEVE DEPTH

 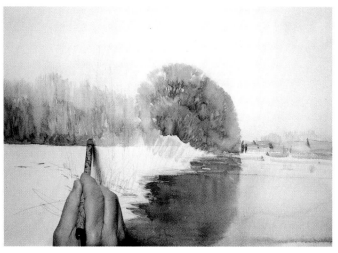

**2** CREATING DEPTH STRAIGHTAWAY
I used a 1½" flat brush to paint the sky and water. The top of the sky should be different than the bottom of the sky. The front water should be different from the distant water. You have to feel the depth of space at this stage.

**3** JUXTAPOSING WARM AND COOL COLORS
While the paper still retained moisture, I applied the cold color on the background tree, and the distant building. I used a Chinese ⅜" round brush to apply warm color on the center tree, and the reflection on the water. It is very important to do the water reflections with one brushstroke in order to achieve transparency and a clean wet-on-wet quality.

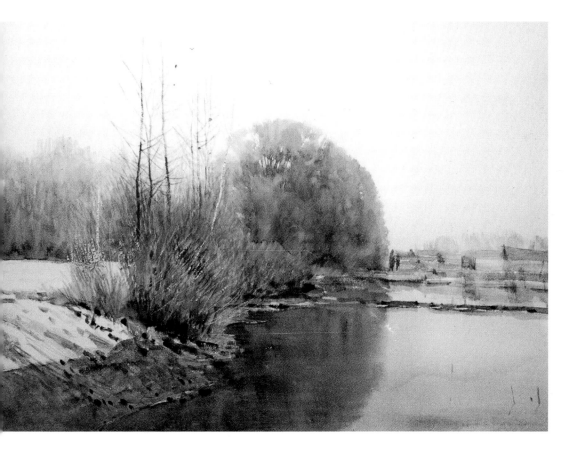

**6** FINISHED
My aim with this painting was to contrast wet and dry techniques and to make the most of warm and cool color temperatures. All this achieves depth.

141

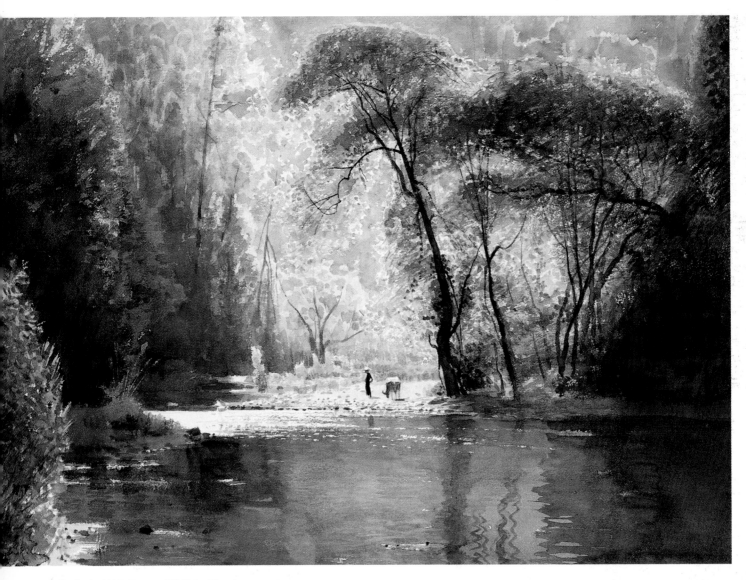

"IN THE VALLEY", 14 x 20" (36 x 51cm)
I was touched by this summer scene near a Buddhist Temple in Southern China. To express a calm and peaceful mood I portrayed the dark water in single brushstrokes.

## TURNING POINT

The turning point in Zhong-Yang Huang's career was really a group of circumstances spanning many years. He started to paint at the age of eight in 1957. During the next seven years he received formal training in traditional Chinese painting and calligraphy. When he was 15, the government put a halt to "Individuality" and for ten years he was forced to work as a laborer in the fields. In 1978 he was accepted as a Master student by the Guangzhou Academy of Fine Arts and received his Masters Degree in 1981. He worked there as an instructor until 1984 when he was given the opportunity to travel to Canada. As a visiting student he completed his studies and received his second Masters Degree from the University of Regina in Saskatchewan.

He then took up residence in Canada, and that was the culmination of his new beginning. He now has dual citizenship in China and Canada.

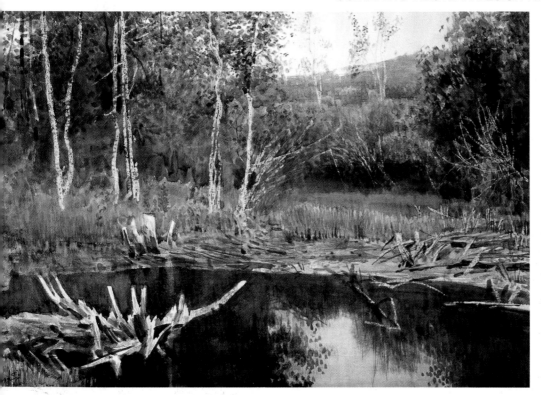

"THE DEEP POND", 15 x 22" (38 x 56cm)
I used a white oil crayon to draw the white aspen trunks. Then I applied different values of green washing layer over layer to depict a mysterious atmosphere.

## ABOUT THE ARTIST

Zhong-Yang Huang was born in Guangzhou, China in 1949. Yang started to draw and paint at the age of eight. His talents were recognized early, and he received formal training in traditional Chinese painting and calligraphy.

During the Cultural Revolution, he was forced to work as a laborer in the fields for 10 years. Although he was in exile, he continued to paint avidly. In 1978 he was accepted as a Master student by the Guangzhou Academy of Fine Arts and received his Masters Degree in 1981. He worked there as an Instructor until 1984, when he was given the opportunity to travel to Canada, where he now lives. Although he became immersed in Canadian culture, his work continues to be influenced by Chinese history from Empress Cixi to Mao Zedong. Yang viewed these rulers' lives and stories through the suffering endured by his own family. This became an artistic vehicle through which he could express his creativity and emotions.

Yang uses the western version of his name, Jong Yan, to sign his works which are influenced by many periods of art history: the Pre-Raphaelite School, the French Impressionists, and the great Dutch painter, Rembrandt. He has a great love for music, which he says he listens to for inspiration.

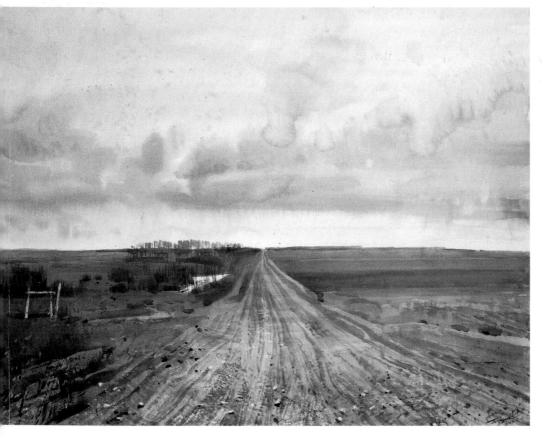

"THE ROAD TO MOOSE MOUNTAIN", 22 x 30" (56 x 76cm)
It was a typical scene in Saskatchewan. I was traveling along the road to Moose Mountain, but I couldn't see any hint of the mountain. I felt as if I was becoming smaller under the big sky. I attempted to achieve harmony between the cloud-laden moving sky and the dry, heavier earth.

If you liked this book you'll certainly want to know about these bestselling watercolor art instruction books by international artists.

### Watercolor Painting with Passion!

by Alvaro Castagnet

ISBN 1-929834-05-5 Hardcover

Shows how it is possible to transcend the principles of technique and awaken your passion every time you pick up your brush.

### Mastering Light and Shade in Watercolor

by Ong Kim Seng

ISBN 1-929834-23-3 Hardcover

Easy to understand Action Plan format builds your knowledge in bite-sized chunks.

### Simplifying Complex Scenes in Watercolor

by Malcolm Beattie

ISBN 1-929834-24-1 Hardcover

The fast-track to watercolor skillbuilding.

### Solving the Mystery of Watercolor

by David Taylor and Ron Ranson

ISBN 1-929834-20-9 Hardcover

Multiple examples and demonstrations of paintings that are within your reach.

### The Art of Designing Watercolors

by Robert Lovett

ISBN 1-929834-14-4 Hardcover

Every step in the design and painting process demonstrated.

### Paint the Sea and Shoreline Using Special Effects

by E. John Robinson

ISBN 1-929834-11-X Hardcover

Learn to paint all the elements that make dynamic seascapes.

### Tom Lynch's Watercolor Secrets

by Tom Lynch

ISBN 1-929834-01-2 Hardcover

Start applying these secret strategies to your own work for the same dynamic results.

### Robert Wade's Watercolor Workshop Handbook

by Robert Wade

ISBN 1-929834-15-2 Hardcover

A complete "watercolor workshop in a book" divided into 7 essential lesson sections.

### Structure and Expression for Watercolor Flowers

by Jean Martin

ISBN 1-929834-22-5 Hardcover

Conquer your fear of structure and find expression!

### Mastering Atmosphere and Mood in Watercolor

by Joseph Zbukvic

ISBN 1-929834-17-9 Hardcover

Learn how to transform ordinary scenes so they convey the message you want.

All these books are published by *International Artist Publishing* and can be obtained by visiting our website www.artinthemaking.com or through North Light Books, an imprint of F&W Publications, Inc, 4700 East Galbraith Road, Cincinnati, OH 45236, (800) 289-0963